BROKEN SPEARS

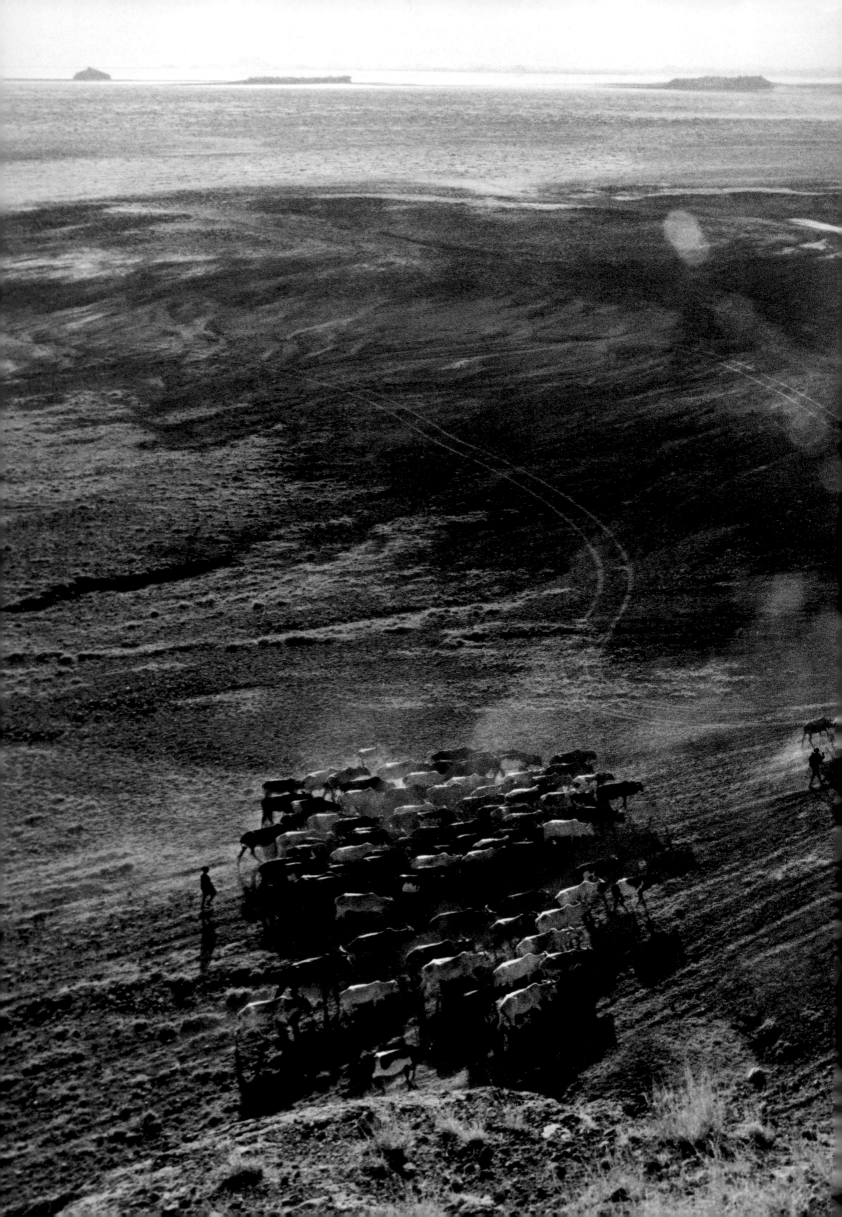

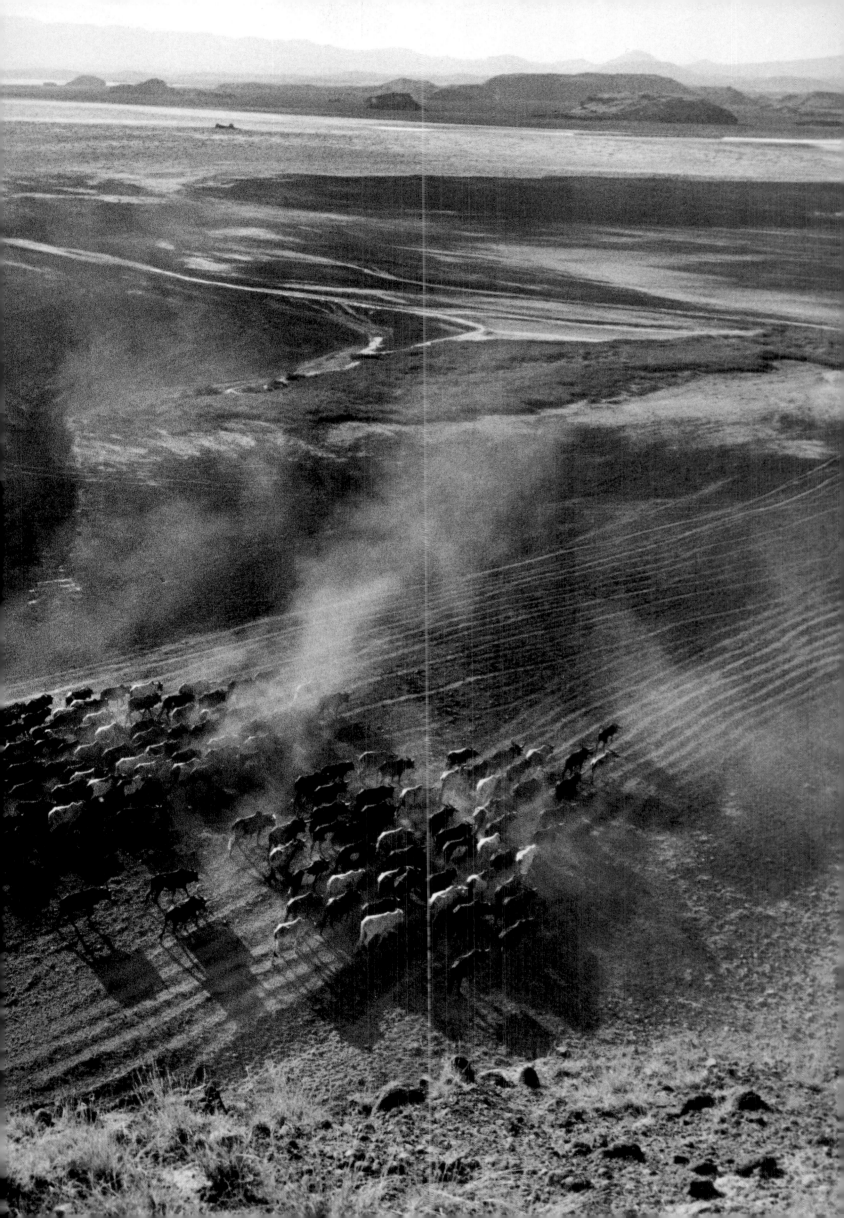

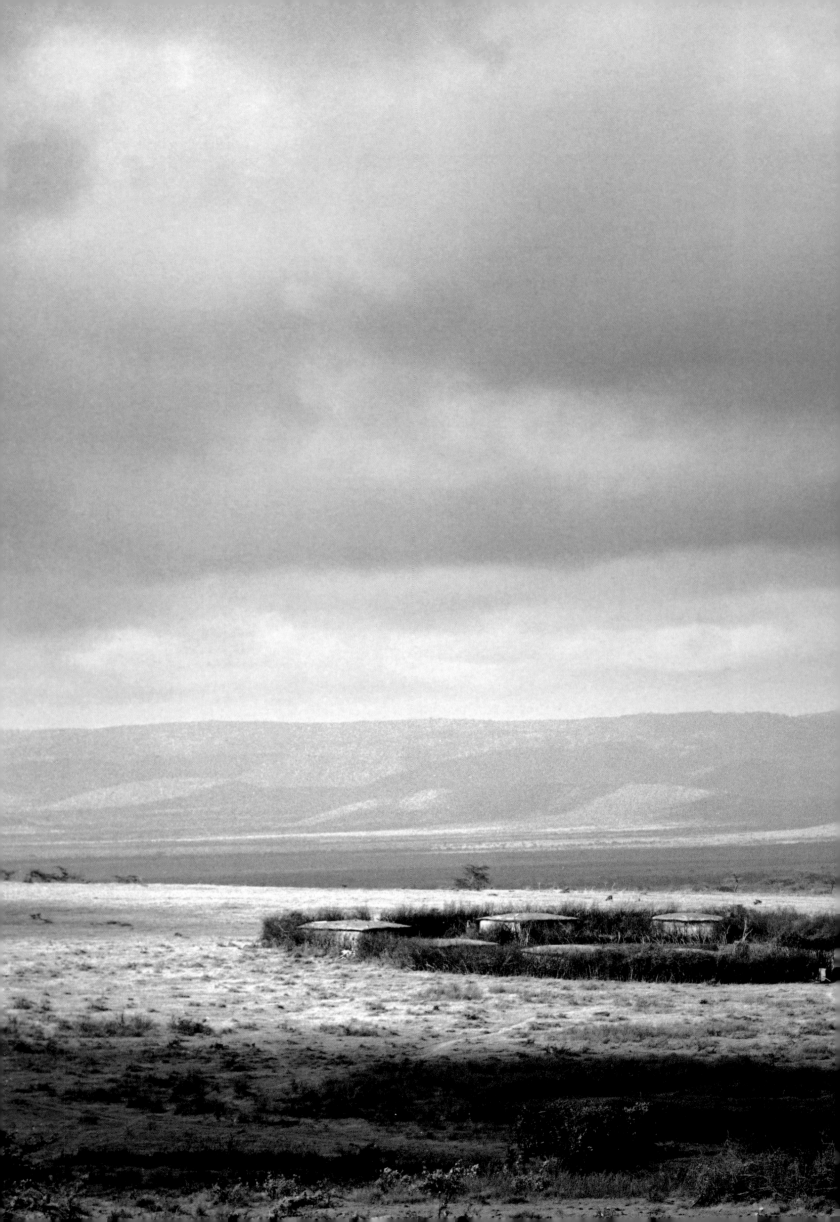

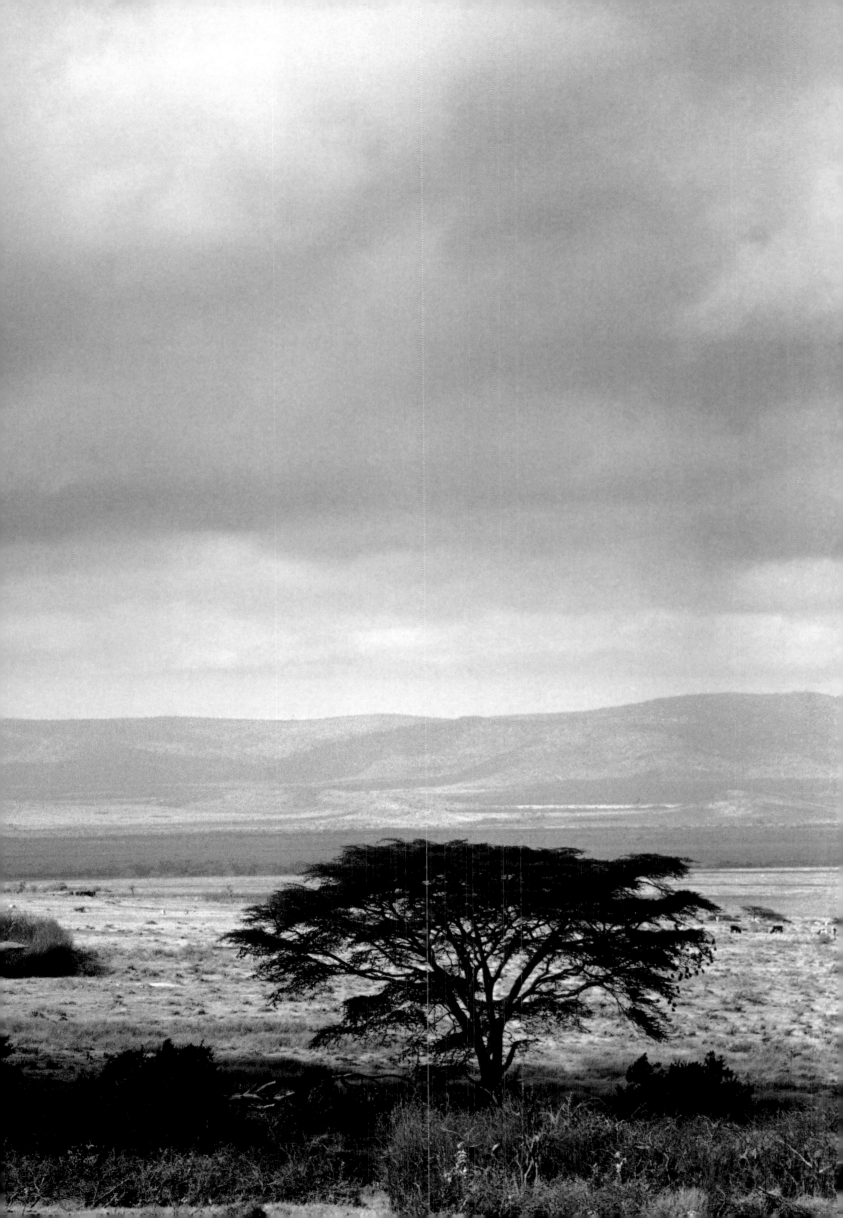

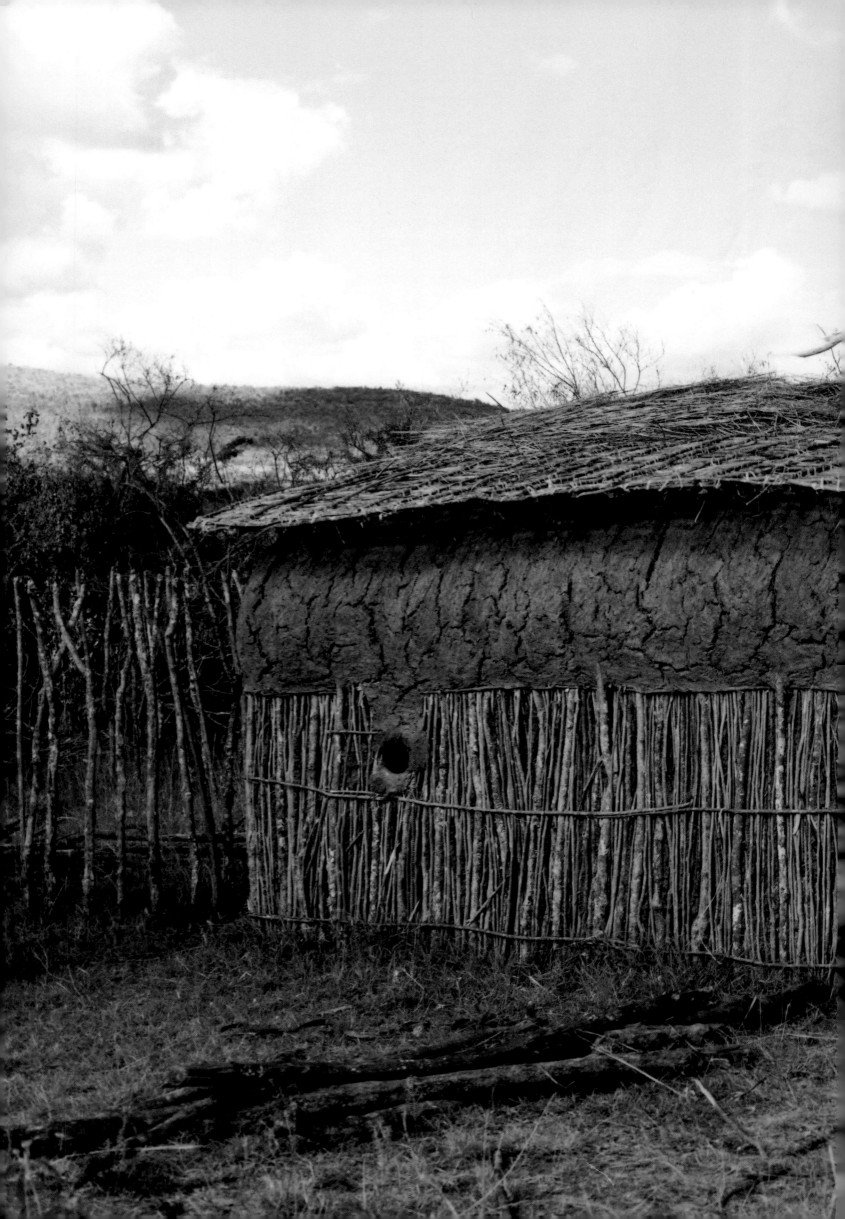

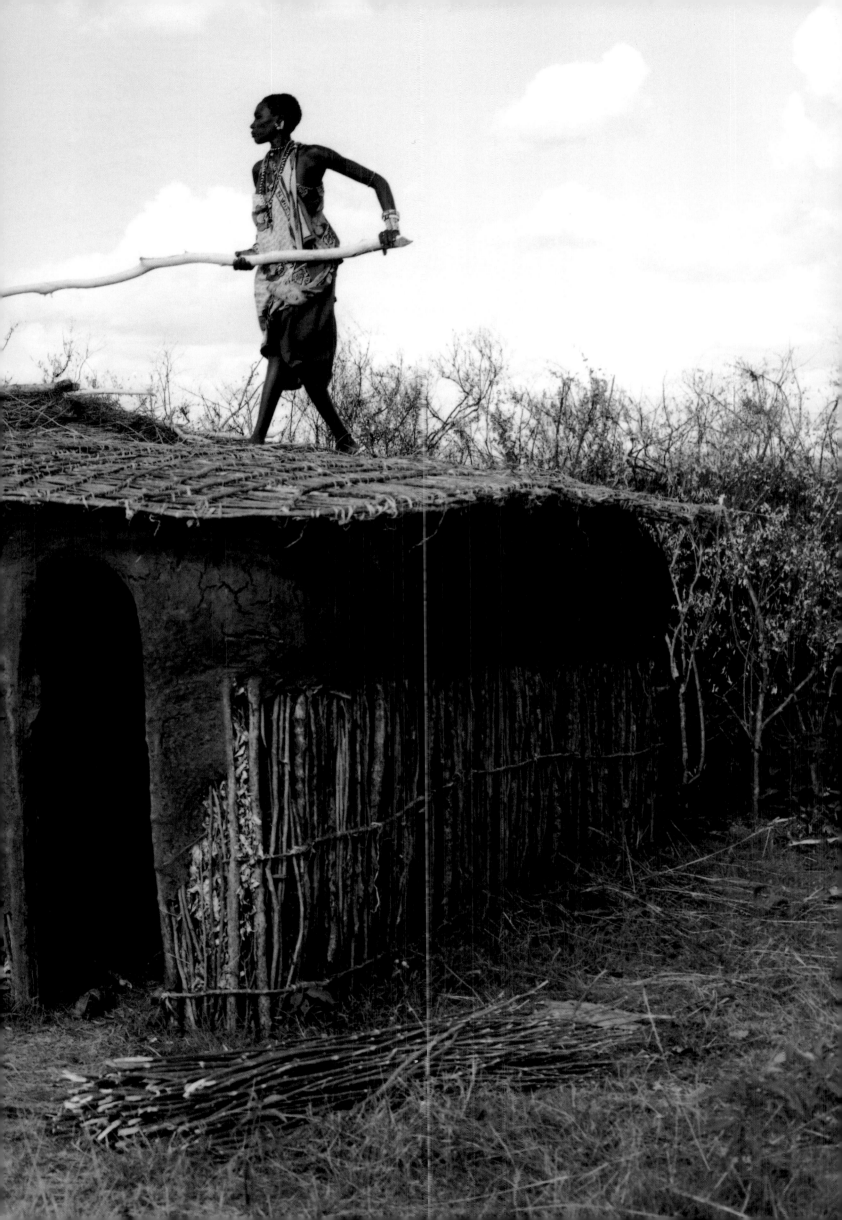

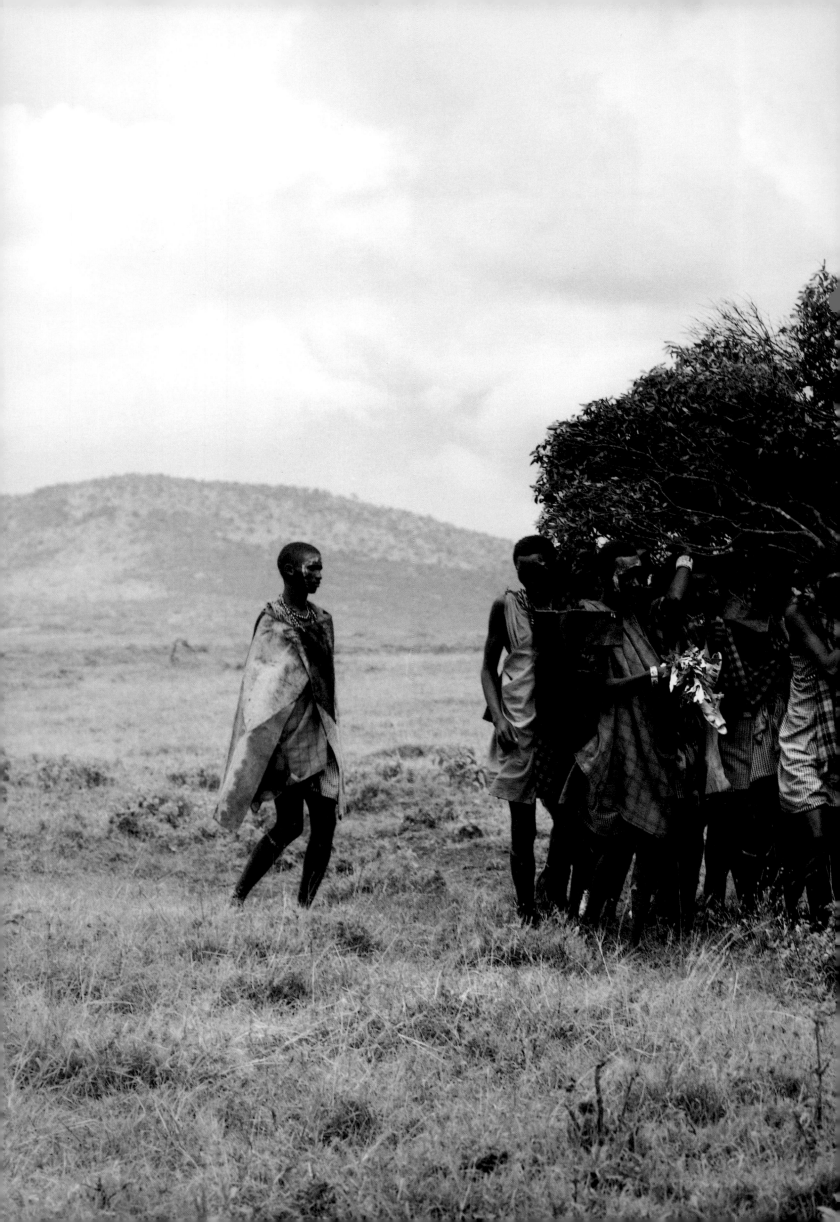

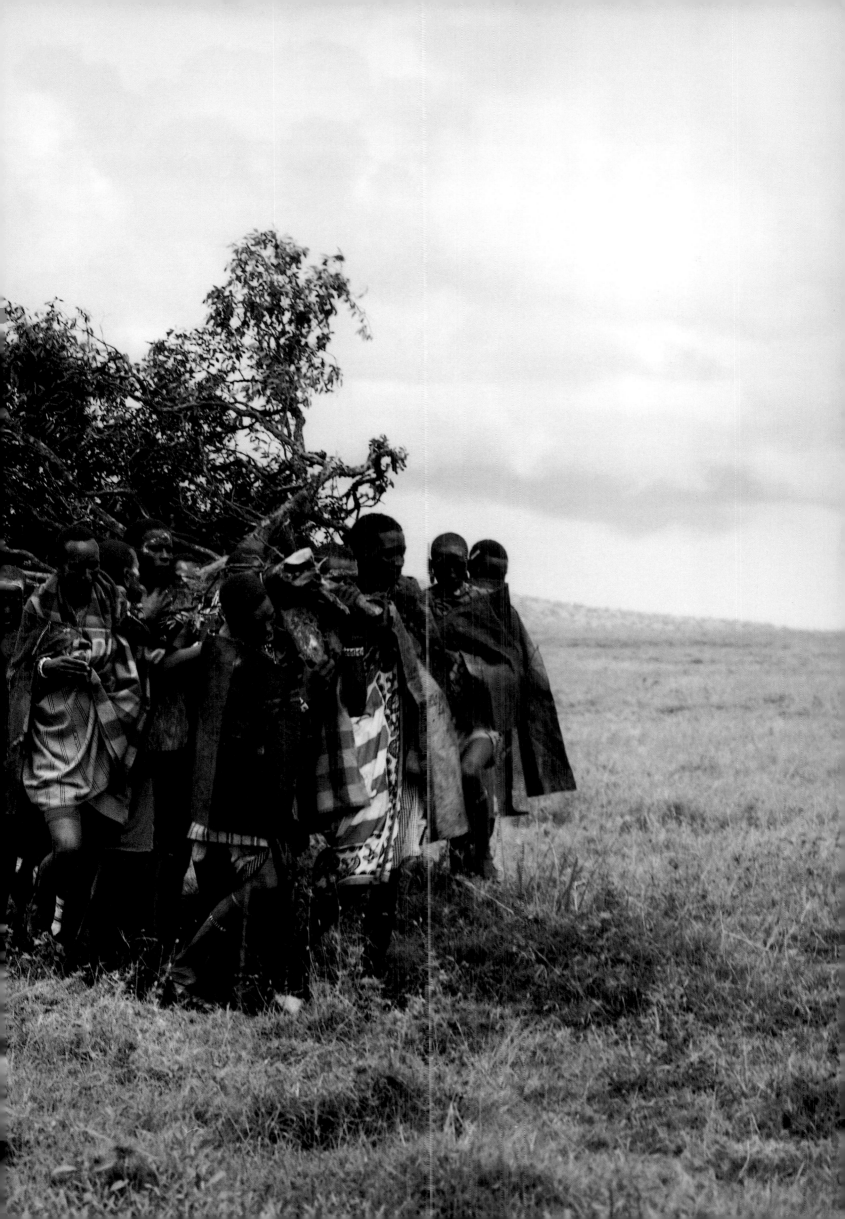

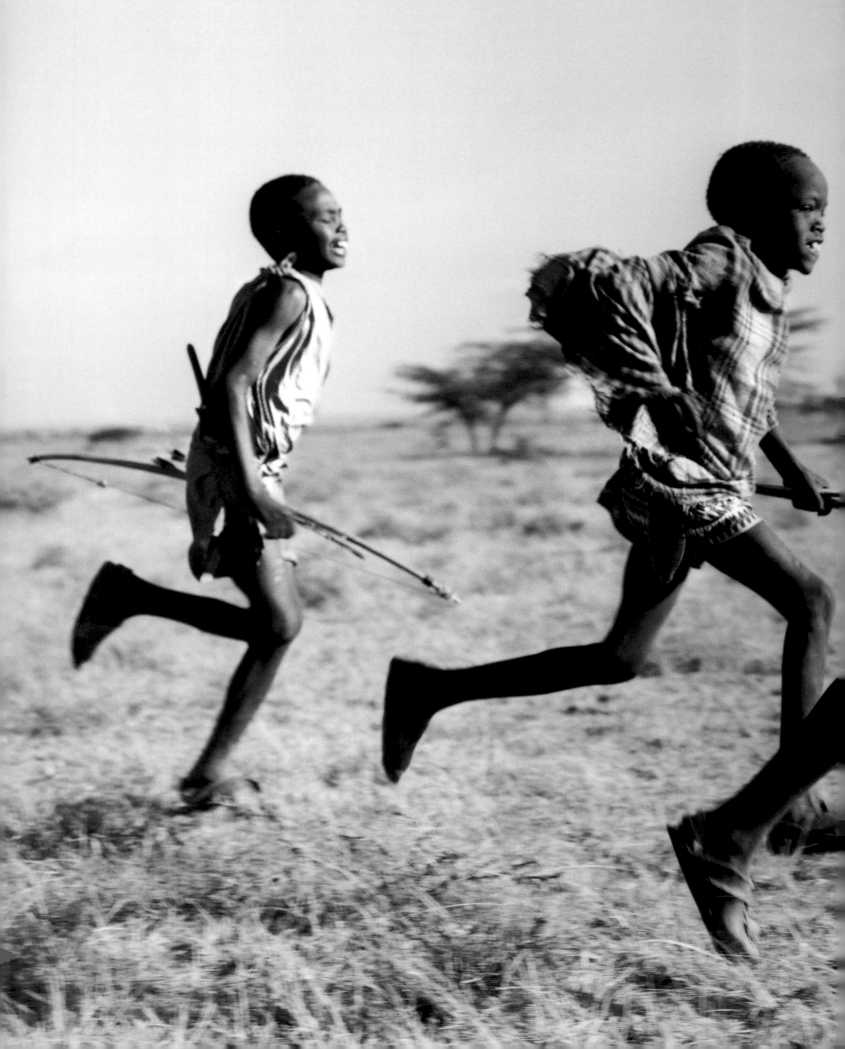

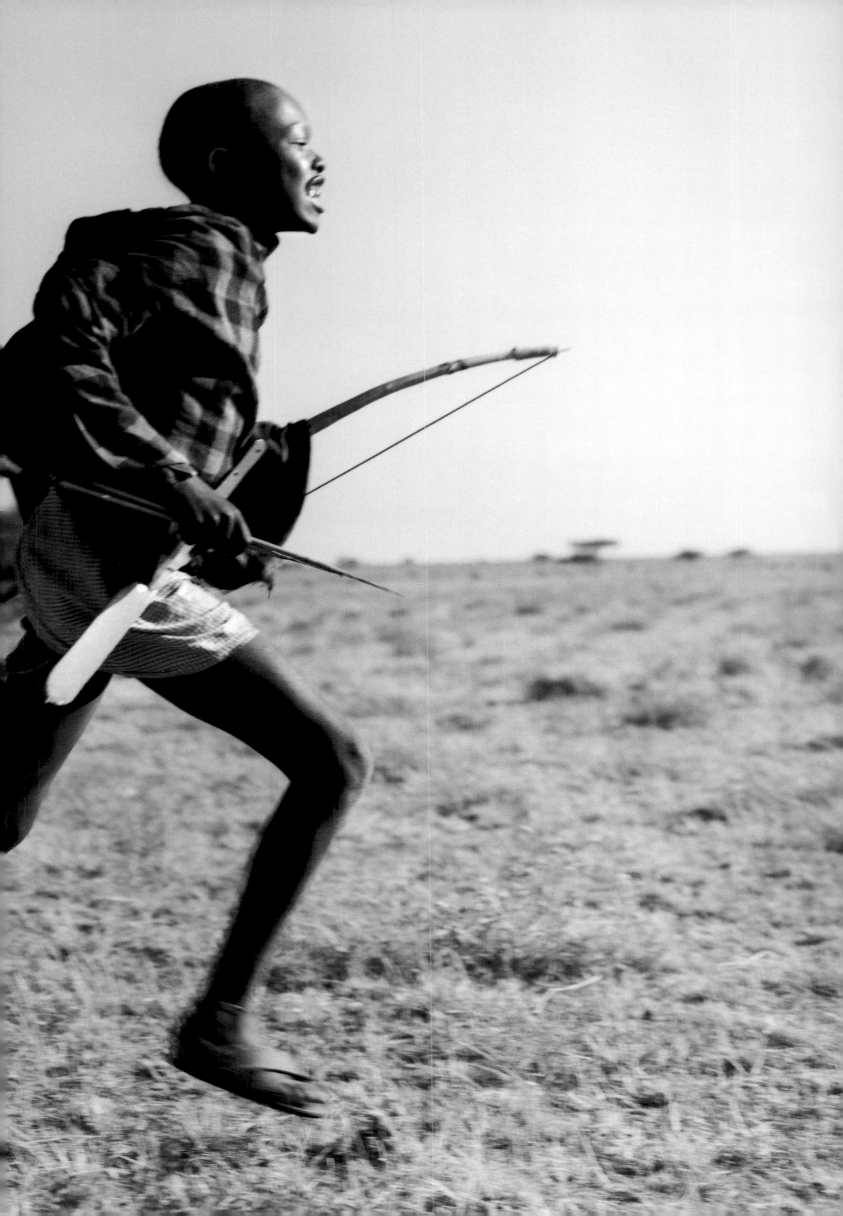

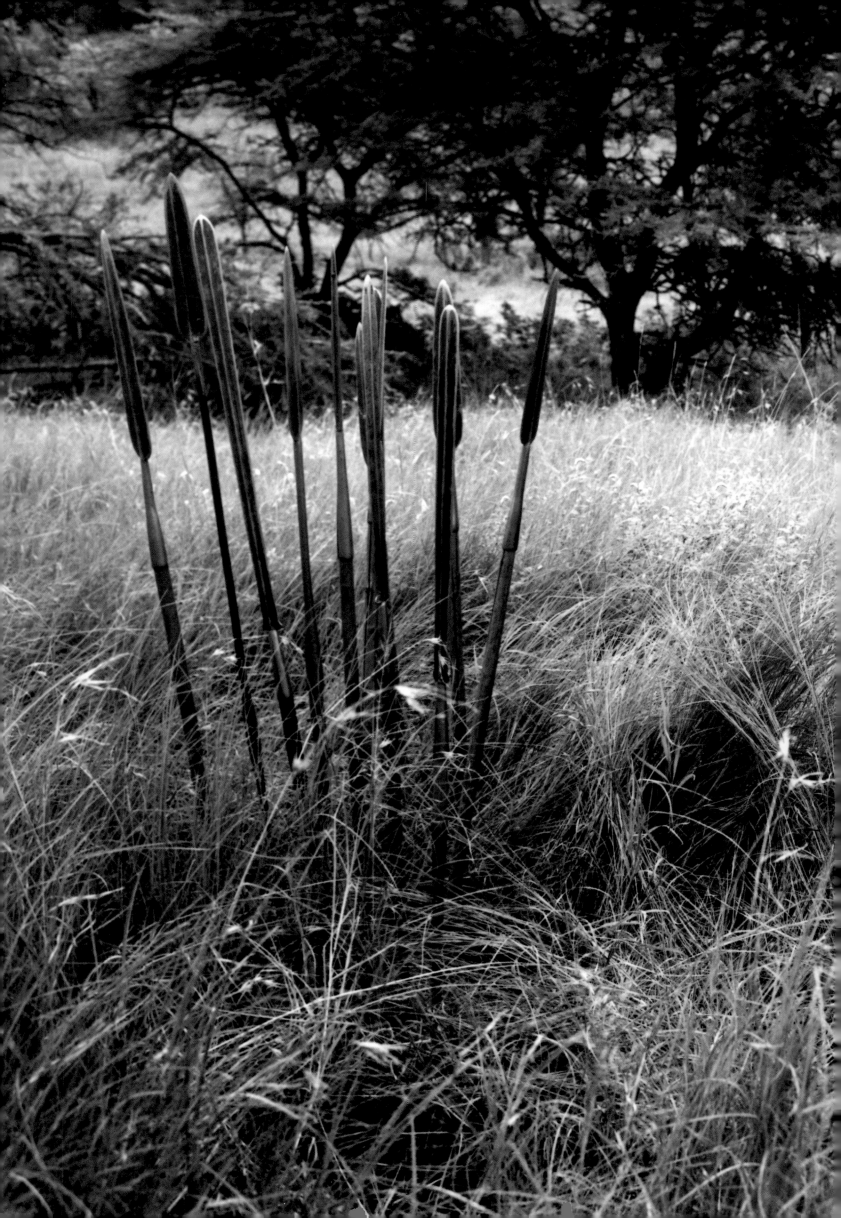

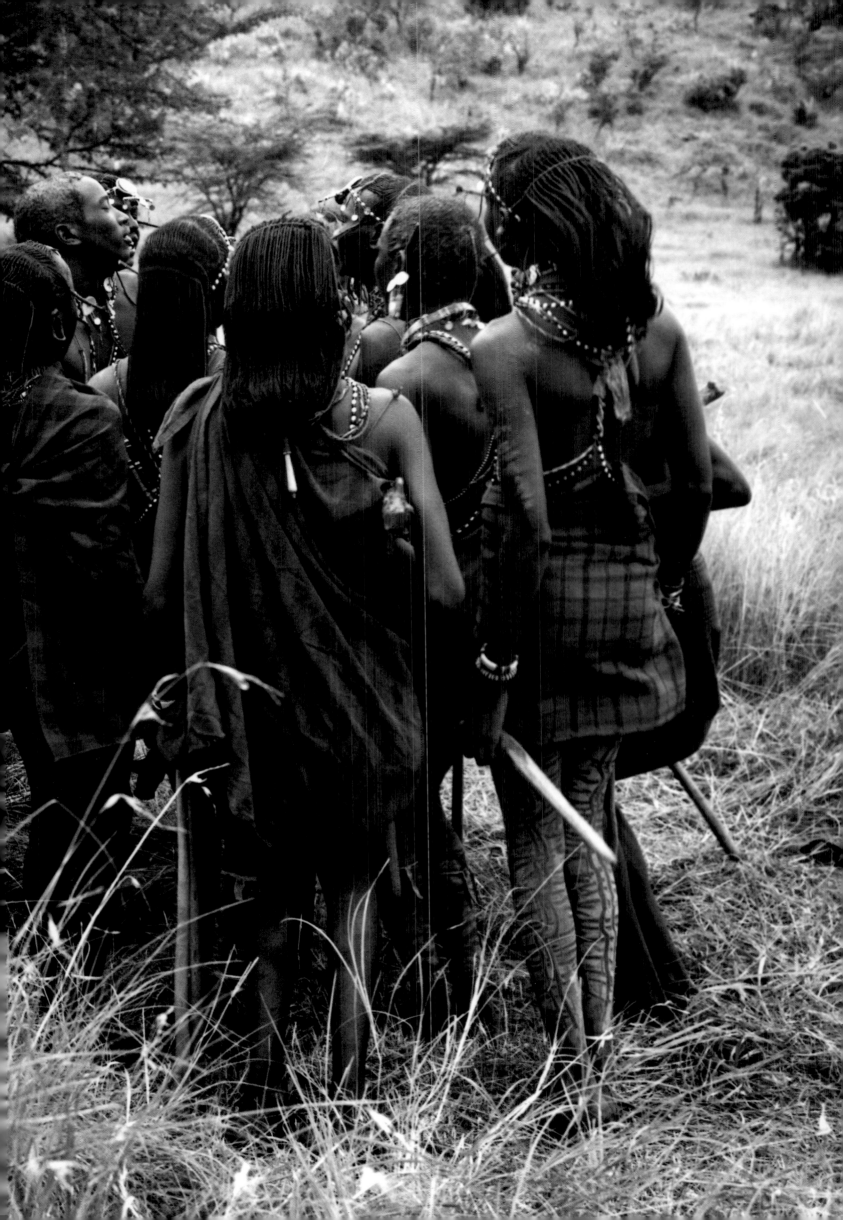

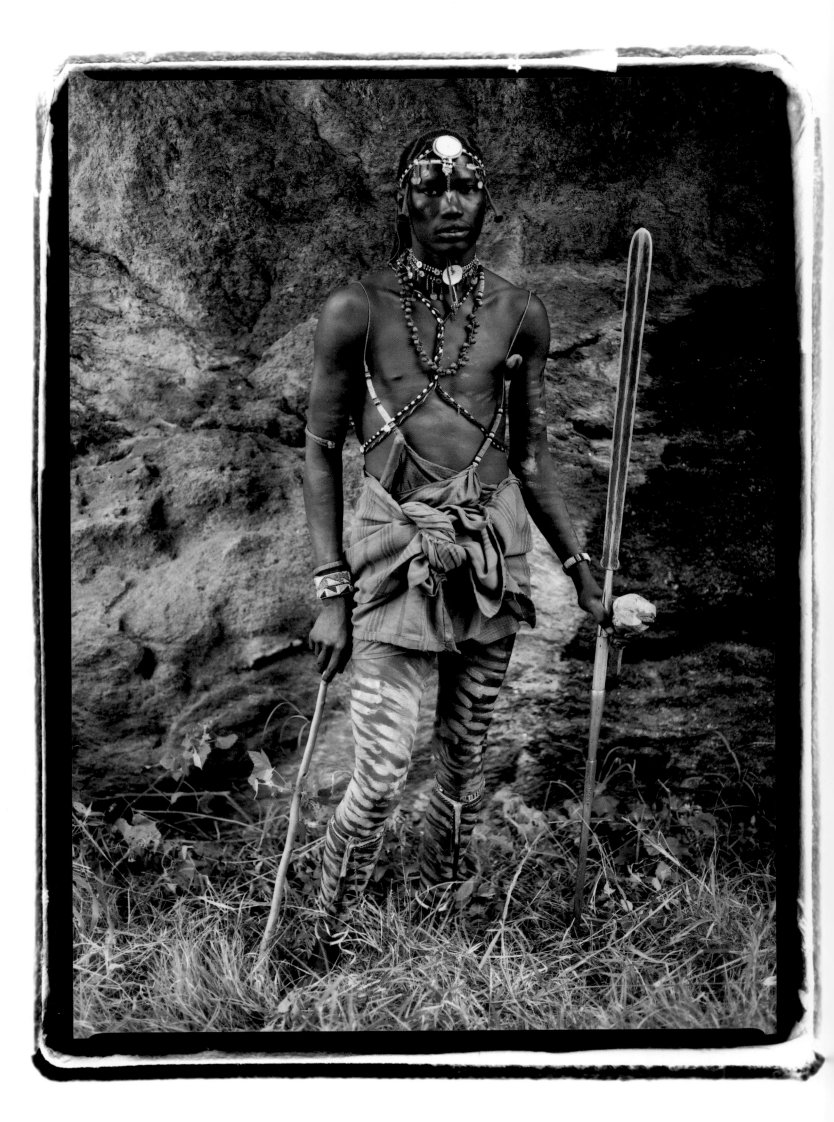

BROKEN SPEARS

A MAASAI JOURNEY

ELIZABETH L. GILBERT

ATLANTIC MONTHLY PRESS • *New York*
ATLANTIC BOOKS • *London*

Published simultaneously in Canada
Printed in Italy

The author gratefully acknowledges the following: the Kenya National Archives and Kenya Railways for permission to reprint photographs appearing on pages 39–49 and the Public Record Office of the National Archives of Great Britain for permission to print the treaty documents appearing on pages 50–55. The painting of Charles Eliot appearing on page 46 is from British Rule in Kenya 1895–1912 by G.H. Mungeam. The warrior blessing on page 134 is from *Maasai* by Telepit Ole Saitoti and Carol Beckwith.

FIRST EDITION

DESIGNED BY JULIE DUQUET AND CHARLES RUE WOODS
PRODUCTION SUPERVISION BY KEN WONG
PRINTED AND BOUND BY MONDADORI, VERONA, ITALY

Library of Congress Cataloging-in-Publication Data

Gilbert, Elizabeth L.
 Broken spears: a Maasai journey / Elizabeth L. Gilbert.
 p. cm.
ISBN:0-87113-840-9
 1.Maasai (African people)–pictorial works.
 2.Maasai (African people)–Social life and customs. I. Title

DT433.545.M33255 2003 2003040378p

ATLANTIC MONTHLY PRESS
841 Broadway
New York, NY 10003

03 04 05 06 07 10 9 8 7 6 5 4 3 2 1

FOR THE MAASAI

Dedicated with love to my parents,
WALTER AND AIMEE GILBERT
in the hope that it may compensate
to some extent for the anxieties
I know they suffered while
I wandered in Africa.

"If a warrior has a broken spear,
it means that he must have been very brave.
A spear cannot break itself
and a coward cannot break a spear."

CONTENTS

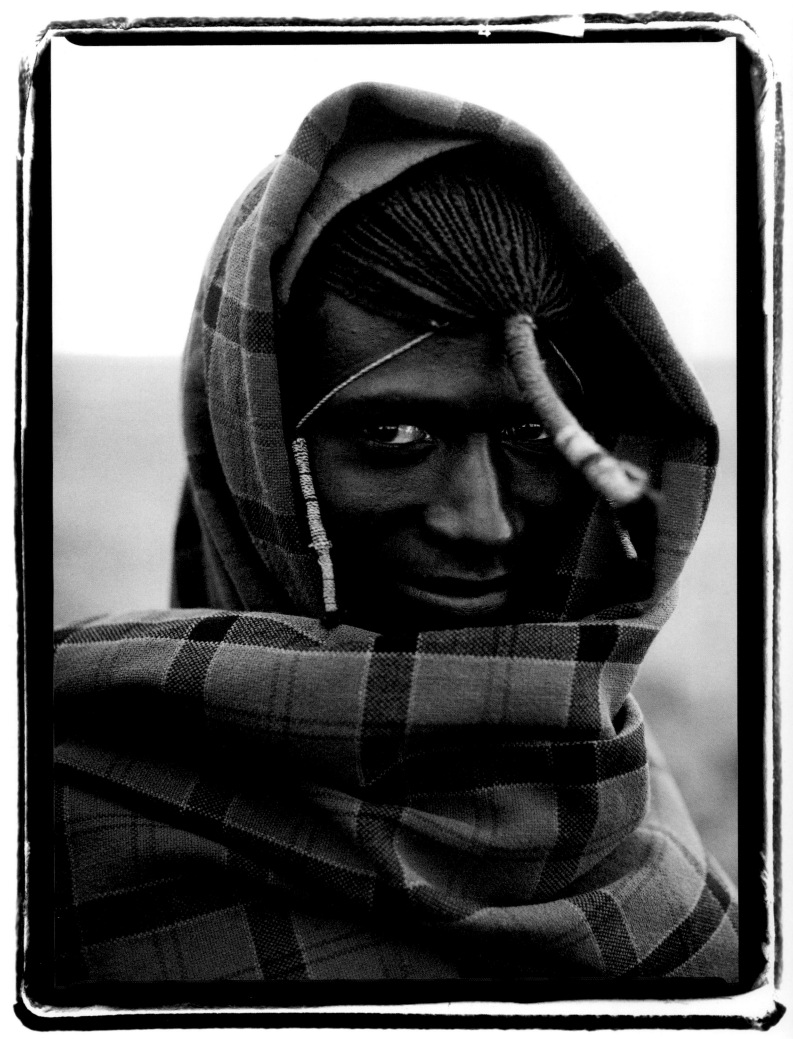

WARRIOR OF THE EMAOI PLAINS

INTRODUCTION

My first home in Kenya had a view of the Nairobi game park where the Maasai hunted lions and herded cattle nearly seventy years ago. Beyond the tree line at the foot of the garden, plains of blond grass spread toward the horizon, and on clear days I could make out the snowy peak of Mount Kenya eighty miles to the north. Wild game often strayed from the park and hyraxes screeched from the cypress trees above my bedroom. An old leopard prowled the neighborhood at night and when the rains came he left distinctive tracks in the mud. It was a romantic feature of life in the town, and from the veranda of that house Africa seemed infinite and ancient.

I had moved to Kenya in 1991 to work as a photojournalist and soon found that landscape far removed from the realities of modern Africa. As a news photographer throughout the 1990s, I covered numerous conflicts across the continent: the Rwandan genocide that claimed a million lives, famine and civil war in Somalia, the overthrow of the dictator Mobutu Sese Seko in Zaire, and a years-long civil war in Sudan that rarely made headlines anymore.

It was a different life. I carried boxes of film, flak jackets, maps, and pills. I flew in old cargo planes and slept in refugee camps. Africa was plagued by wars and conflicts, any one of them a short flight away from my home in Nairobi. In Rwanda, I photographed widespread massacres and the exodus of Hutu refugees as they fled reprisals from Tutsi rebels. Once, on a holiday weekend, I traveled to Lake Victoria and rowed a canoe with local fishermen to collect the bodies that had floated downriver from the genocide. I made annual trips to Sudan, steadily documenting the cycle of famine that wracked the south. In Somalia, I photographed the *Sharia* court case of a desperate, crazed teenager whose hand was severed with a kitchen knife as pun-

ishment for stealing a woman's scarf. And, years later, I stood on a stretch of Somali coastline, watching the last American troops disappear over the horizon while gunmen looted all that was left of a failed UN mission.

Travel was always dangerous. On one flight, a drunken Russian pilot stole my flak jacket and dropped me on an airstrip under mortar attack. On another flight, our plane hit a deaf man crossing the runway on takeoff, suspending his torn body in the undercarriage of our wing until we crashed in a grassy field in Uganda. I bribed my way through border posts, quarantines, and airports, photographing the conflicts and destruction that shaped the end of the twentieth century.

After seven years of news, I realized that the photographs of those tragic events had very little impact on their outcome. It was a dark time in East Africa and nothing seemed to be improving. When one war ended, another began, and famine and poverty were rampant. I began to rethink my work; I wanted to get back to the richness of the land and its heritage. I wanted to find the Africa that hadn't yet been ravaged by foreign empires, war, and the modern world.

I didn't know any Maasai then. They are a minority tribe of approximately 400,000 people, though no one knows their exact numbers because the Maasai superstitiously do not like to be counted. Their adherence to cultural traditions was famous, however, and most still lived in a five-thousand-square-mile tribal reserve of empty bush that stretches south of Nairobi all the way to Tanzania. Like the view from the house, it was an unspoiled landscape that possessed something purely African, an old world that was vanishing in the continent's quest for modernity.

I often saw the Maasai wandering the streets of Nairobi dressed in traditional *shukas*, the red plaid fabric that they drape over their shoulders. They looked misplaced with their cut earlobes and beaded jewelry, selling crafts in the market or herding cattle along the side of the highway. Yet their images were everywhere. Pictures of warriors were printed on postcards, T-shirts, safari advertisements, and hotel logos. They were promoted as a tourist attraction, nomadic herdsmen and practitioners of ancient ceremonies that have held them together as a tribe for the past two centuries. Photography had souvenired them in their colorful tribal adornment, but in reality their traditional life was disappearing. Education and the demands of a modern economy were forcing the Maasai to abandon their traditions, and by the end of the 1990s it seemed that their old customs would not survive another decade.

In 1998 I borrowed an old Land Cruiser and set off on what would become a four-year journey to photograph what was left of traditional Maasailand. I commissioned an Indian tent maker in Nairobi to build a canvas studio for portraits, an enormous piece of equipment ten feet wide, deep, and tall. I also enlisted the help of a Maasai who could speak English and who knew the back roads. Tiampati, an aspiring television journalist in Nairobi, had a traditional Maasai upbringing but had opted for school instead of becoming a warrior. He became a trusted friend and traveling companion, with his gentle way of speaking with strangers. His roots as a Maasai and his understanding of Western culture made my friendship with the Maasai possible, and we spent months driving across vacant plains and camping in villages.

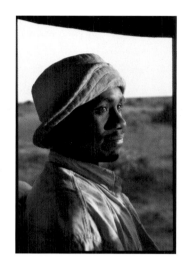

Tiampati

Maasailand begins not far from Nairobi, where the forest summit of the Kikuyu Escarpment drops away to reveal the vast plains of the Rift Valley floor stretching out to Tanzania. The landscape is diverse, spreading across arid soda lakes, grassy plains, whistling thornbush, and acacia trees to the hills and forests of the Loitas. Across the border lie the mountains in Tanzania: Kilimanjaro, Black Mountain, Namanga, and the Mountain of God. At its southernmost point, Maasailand branches to the foothills of Kilimanjaro, cutting east across the Maasai Steppe where it ends only a few hundred kilometers short of Dar es Salaam, Tanzania's capital. To the west it sweeps past Serengeti, stopping just short of Lake Eyasi, where the Barabaig, Tortoga, and other Nilotes have staked claim.

Our journeys across this territory brought us into an African world where life revolves entirely around the welfare of cattle and the rain that sustains them. For the Maasai, life is dependent on livestock and they have more than forty different words for cattle, each one describing a distinct feature of the animal. Branded with decorative drawings of the land, sun, and hills, these designs mark the owner of the cattle and his clan. Young boys responsible for grazing these animals memorize the pattern of the herd and can tell at a glance if they are missing even a single one out of a hundred. Maasai believe that at the start of creation, God assigned them ownership of all the cattle on the earth. They view the herds of other tribes as stolen merchandise and cannot understand why, after a raid, they should be imprisoned for reclaiming them.

Everything that is Maasai is derived from this reliance on cattle, and homesteads serve as kraals where man and livestock sleep at night within the same thorn-branch enclosure. The houses are thatched and mortared with cow dung that bakes and hardens in the sun. Nearly all are built with the same architectural plan, which is a simple rectangle divided into private sleeping quarters with one portholelike

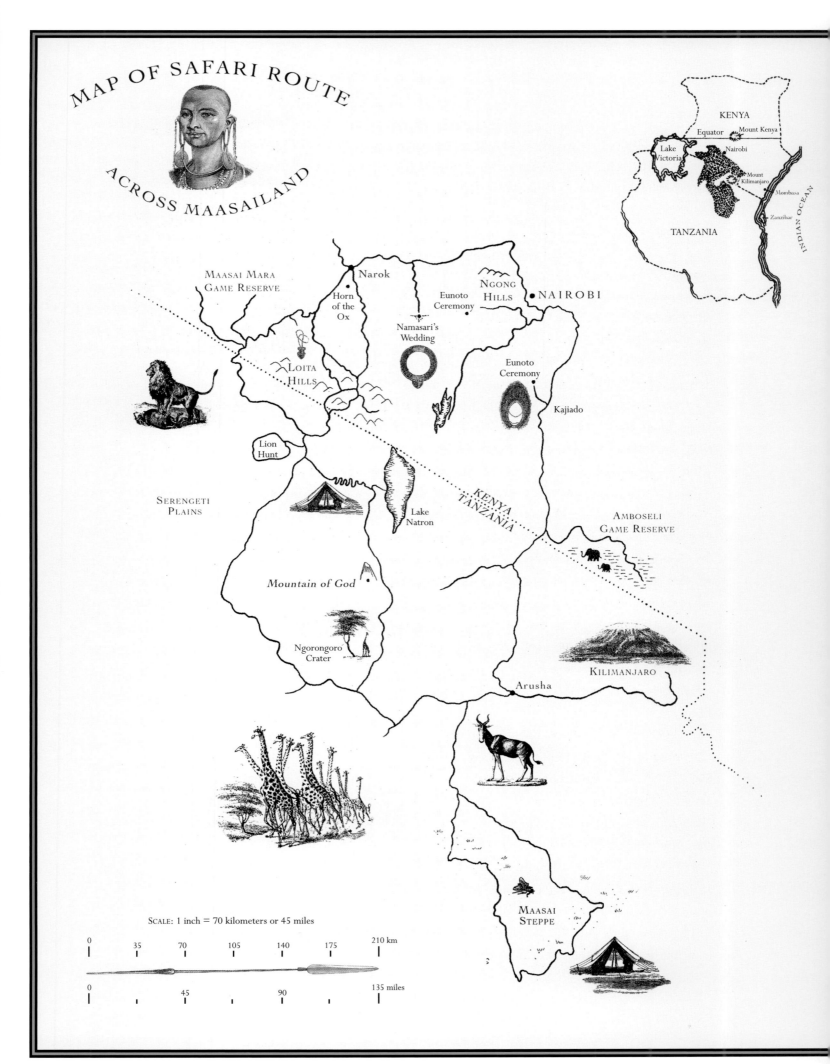

MAP OF SAFARI ROUTE
ACROSS MAASAILAND

KENYA

Equator · Mount Kenya

Lake Victoria · Nairobi

Mount Kilimanjaro

Mombasa

TANZANIA

Zanzibar

INDIAN OCEAN

MAASAI MARA GAME RESERVE

Narok

Horn of the Ox

Eunoto Ceremony

NGONG HILLS

NAIROBI

Namasari's Wedding

LOITA HILLS

Eunoto Ceremony

Kajiado

Lion Hunt

SERENGETI PLAINS

Lake Natron

KENYA TANZANIA

AMBOSELI GAME RESERVE

Mountain of God

Ngorongoro Crater

KILIMANJARO

Arusha

MAASAI STEPPE

SCALE: 1 inch = 70 kilometers or 45 miles

| 0 | 35 | 70 | 105 | 140 | 175 | 210 km |

| 0 | | 45 | | 90 | | 135 miles |

MAP SHOWING SAFARI ROUTE AND LOCATION OF CEREMONIES

window and a pen near the entrance where calves and goats are awarded luxury accommodation at night. Inside these dim huts, women keep a fire of olive logs burning where fresh milk is boiled and drunk with tea throughout the day. Most Maasai shun farm labor as the work of inferior tribes, relying instead on livestock for their diet of smoked milk and yogurt. This is collected in smooth brown gourds and supplemented on special occasions by a meal of goat meat.

During their southern expansion from the Nile, the Maasai developed the system with which they continue to sustain this way of life, separating themselves into age groups, with each being given a set of responsibilities. Boys herd livestock until their early teens, when they are circumcised and become warriors. After a military service of seven years, warriors are allowed to retire and marry. Women and young girls are responsible for all household chores, including the collection of water, food, and firewood. Elders offer counsel, settle disputes, and oversee the needs of the cattle herds. The passage from one age group into the next is marked by ceremony and ritual.

The Maasai believe in one God, Enkai, who is the master of creation. They pray to him daily, often asking for rain and prosperity. But for spiritual guidance, and on pressing matters of health, business, or love, the Maasai consult *laibons,* who are the vision seekers of the tribe. *Laibons* prefer to live in the hills, where the altitude and the view inspire spiritual connection. They can divine the coming of rain from the movement of snakes and birds, prod fertility in livestock and women through a concoction of powders and rituals, and predict love and wealth. Depression among the Maasai is not uncommon. Poverty, drought, and a sense of hopelessness are its agents. For these maladies, the *laibons* prescribe a soothing cocktail of herbs used as an antidepressant. Yet when rains fail and herds are wiped out, people can be driven to madness. Suicides are rare but do occur, especially after a drought. This is done by hanging, taking poison, or jumping onto a spear firmly staked in the ground.

During the initial safaris, my relationship with the Maasai was distant and businesslike. Many had tired of being photographed by tourists and as a result charged me for everything they could think of, whether it was directions or the shade of a tree. The Maasai never gave anything away for free. They are wary of strangers and in the beginning they saw me as tourist, a foreigner passing through with another life somewhere else. To me they were relics from Africa's past. When I looked at them I saw the history, the greatness they had known when the Rift Valley was theirs. The early photographs from these safaris are like artifacts to me, pieces of history suspended in time.

Things changed as I brought the photos back for the Maasai to look at. They became more than my subjects; they became my collaborators. They liked the idea that the pictures would be a permanent record of their culture, and some would

walk miles to a pay phone in Narok to call Tiampati or me about a ceremony. When we built the studio tent on the plains, they brought jewelry and leather capes and dug up their old lion manes for portraits, allowing me to photograph rituals and artifacts that are now illegal. I discovered, in my effort to document their culture, the Maasai's own sense of longing for their past. At night the elders sat around camp and discussed the way things were changing, calling the new generation of warriors "the plastics" for the rubber shoes and bicycles they owned. When I was back in New York they sent thin, weightless letters, urging my return for a wedding or the naming of child.

The Maasai were interested in keeping my photographs for their records, but they also documented traditions on their own. Someone at a ceremony would bring a tape recorder, capturing the sounds of warriors fainting and screaming, women ululating, children dancing and singing. They played these tapes over and over in the *manyatta*, delighting at the sounds of people they knew. Whenever I saw this, I felt sorry they didn't have cameras of their own. They would have made much better documentarians than I could ever have hoped to be, for only a true Maasai could know the fund of intricate ceremonies, legends, and spiritual beliefs that were at the core of Maasai identity.

Tiampati and I were in constant pursuit of ceremonies we hadn't seen before. My interest in photographing was matched by Tiampati's own desire to experience the culture he had missed when he was a student. We trolled the markets and *bomas* around Narok listening for news of upcoming events, and months would pass before we'd hear of anything. I would find a ceremony I wanted to see and then, when I thought I had everything, I learned about something else and wanted to document that, too. The photographs were a collection. Once I had made the warriors' portraits, I wanted to photograph the big graduation ceremony. If I had photographed that, then I wanted to photograph the lion hunt, until everything seemed complete.

It is a difficult thing to find a Maasai lion hunt and it was revealed to me at the end of my journey, when I wasn't hanging on to anything anymore, when I had given in to the bush and grown to like all that milky tea and goat meat and never wanted anything but to be on the road, when the car was a mess full of bones and corn husks and empty Coke bottles and the seats were smeared with red ocher and the dust had gotten so deep into everything that I didn't care anymore. I had been searching for the lion hunt for four years and it was shown to me when I felt most accepted in their world. Once I photographed it, I knew that my work was done and that it was time to go home.

These pictures are a collection of events and faces that, to me, represent the essence of traditional Maasailand. They were taken by an outsider, but no events or ceremonies were staged for my camera. They are dispatches from another world,

a world where there isn't a telephone wire or tin roof in sight. This world is quickly changing. Every year brings with it more houses, more shops. The Maasai have been forced to subdivide their land and sell individual plots to outsiders. Fences are being built. Farms of maize fields have spread through the once empty bush. More and more Maasai children are being sent to school, forgoing warrior life altogether and the traditional rites of passage. I met many educated Maasai who were eager to dispense with the old traditions, seeing them as backward and antiquated. They appreciated their culture but were also frustrated with a world that had seemingly passed them by.

In the photographs, you can see this world creeping up on them. At first glance the images seem timeless, but closer inspection reveals the tokens of modernity that are evident in bush life—a pair of sneakers, a wristwatch, a T-shirt. They remind us that the Maasai are people of present time, consciously upholding their traditions as they carve out their identity in the modern world. It is the elders who are most intent on maintaining Maasai culture, and when they are gone much of the past will go with them. The Maasai know this, too. Allowing me to photograph them for the purpose of preserving their culture was an acceptance of its end, their own acknowledgment that the idealized Maasai identity that has existed for two centuries is finally disappearing.

Believing that I was documenting a vanishing culture strongly influenced my approach to this work and I have chosen to photograph those aspects of Maasai life that are most in jeopardy of being lost forever. My hope is that this book will serve as a scrapbook for the Maasai and a meaningful record of their heritage when that life is just a memory.

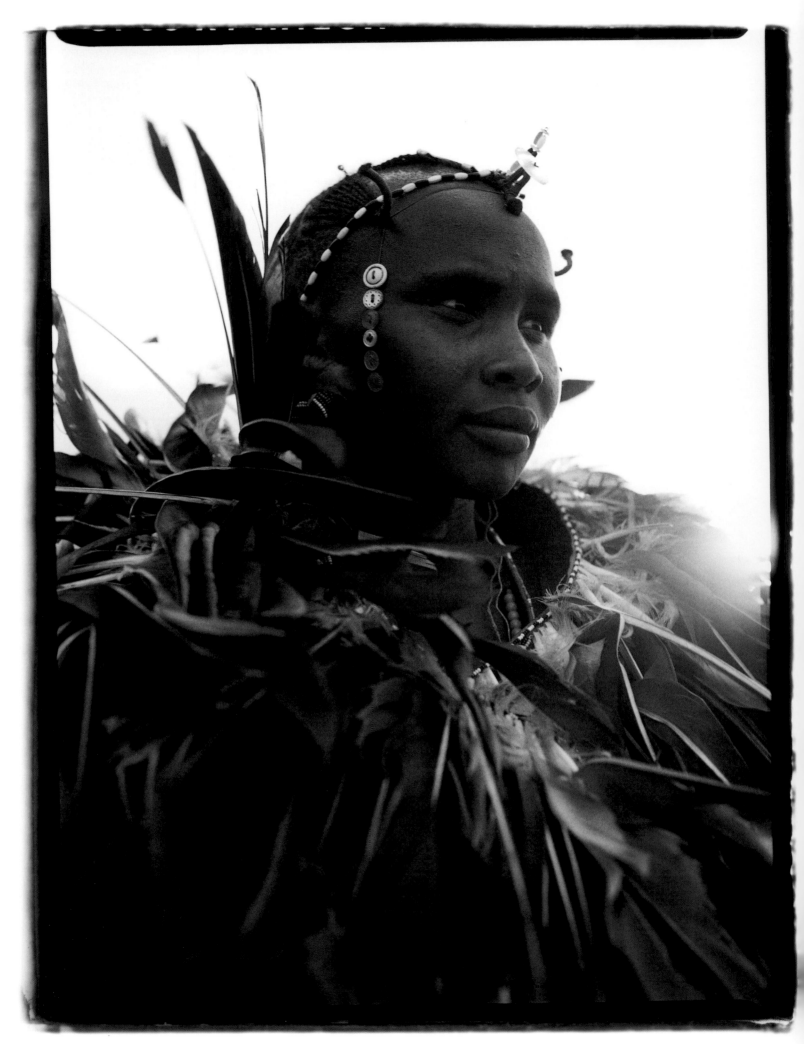

AMBOSELI WARRIOR WEARING VULTURE FEATHER CAPE

"Every generation has its song."

— MILTON OLE SILOMA

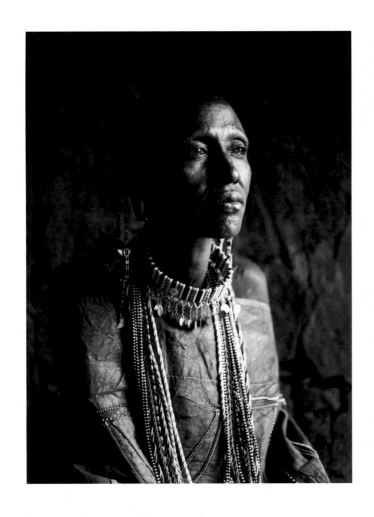
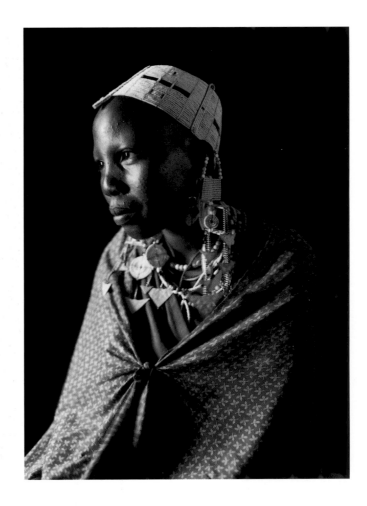
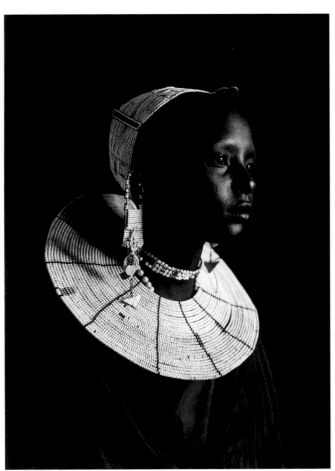
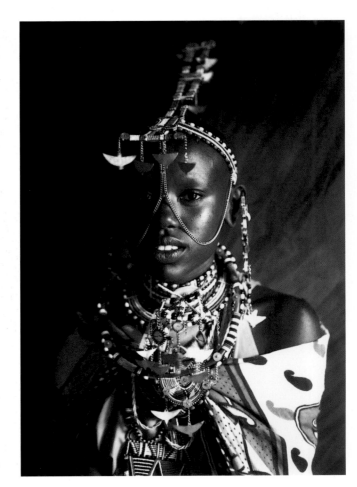

MAASAI WOMEN WITH BEADED JEWELRY

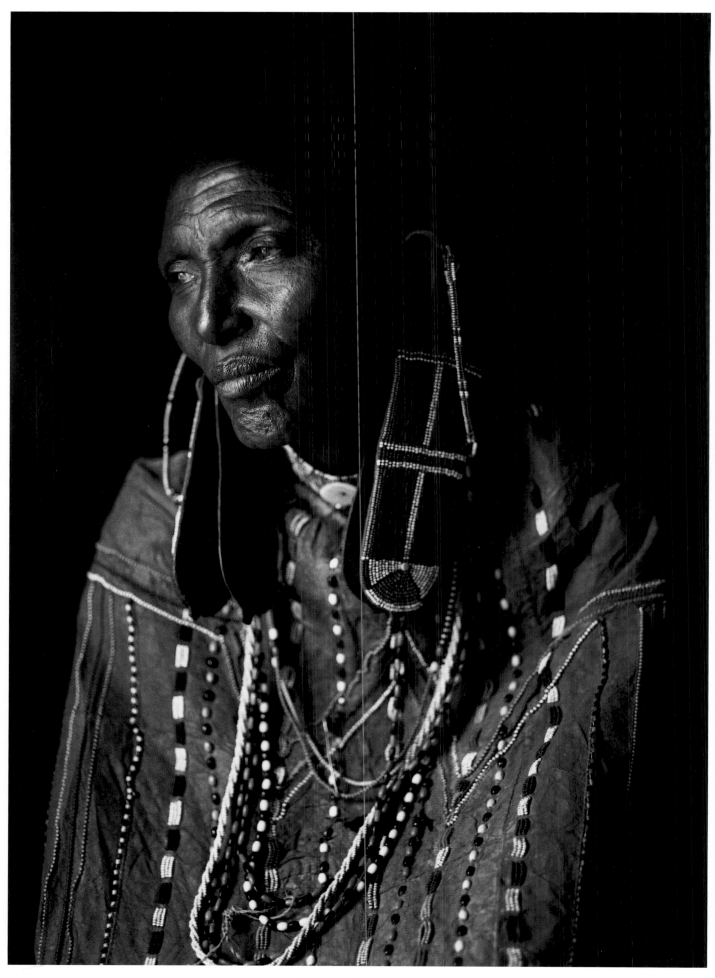

NALAMAI ENE NYAPIT
Mother of a chief

33

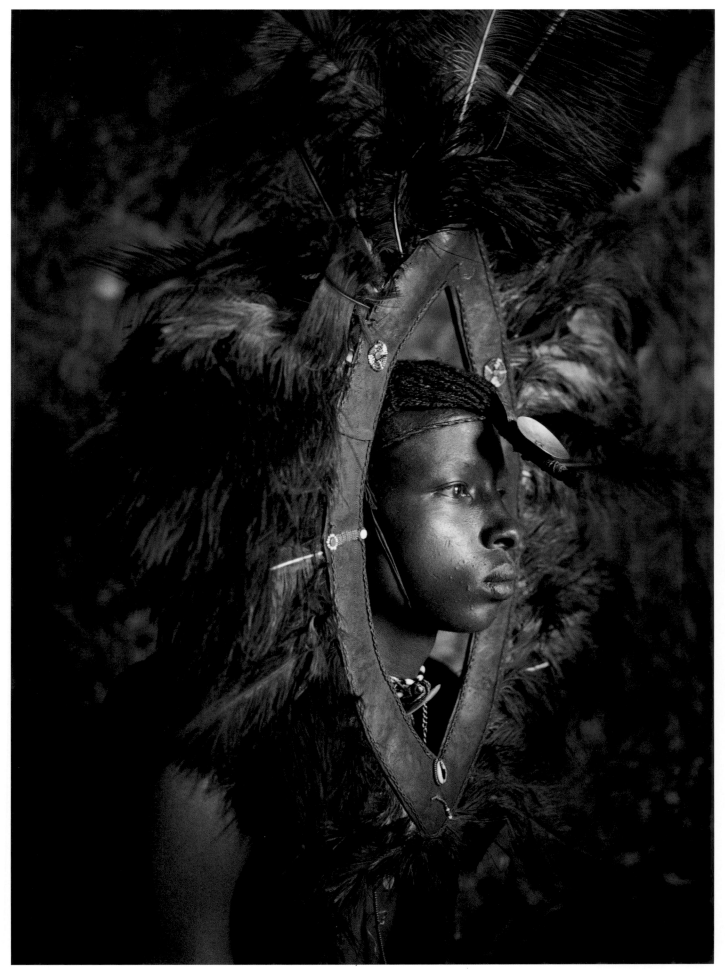

WARRIOR IN OSTRICH FEATHER HEADDRESS

Ostrich feather headdresses were commonly worn by warriors until the end of the twentieth century when education and government diminished the need for tribal military service. The tall headdresses were originally worn to frighten enemies and are now modeled only at ceremonial occasions.

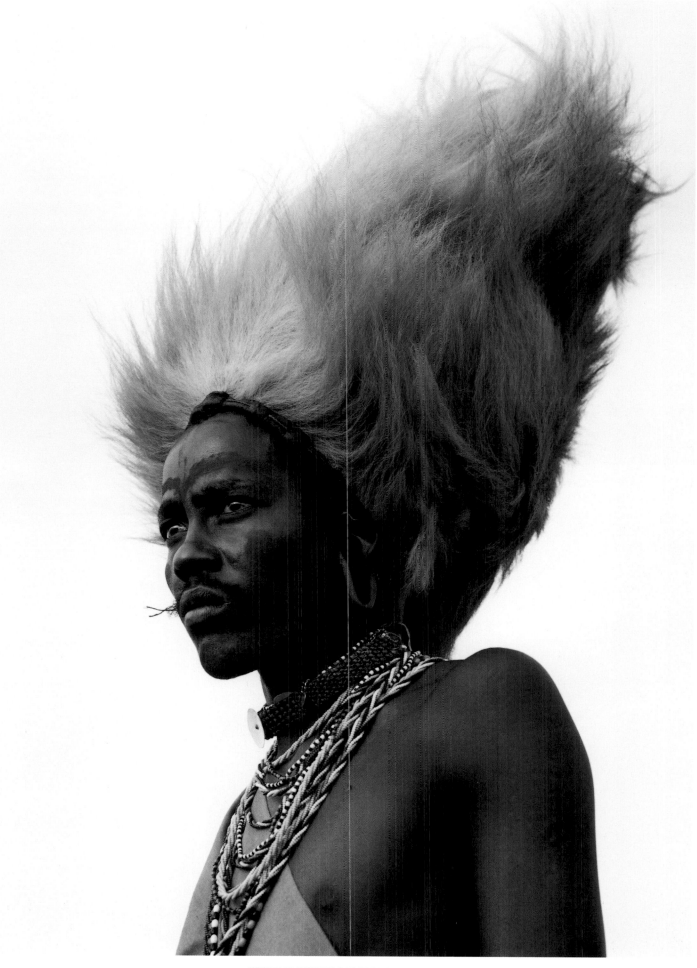

KITULI TAKI IN LION MANE HAT

Hats fashioned from lion manes are the trophies of warriors who have successfully killed a lion.
They are evidence of bravery and are the most admired of all the warrior's adornments.

35

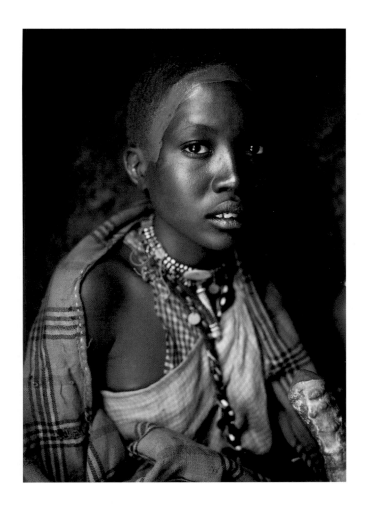

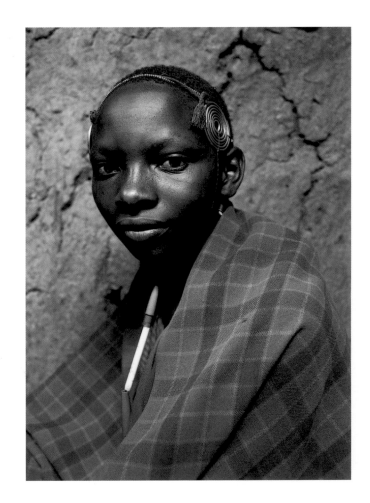

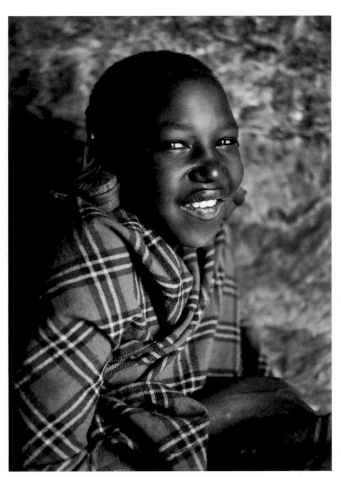

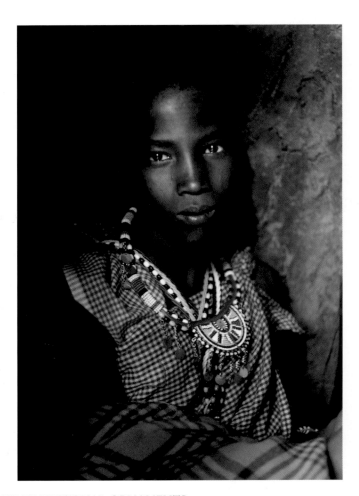

MAASAI BOYS WEARING SHUKAS AND TRADITIONAL ORNAMENTS
INCLUDING EAR STRETCHERS, BEADED JEWELRY, AND CIRCUMCISION HEADGEAR

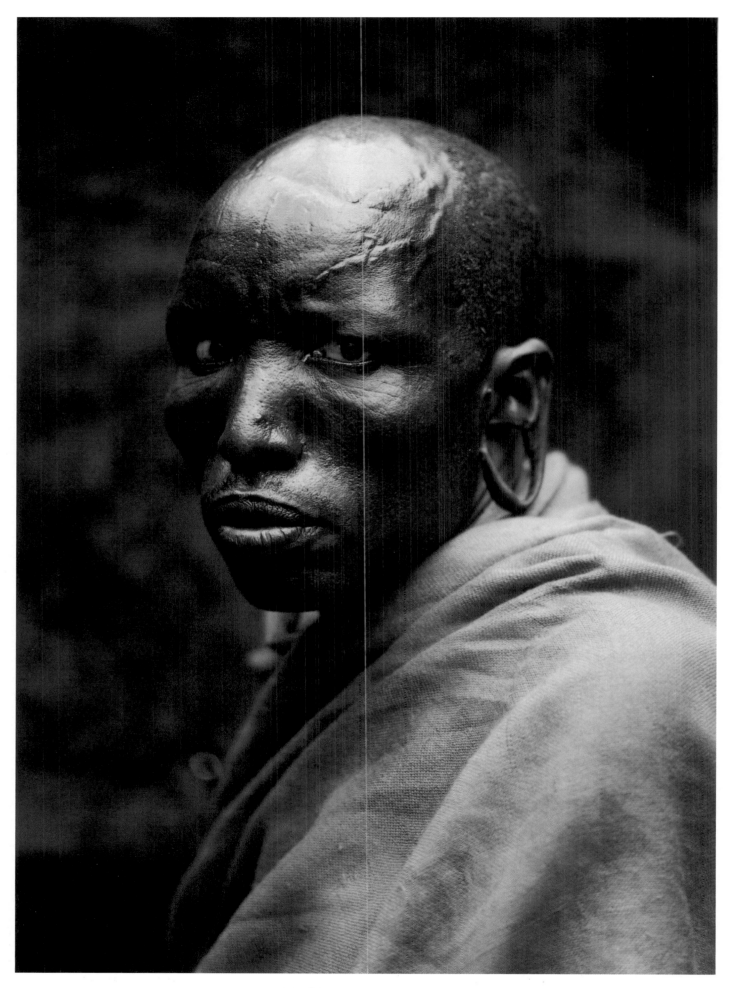

MAN SCARRED BY A LEOPARD

37

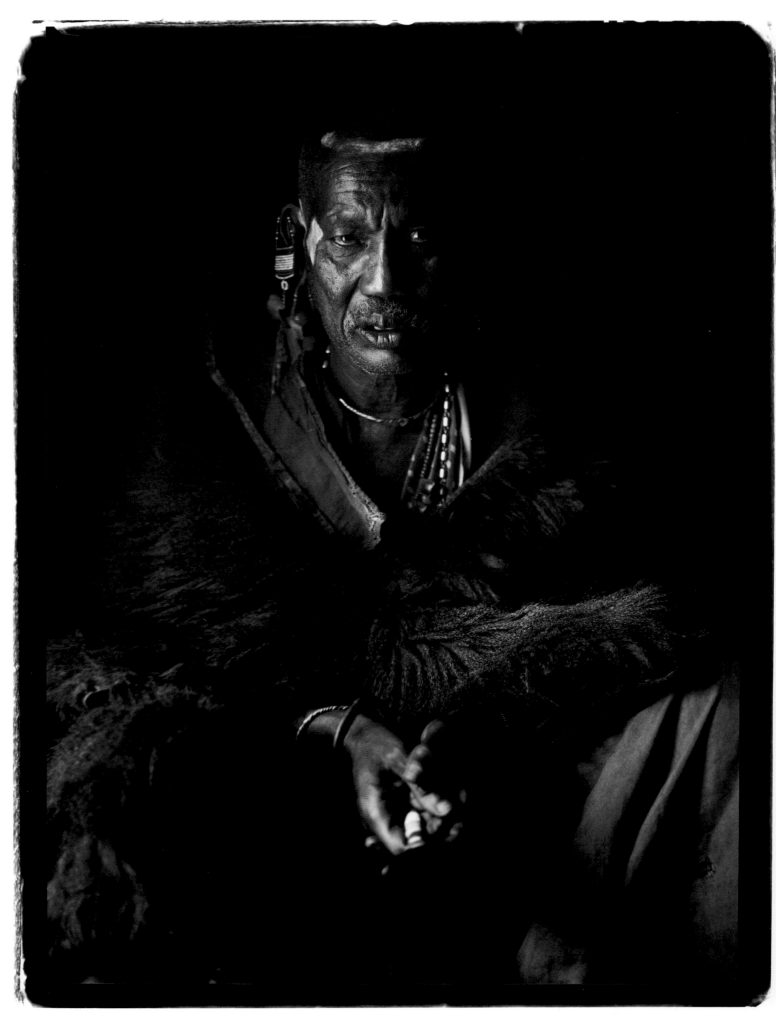

THE LAIBON MOKOMPO

The *laibon* Mokompo, descendant of the famous vision-seeker Mbatiany,
who foretold the arrival of the British and the construction of the railroad

THE PAST

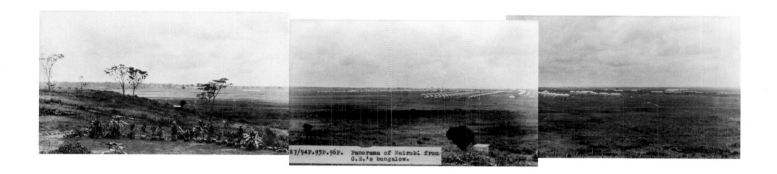

87/94P.95P.96P. Panorama of Nairobi from G.H.'s bungalow.

During my travels in Maasailand, I never saw a funeral or heard a Maasai speak of the dead. When I asked about this, I was told that it was not good to talk about the deceased. To the Maasai, death is taboo, an impolite topic and useless to discuss. When I offered one of my photographs to an elderly Maasai woman, she looked at it and asked, "What for?" I replied that her family might treasure it and that many years later, when she was gone, they would remember her by the picture. She laughed and handed it back. The Maasai believe when someone dies they should be gone forever.

Yet the Maasai elders are filled with stories of the past. When I drove down to the Maasai Mara plains to set up the studio for portraits, they came with their old cowskin capes and fly whisks made from wildebeest tails. They talked about the land, the colonial officers they knew over half a century ago, years of drought and cattle raiding, and the lions they had killed, and they told with equal terror of the first school that was built and how it hurt to send their children away to it. They remembered the first plane that flew over Maasailand, and the first time they saw a car rumble down the dirt road to Narok. I loved talking to the elders about their history, so when I heard of an old *laibon* whose family had played a major role in land negotiations with the British I set out to find him.

It took three days to find Mokompo, who lived above a swamp in the hills near Tanzania. Great-grandson of Mbatiany, grandson of Senteu, son of Simel, Mokompo came from a long line of famous *laibon*s who had a prominent place in colonial history. When we arrived he was dressed for visitors, wrapped in a cape of hyrax skins and clutching a bottle of honey beer. He wasn't surprised to see us and said he'd seen us coming in a dream.

Inside his house we were joined by a group of men who, upon hearing we were researching Maasai history, decided to stay. Everyone liked to hear the old stories. Smoke from the fire burned our eyes and cast a blue haze inside the room. Mokompo sat on a wooden stool and took a swig from a gourd filled with honey beer. Then he unwrapped a cow horn from a black cloth and laid it on the ground. This was the *enkidong*, and all the Maasai *laibons* had one. He gave it a vigorous shake, and out onto the floor splashed a handful of pebbles, stones, glass beads, and marbles. He began with the prophecy of his blind great-grandfather, who saw in a vision the arrival of the British.

"This story is told to each generation and my father is the one who told it to me. Everyone has his own version of the story and with each passing year it changes. But we know that Mbatiany saw the white people a long time before they set foot here. That was my great-grandfather. He had one eye and was the great *laibon* of all the clans. He had been having dreams, so he called a meeting and said, 'I see butterflies—white—and they have an iron snake.' That was the train, you see? And he asked the people, 'Now that there is this snake cutting through the country, shall I hit it?' Since the Maasai were brave, they told him, 'No, let it come so that we can see it.' He replied, 'Let me hit its head because if it comes, then things will never be the same.'

"The old men wanted him to use his magic to get rid of the snake. But it was the warriors who stopped him. They weren't afraid of anything so they just waited for it to come. You know, only God plans what will happen. He just uses the *laibon*s as mediums so that people can see the future and be warned. Looking back I don't think there was anything we could do to stop the British. They were coming no matter what."

The men sitting around Mokompo clucked their tongues and shook their heads, noting the truth of

Olonana, the most famous of all the Maasai *laibons* (vision-seekers), who befriended the British and represented his tribe in land negotiations at the turn of the century

what the *laibon* had said but feeling that it was all a great shame. They murmured among themselves, adding details and observations. It was interesting that so many tribal sagas began with a dream. Many cultures that have been felled by conquering empires can recall an oracle who predicted their own demise. I had read about similar Kikuyu and Turkana prophecies, so when you put them all together it had an epic quality, as if all of East Africa were waiting for something. And what happened later when the British arrived had such an enormous effect on the Maasai that it seems possible that it might have been felt in advance by people who were so sensitive to danger and nature.

Mokompo continued his story. "The *laibon* Mbatiany had two sons, Senteu and Olonana, from two different wives. They were, therefore, half brothers, but were of the same age. In the way the story is usually told, there came a time when Mbatiany wanted to give Senteu the sacred *enkidong* and make him a *laibon*. We don't know why he favored Senteu. Perhaps he figured that Senteu had the qualities of a good leader. When responsibilities are issued, they are given to those who can carry them. So when Mbatiany got so old that he could no longer see or move and spent most of the time sleeping, lying in bed, he called for Senteu and told him in private, 'Senteu my son, you see an old man before you now. You must come very early in the morning so that I can give you the *enkidong* before I die.' Mbatiany made this appointment in secret because he wanted to ensure that Senteu inherited the *enkidong*.

"Senteu's brother, Olonana, who was always smart and cunning, was hiding outside the old man's house and heard Mbatiany. He was very jealous about this and made a plan to get his father's magic all for himself. At dawn the old blind man heard someone come into the house and he whispered, 'My son, Senteu, is that you?' Olonana responded, 'Yes,

father.' So Mbatiany was fooled and handed over his blessings. But as Olonana was leaving with the stones and magic, Senteu arrived and saw what had happened. He ran into his father's house and Mbatiany said, 'Oh, come here so I can bless you. The hawk got here before you and has already taken it.' All he could do was bless Senteu so that he could go out there and face the world. So that is how it all happened."

Mokompo became quiet, as if pondering the end of something. He drained the last of his honey beer and opened a bottle of whiskey.

"From that day on there was bad blood between Senteu and Olonana. It was inevitable that they would someday part ways. They remained together for a while after their father's death, but eventually Senteu's hatred of his brother grew worse and he moved here to Loita with all his wives. He had at least thirty of them, and several times as many children.

"The reason why Senteu did not want to stay or continue living there was because Olonana talked with Europeans and gave out the land. Senteu got angry and said, 'I am leaving this place to look for land where I will be the leader and will never give it away.' Later, Olonana asked the Europeans to get rid of Senteu and send him to a place called Olorgoti where he would be sure to die of malaria. That was how Olonana was. He was very crafty."

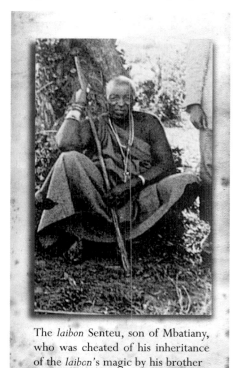

The *laibon* Senteu, son of Mbatiany, who was cheated of his inheritance of the *laibon*'s magic by his brother Olonana

After a long time telling stories and drinking whiskey, Mokompo lost track of the tale. He got drunk and became more interested in the stones on the floor. There was more to the story about the Maasai and the British, but it was complicated and hard to follow through the haze of booze. Now the old men wanted to talk about technology and cattle and rain. The more whiskey Mokompo drank, the more he flailed his arms and raised his voice. With the stones on the floor he began delicately spitting on everyone, a form of blessing to the Maasai, and foretold our general prosperity.

Mbatiany is remembered even today and his likeness is painted on trading posts and bars throughout Maasailand. Oral history has kept the story of the brothers alive, but the events that followed are buried under an avalanche of folders in the basement of the National Archives building in Nairobi, either crammed into rows of tall metal cabinets or stacked perilously against the walls. The entire history of Kenya rests there in the old converted bank building—district reports, photographs, letters, ethnological surveys, land ordinances, all spilling from faded manila folders.

Several of these folders were handed to me on a sunny day while I waited in the research room watching traffic hum on the streets below. Whenever I was in town between safaris, I spent afternoons looking for clues to the past. Mokompo's story was very much on my mind and I wanted to see if there was any record of it in the archive. The librarian was eager and appeared at my desk with a stack of worn files, their pages thin and brittle. As I held the old district reports, the world outside the archive windows drifted away. There was no one alive anymore who could tell me the truth of the past. Any written account of that era, though colonial, would lie in the pages of the basement documents.

At the end of the nineteenth century, Mbatiany's visions were realized. The British arrived on the shores of East Africa and arbitrarily drew a border between what is now Kenya and Tanzania, dividing Maasailand in half. With the construction of the Uganda railway in 1896, more settlers arrived. The railroad, winding through treacherous escarpments, ravines, and the lion-rich plains of Tsavo, was hailed as the greatest technological feat on the continent and was a star attraction for Europeans wanting to try their luck in Africa. When they arrived, they pitched their tents on the grasslands of Nairobi, where the

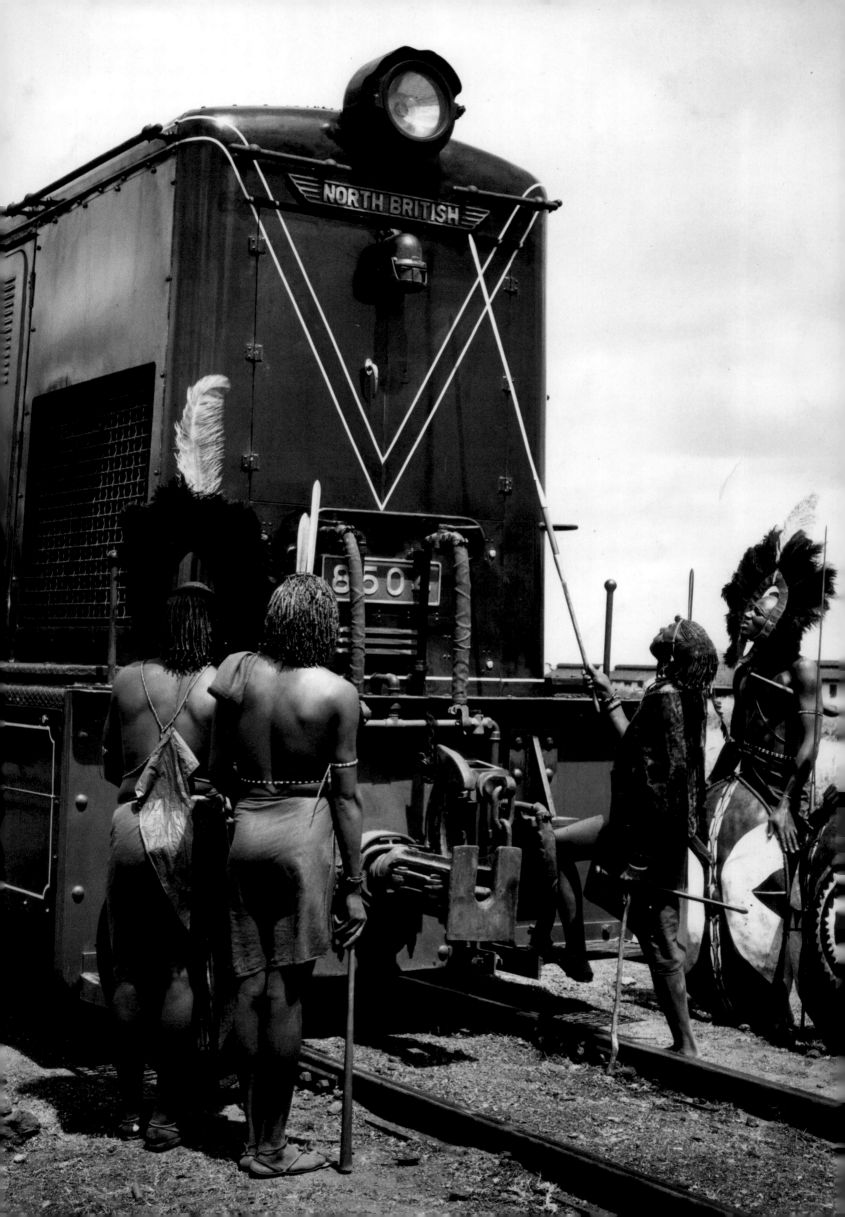

Maasai had hunted lions and watered cattle for two centuries. Indians employed to build the railroad stayed when their contracts expired and opened shops and private businesses. Nairobi developed into a frontier town. Soon there was a hotel, government offices, a Catholic church, a number of bars, even a Japanese brothel. Plans were drafted to parcel out land and develop Kenya to the best of its economic potential. To the British, this meant transforming the wild African bush into a giant grid of farms for settlement and agriculture, both of which were detested by the nomadic, pastoral Maasai.

There was a photograph taken of Olonana around this time. He is lean and intense and seems wary of the camera, and of the company of the British officers with whom he is sitting. Not long after it was taken, a dramatic encounter occurred, which set the stage for a friendship that endured throughout his life.

Early Nairobi, 1928

Having settled with his supporters in the Ngong Hills, Olonana watched the activities of the British with increasing interest. Despite the misgivings of his people, he set out to meet the British at their newly erected outpost, Fort Smith. In November 1895, shortly after his arrival at the fort, news came that a large caravan of Kikuyu porters traveling through the Kedong valley on government duty had been attacked by the Maasai. Nearly all the Swahili porters were killed. The British immediately detained Olonana pending an investigation.

It was revealed that the headman of the caravan had been the aggressor, attempting to kidnap two girls from a Maasai *boma*. The girls were returned after the Maasai protested, but a second attempt to capture them was made the following morning. During this second encounter, a gunshot was fired into the village, killing one of the Maasai's treasured cows. The Maasai immediately retaliated, setting upon the caravan with their spears and clubs, killing some four hundred people. An English trader traveling through the area saw this, shot a large number of the Maasai, and stole their herd. Warriors fanned out and killed him as he retreated up the escarpment. The gruesome remains of the caravan massacre, which included a large pile of the porters' skulls, remained at the site for many years, a potent reminder of the Maasai's military prowess and ferocity.

The British officers at Fort Smith ruled the Maasai had acted in self-defense and should not be severely punished. The cattle stolen by the English trader were paid to the families of the Kikuyu who lost their lives in the massacre and the case was settled. Olonana was delighted with the fairness of the decision. With his father's prophecy in mind and his brother's rivalry weighing upon him, he solemnly vowed allegiance to the British government. In the years that followed he was the closest ally the British had among the native peoples of Kenya.

Had Olonana known what the British really thought of the Maasai, would he have remained an ally? The archives revealed plans to change the "peculiar" customs of the Maasai and to discourage them from "straying about" with their "useless herds of cattle." District officers described the Maasai as "listless, conservative, slothful people" and Charles Eliot, the first governor of Kenya, observed that the mind of a Maasai was "far nearer to the animal world than is that of the European or Asiatic, and exhibits something of an animal's placidity."

"The future of these people is not an easy problem," wrote Eliot. "They resemble the lion and the leopard, strong and beautiful beasts of prey, that please the artistic sense, but are never of any use, and often a very serious danger. Even so, the manly virtues, fine carriage, and often handsome features

Curious Maasai warriors stop to look at the train, circa 1950.

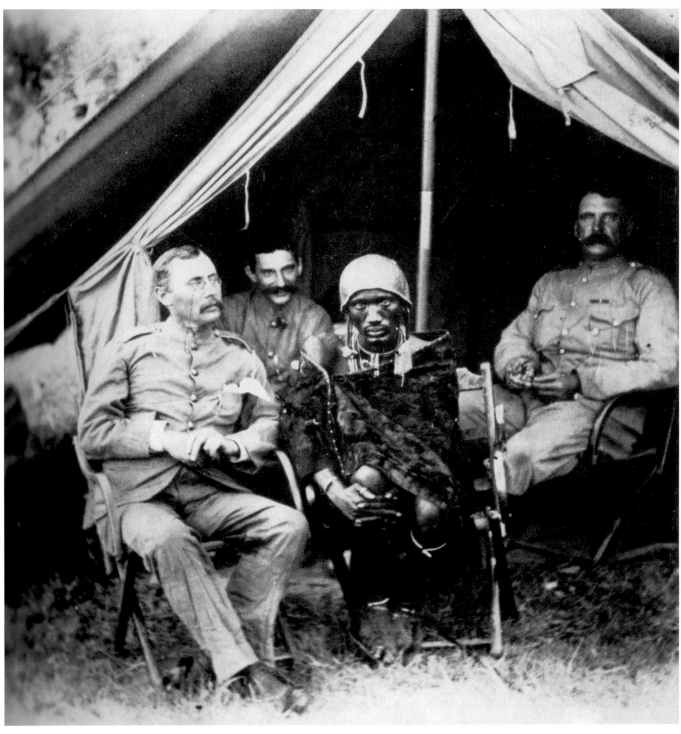

The *laibon* Olonana with British officers at the turn of the century

of the Maasai arouse a certain sympathy; but it can hardly be denied that they have hitherto done no good in the world that anyone knows of; they have lived by robbery and devastation, and made no use themselves of what they have taken from others."

Frustrated by the Maasai's unwillingness to conform to an agrarian lifestyle, a plan was set in motion to put the tribe on a reserve. On August 9, 1904, a meeting was held with Olonana and a group of Maasai chiefs where it was agreed that the Maasai would relocate to two separate reserves on either side of the railroad. A land treaty "in the best interests of the Maasai" was signed by all parties, relinquishing the Rift Valley plains they had conquered and dominated for two centuries. The wily old Olonana, who had cheated his brother Senteu, was the first signatory on the agree-

Fort Smith

ment. A map accompanied the document, outlining the boundaries of the reserves they had agreed to live on. In the final paragraph, there was a polite request by the Maasai that the settlement endure "as long as the Maasai as a race shall exist."

The Maasai finally cleared out of the grasslands of Nairobi, and Olonana settled with his eighty wives and children in Ngong. The Rift Valley Maasai moved north to Laikipia. Senteu, outraged by the agreement, shuttled back and forth between Loita and German Tanzania, where he met many obstacles from the German government.

Having enjoyed nomadic freedom their whole lives, the Maasai felt restless within the confines of the reserve. Their numbers rebounded after years of drought and plague, but their livestock quickly grew to overpopulate the land to which they had been assigned. Then considered one of the wealthiest tribes in the world, numbering 600,000 people with three-quarters of a million head of cattle, the Maasai soon found it necessary to wander beyond the reserve in search of adequate watering grounds.

As part of two separate reserves, the Maasai were angry to find themselves cut off from one another. A promised road between the areas was never developed and was useless for herding, flanked on either side by European farms and lacking watering holes. Quarantine regulations prohibited the movement of

cattle between the reserves and it soon became a requirement to ask the government for permission to have ceremonies joining the groups from both sides.

Due to Olonana's relationship with the government, the Maasai had managed to negotiate far more land for themselves than had other tribes in the region. However, British settlers eyed the Northern Maasai Reserve's farmland potential and complained that the Maasai had been awarded too much territory. Just two years after the initial treaty was signed, the government approached Olonana to renegotiate. Olonana, who was then on a government salary, agreed it would be best to have all Maasai on a single reserve south of the railroad, a move that would also consolidate his power. In exchange for the northern reserve, the southern reserve would be extended. A treaty was drawn in 1910, but it was never signed. Other Maasai chiefs were not supportive of the arrangement and expressed doubt.

Olonana died of complications from dysentery on March 7, 1911. The district commissioner of the Southern Maasai Reserve was conveniently on hand to record his dying wishes: "Tell the government to look after my children and give them the money which I should have earned if I had been alive. Tell my people to obey the government as they have done during my life. Tell the Laikipia Maasai to move with their cattle to the Loita Plains." The old *laibon* was

buried in the Ngong Hills outside Nairobi and an olive tree was planted to mark his grave. The tree, with its branches shaped like the African continent, still stands alone on an empty hilltop overlooking the Rift Valley and the suburbs of Nairobi.

Until the arrival of the British in East Africa, the Maasai had no leading politicians or monarchs. The power Olonana was given to speak for his people was unprecedented within the history of the tribe. Nowhere was that more evident than at the final meeting between the Maasai chiefs and representatives of the British government, in which a new treaty relocated all the Maasai to the farthest boundaries of the southern reserve. The Maasai, who were unhappy with this plan, accused the British government of trickery and insisted that Olonana's thumbprint was stolen from his corpse after his death, a rumor that endured throughout the century. When I finally found the original copy of the treaty, I saw the truth. In a peculiar chain of events, Olonana's oldest son, Seggi, who was then only thirteen years of age, was voted head *laibon* after his father's death. His red thumbprint is pressed at the top of the Maasai signatures where he is regally titled "Paramount Chief of the Maasai." Eventually Seggi fell into obscurity and did not prove as great an ally to the British as they had hoped. The governor recommended that the office of Paramount Chief be abolished, a title that had been invented by the British to suit their own needs during treaty negotiations but had never existed in Maasai culture. Today when the Maasai are asked if they remember the story of Seggi, they only shrug and ask, "Who's Seggi?"

Four routes were designated for the Maasai relocation to the southern reserve. Most of the tribe trav-

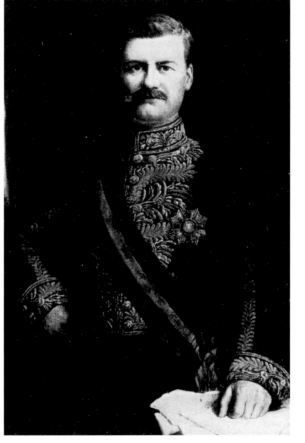

Sir Charles Eliot

eled there successfully, but a large group clustered at the top of the Mau escarpment, where heavy rain and cold weather forced them back to Laikipia. Scores of cattle were lost. Prominent Maasai chiefs reconsidered the move after realizing the southern reserve would not provide sufficient grassland or water for the arriving herds. When they announced their decision to the British government, they were told that they could relocate voluntarily or through the use of force.

Not all Europeans were in favor of the relocation. Many felt the Maasai were being cheated. Among this group of sympathizers was a man named Morrison with whom the Maasai chiefs sought counsel. A year after the move, Morrison addressed the Colonial Office on behalf of the Maasai in legal proceedings against the government, claiming that former Maasai representatives were not legally authorized to sign land away on behalf of the entire tribe. He also argued that the government had not kept its promise of providing adequate roads between the reserves, and that the Maasai should be compensated for livestock lost in the move. This unprecedented argument was the first time in the history of British colonization in East Africa that a tribe sought legal counsel to get their land back. Had the Maasai won the case, the results would have been disastrous for the government, exposing them to further court cases with other tribes. Much to the disappointment of the Maasai, the case and all subsequent appeals were eventually dismissed.

The Southern Maasai Reserve was declared a "closed district" and went largely undeveloped during nearly sixty-eight years of colonial rule, save for the construction of a few schools, which the British saw as a great benefit to the Maasai people. Yet because of

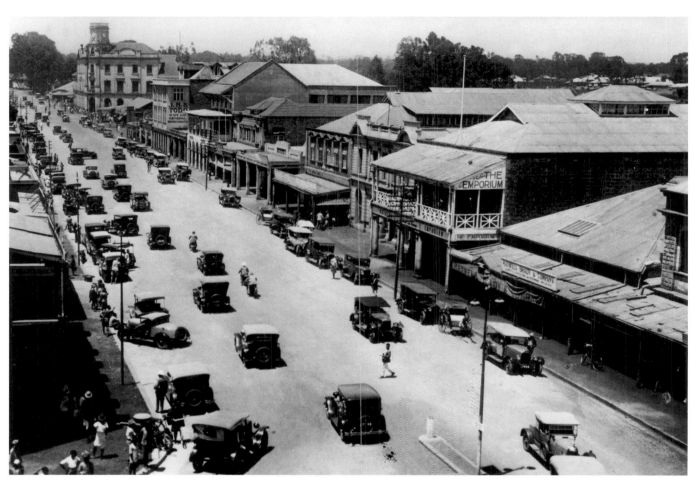

Early downtown Nairobi with automobiles

poor funding, no serious educational facilities were ever established. The schools were deeply unpopular. The Maasai couldn't understand why they should send their children away to receive knowledge for which they felt they had no use. Preferring to keep their children at home, the Maasai kidnapped dozens of Kikuyu youths and enrolled them in school as their own.

Further integration pressure came in the form of recruiting warriors for service in the King's African Rifles. The Maasai refused, preferring to die of starvation than to serve the British crown. This led to even tighter restrictions on the Maasai's way of life. A hut tax was imposed, demanding payment in livestock to live on the land that had been free to them for centuries. To leave the reserve, the Maasai had to obtain passes that were awarded under strict regulations, requiring proof of legitimate business dealings. Isolated in five thousand square miles of empty bush, the Maasai remained, at least culturally, as they had been for the past two hundred years.

While the Maasai languished in the confines of their reserve, Kenya's history fell into the hands of another tribe. In 1952, the Kikuyu led a campaign of terror against white settlers in order to chase them off their farmland. The *Mau Mau* uprising, a Kikuyu word with no clear definition, was front-page news in British newspapers for the next five years. Mau Mau gangs held secret initiations in which they pledged to reclaim the land that had been taken from them by white settlers. Armed with machetes, they broke into isolated farmhouses, butchered the white occupants, tortured African farmhands whom the gangs viewed as traitors, and set fire to the property. The British military moved in to quell the rebellion, forcing the Mau Maus into the forests, the natural habitat of the Kikuyu people. In an effort to flush the Kikuyus out, Maasai warriors were trucked in from the southern reserve, more than happy for the opportunity to bloody their spears and wage war with their tribal rivals. The most dangerous leader of

47

the Mau Mau, Dedan Kimathi, who had grown long dreadlocks and lived entirely off the forest, was finally captured and hanged in 1957, putting an end to the violent uprising that claimed the lives of 13,547 people, most of them African.

Though the settlers had suppressed the Mau Mau uprising, they had not won the tide of public opinion in Britain. Black majority rule was inevitable and on December 11, 1963, Kenya became an independent country. Jomo Kenyatta, a Kikuyu who had been educated by missionaries as a boy, attended university in London and returned to Kenya to be a speaker for his people, was elected the president of Kenya for life. This must have seemed a bizarre turn of events to the Maasai who had lorded over the Rift Valley plains less than a century before. Despite their negotiations with the British, they now had very little influ-

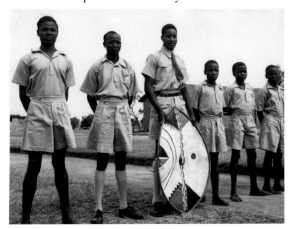

Maasai boarding students are awarded a shield as a trophy for keeping the cleanest dormitory in a weekly competition at their school, circa 1950.

ence or representation in government. Life on the reserve remained virtually unchanged, while the Kikuyu rose to become the leading politicians and businessmen of the country. The balance of power had shifted for good.

As I looked out over Nairobi from the sooty windows of the archives, I thought not only of the Maasai but of the white Kenyans who chose to stay behind. They were relics, too, eking out a living running safaris, fixing old cars, and selling crafts. Imprisoned in the suburbs with their servants, electric security fencing, and trim plots of bougainvillea, they seemed to long for days past. They were no longer part of a ruling class, and many would be considered poor by European standards. Yet they still carried that peculiar air of superiority unique to expatriates all over the world, even as they were relegated to live out their days behind the barred windows of their cottages, a lost tribe of foreigners who were now the targets of theft and resentment from the Africans they had for so long exploited. In the center of town, old colonial buildings crumbled and were torn down to make way for high-rises and the new Kenyan business elite. At night, bands of thieves prowled the predominantly white suburbs, hijacking cars and burglarizing houses.

After weeks in Nairobi, Tiampati and I packed the car and headed up the escarpment with enough supplies to get us through two weeks. As we drove across the Rift Valley, I thought of the tribal wars the Maasai had fought there in the past century. The land was still relatively empty but I could tell that was already changing. Tin roofs sparkled in the sun near the side of the road and in the distance an enormous pair of satellite dishes transmitted television signals across the bush.

Mark of Segi son of Ol-onana (Lenana), Paramount Chief of all the Masai.

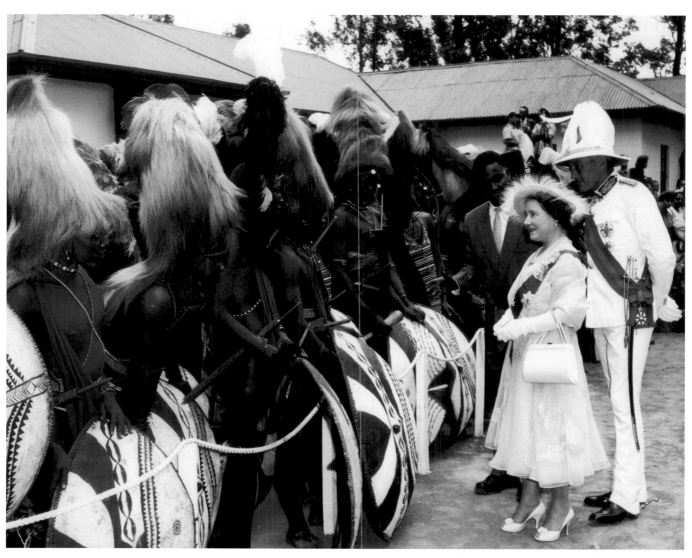

The Queen Mother with Maasai warriors at Narok, 1959

OVERLEAF

THE MASAI AGREEMENT OF 1911

<u>Agreement</u>

We, the undersigned, being the paramount Chief of all the Masai and his regents, and the representatives of that portion of the Masai tribe living in the Northern Masai Reserve, as defined in the agreement entered into with the late Sir Donald William Stewart Knight Commander of the Most Distinguished Order of Saint Michael and Saint George, His Majesty's Commissioner for the East Africa Protectorate, on the ninth day of August one thousand nine hundred and four, and more particularly set out in the Proclamation of May Thirtieth one thousand nine hundred and six and published in the Official Gazette of June first one thousand nine hundred and six, do hereby on our own behalf and on behalf of our people whose representatives we are being satisfied that it is to the best interest of their tribe that the Masai people should inhabit one area, and should not be divided into two sections as must arise under the agreement aforesaid whereby there were reserved to the Masai tribe two separate and distinct areas of land, enter of our own free will into the following agreement with Sir Edouard Percy Cranwill Girouard, Knight Commander of the Most Distinguished Order of Saint Michael and Saint George, Member of the Distinguished Service Order, Governor and Commander in Chief of the East Africa Protectorate, hereinafter referred to as the Governor.

We agree to vacate at such time as the Governor may direct the Northern Masai Reserve which we have hitherto inhabited and occupied, and to remove by such routes as the Governor may notify

to us our people, herds, and flocks to such area on the South side of the Uganda Railway as the Governor may locate to us the said area being bounded approximately as follows, and as shown on the attached map.

On the South by the Anglo-German frontier;

On the West by the Ol-orukoti Range, by the Amala River otherwise called Eng-are-dabash or Eng-are-'n-gipai, by the Eastern and Northern boundaries of the Sotik Native Reserve, and by a line drawn from the most northerly point of the Northern boundary of the Sotik Native Reserve to the South Western boundary of the land set aside for Mr E. Powys Cobb on Mau;

On the North by the Southern and Eastern boundaries of the said land set aside for Mr E. Powys Cobb and by a straight line drawn from the North Eastern boundary of the said land to the highest point of Mount Suswa otherwise called Ol-doinyo onyokie;

On the East by the Southern Masai Native Reserve, as defined in the Proclamation dated June eighteenth one thousand nine hundred and six, and published in the Official Gazette of July first one thousand nine hundred and six.

Provided that nothing in this agreement contained shall be deemed to deprive the Masai tribe of the rights reserved to it under the agreement of August ninth one thousand nine hundred and four aforesaid to the land on the Slopes of Kinopop whereon the circumcision rights and ceremonies may be held.

In WITNESS whereof, and in Confirmation of this agreement which has been fully explained to us we hereby set our marks against our names, as under.

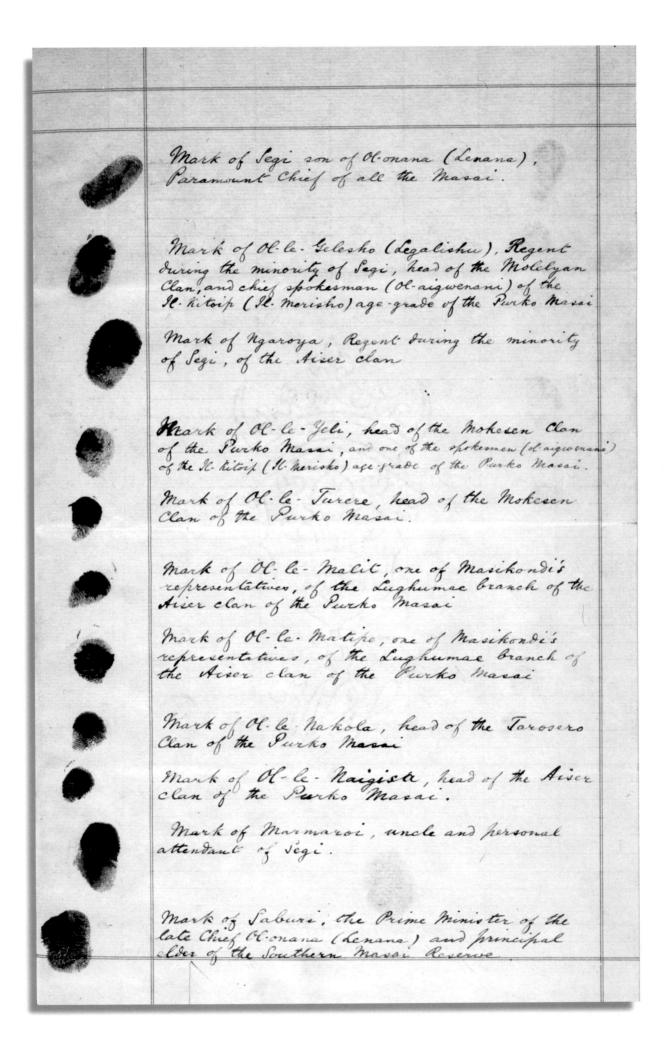

Mark of Segi son of Ol-onana (Lenana),
Paramount Chief of all the Masai.

Mark of Ol-le-Gelesho (Legalishu), Regent
during the minority of Segi, head of the Molelyan
Clan, and chief spokesman (Ol-aigwenani) of the
Il-kitoip (Il-Merisho) age-grade of the Purko Masai

Mark of Ngaroya, Regent during the minority
of Segi, of the Aiser clan

Mark of Ol-le-Yeli, head of the Mokesen Clan
of the Purko Masai, and one of the spokesmen (ol-aigwenani)
of the Il-kitoip (Il-Merisho) age-grade of the Purko Masai.

Mark of Ol-le-Turere, head of the Mokesen
Clan of the Purko Masai.

Mark of Ol-le-Malit, one of Masikondi's
representatives, of the Lughumae branch of the
Aiser clan of the Purko Masai

Mark of Ol-le-Matipe, one of Masikondi's
representatives, of the Lughumae branch of
the Aiser clan of the Purko Masai

Mark of Ol-le-Nakola, head of the Tarosero
Clan of the Purko Masai

Mark of Ol-le-Naigista, head of the Aiser
clan of the Purko Masai.

Mark of Marmaroi, uncle and personal
attendant of Segi.

Mark of Saburi, the Prime Minister of the
late Chief Ol-onana (Lenana) and principal
elder of the Southern Masai Reserve

Mark of Agali, uncle of Segi, representing the Loita Masai.

Mark of Ol-le-Tanyai of the Tarosero clan, Chief Spokesman (Ol-aigwenani) of the Lemek (Meitaroni) age grade of the Purko Masai.

The above set their marks to this agreement at Nairobi on the fourth day of April nineteen hundred and eleven

A.C. Hollis
Sec'y Native Affairs

ol le Masikondi head of the Lughumas section of the Aiser clan; chief elder of the Purko clan Masai, called in the former treaty ol oiboni of the Purko Masai.

Ol le Batiet head of the Aiser Clan of the Purko Masai on Laikipia; ol aigwenani of the age known as il Merisho.

The above set their marks to this agreement at Rumuruti on the 13th day of April nineteen hundred and eleven.

Witnesses. Asper Collyer E.D. Browne
 D/c. Laikipia. a.Dc. Laikipia.

His Ole Lengiri of the aiser clan Purko Masai
Mark.

His Olegesheen head of Tamseno Clan of Purko Masai
Mark.

His Ole Salon brother of OleKotikosh as a deputy for Olle Kotikosh
Mark The Above set their marks to this agreement at Rumuruti
on 17th day of April 1911
 J. Browne a.Dc. of Laikipia

We the undersigned certify that we correctly interpreted this document to the Chief, Regents and Representatives of the Masai who were present at the meeting at Nairobi
 A.C. Hollis

 Ol-le-Tinka of the Il-Aiser clan

We the undersigned certify that we correctly interpreted this document to the Representatives of the Masai at Rumuruti
 Ole Tinka
Asper Collyer His Mark Sir P. Girouard
 D/c. Governor 1906-9

53

In consideration of the above I, Edouard
Percy Cranwill Girouard, Knight
Commander of the Most Distinguished
Order of Saint Michael and Saint George
Member of the Distinguished Service
Order, Governor and Commander in chief
of the East Africa Protectorate, agree on
behalf of His Majesty's Government
but subject to the approval of His Majesty's
Principal Secretary of State for the Colonies
to reserve for the exclusive use of the Masai
tribe the area on the South side of the
Uganda Railway as defined above and
as shown on the attached map, which
area is coadunate with the Southern
Masai Native Reserve and to further
extend the existing Southern Masai
Native Reserve by an addition of an
area of approximately three thousand
and one hundred square miles, such
area as shown on the accompanying
map the approximate boundaries
being on the South the Anglo German
Frontier, on the West the eastern
boundary of the aforesaid Southern Masai
Reserve on the North and East by the
Uganda Railway Zone from the Athi
River to Sultan Hamud Railway
Station thence in a line drawn from
the said Station drawn to the North
West point of the Chiulu Range thence
along the Chiulu Range to the South
Eastern extremity thereof thence by a
straight line to the meeting point of
the Eng-arc Rongai and the Tsavo Rivers
thence by the Eng-arc rongai River to the
Anglo-German frontier and to undertake
on behalf of His Majesty's Government to
endeavour to remove all European
Settlers from the said areas and not to
lease or grant any land within the said
areas (except such land as may be
required for mining purposes or for any
public purpose) without the sanction
of the paramount chief and the

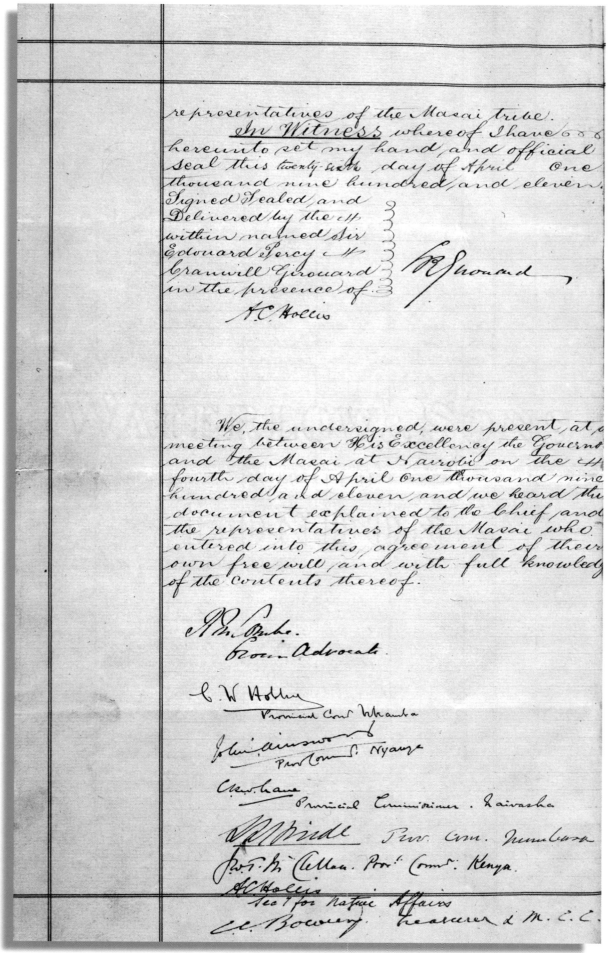

representatives of the Masai tribe.

In Witness whereof I have
hereunto set my hand and official
seal this twenty-sixth day of April One
thousand nine hundred and eleven.

Signed Sealed and
Delivered by the
within named Sir
Edouard Percy
Cranwill Girouard
in the presence of:

A.C. Hollis

We, the undersigned, were present at a
meeting between His Excellency the Governor
and the Masai at Nairobi on the
fourth day of April One thousand nine
hundred and eleven, and we heard the
document explained to the Chief and
the representatives of the Masai who
entered into this agreement of their
own free will and with full knowledge
of the contents thereof.

Crown Advocate.

C. W. Hollis
Provincial Court Mkamba

John Ainsworth
Prov. Comm. Nyanza

Provincial Commissioner. Naivasha

Prov. Com. Mombasa

Prov. Comm. Kenya.

A.C. Hollis
Sec'y for Native Affairs

Treasurer & M.C.C.

OVERLEAF
OLONANA'S TREE
Though it is not traditional for the Maasai to hold funerals or inter the dead,
laibons are given important burials and their graves are often marked with stones or a shady tree. The *laibon* Olonana, who signed the
first land treaty with the British on behalf of the Maasai, was buried beneath this olive tree on the outskirts of Nairobi in 1911.
The tree rests near a children's soccer field on a hill that commands a view of the Rift Valley on one side and Nairobi on the other.
The grave is sometimes visited by Olonana's descendants, many of whom are *laibons* today and continue the family practice.

SLAUGHTER OF A BULL

Cattle are slaughtered at important ceremonial occasions. Here a young bull has been
slaughtered for a ceremony marking the naming of a child.

HORN OF THE OX

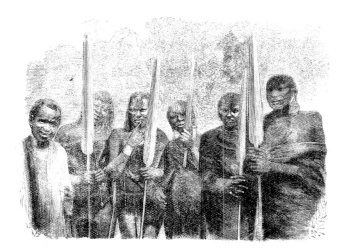

Ceremonies marking the passage of one age group into a different part of life occur once every seven years and are at the heart of Maasai culture. Entire villages are built to accommodate the crowds who attend them. These ceremonies go on for days and unite the tribe in drinking their livestock's blood, spraying honey beer on one another in blessings, slaughtering bulls in the forest, and marching together in solemn processions. The members of an age group are friends for life. Young warriors who hunt together will swap courageous stories when they grow old, spending their days idly in the shade of the acacia trees.

It was around Christmas one year when the Maasai arranged a *manyatta* for a group of boys about to be circumcised. Tiampati and I had been wanting to document it for months, driving down to Narok every few weeks to see if a date had been set. The Maasai never liked to talk about dates. They were superstitious that way and said if they revealed the date, someone might set out to curse the event. So one would never know until the last minute when things were actually going to start. I'd canceled my Christmas plans and dragged Tiampati away from his own holiday so that I could document the ceremony. There was only one problem: they wanted one thousand dollars for permission to photograph the event. When dealing with a white person, no amount was too high. The Maasai were always at an advantage because they knew that I wanted to photograph their ceremonies and they had nothing to lose by refusing.

"You old people!" I shouted. "I've been coming here for years! My friends invited me here. I sponsor their boys in school. Where do you think I am going to get a thousand dollars?" Tiampati, who was always reverent and solemn in dealing with the elders, looked shocked.

To our relief, the elders burst into laughter. Negotiations were always the same. Just when I wanted to give up, everyone would laugh and then we would settle business with a cow or a goat and never talk about money again. The Maasai, who were polite and gracious, thanked me for my contribution, as though it had all been my idea. In that moment the negotiations were buried and I was treated as a welcomed guest.

A procession of a hundred and fifty boys filed in line to greet their mothers and a delegation of elders overseeing the ceremony. The women, who had spent the past two months building the temporary houses in the *manyatta,* cried and held one another when they saw their sons about to begin the next chapter of their lives. The ceremony, called "The Horn of the Ox," would culminate in a competition to chase an ox through the *manyatta,* each of the boys attempting to grab it by the horns. When it was over, the boys would go home and be circumcised, entering the first stage of adulthood.

"It's one of the most serious rituals that a boy has to go through," Tiampati explained. "In it they show that they are ready to take on all the hardships of life. The ox represents all the trials and tribulations that man has to face, and by holding its horns you show that you are not afraid of it. From that moment on, a lot of responsibilities are handed down to them and some of these things are very difficult and painful. Grabbing the ox by the horns shows that the boys are ready for life."

The boys had been dreaming of this moment for months, each one fantasizing on his pallet at night of outrunning the group and grabbing the horns. It was an honor to catch the ox's horns first, and whoever managed it would be remembered for it for the rest of his life. In the days leading up to the event the boys collected goats and honey, gathered for blessings, and marched around the *manyatta.* They were given long sticks used to herd the ox into the forest for slaughter on the final day of the ceremony. Each day they paraded before the guests, waving their sticks in the air and singing songs about the ox.

The ceremony fell over the New Year's holiday and coincided with a bright, full amber moon that cast shadows of the boys dancing across the *manyatta* floor. The night before the competition, a warm breeze coursed across the bush, carrying the sound of the kudu horn and the din of conversation. The ceremony, like the new year, represented a fresh start.

At three o'clock the next afternoon, the boys marched around the *manyatta* and formed a line against the circle of homesteads. In an arc formation, they waited until an enormous gray speckled ox was led into the arena. The ox was nervous, singled out from the herd for reasons it did not understand. A signal was given and at once there was pandemonium. A hundred and fifty boys ran for the bull, each one screaming, "That's my bull! That's my bull!" Many of the smallest boys fell into the dirt. The mob pushed and shoved others out of the way. The tallest boy in the group

was the first to grab the horns and hung on while the ox ran in a panic, dragging him along the cow dung floor. Other boys followed suit and in the end the animal was surrounded by the mob. The boys who had it were unwilling to let go and had to be pried away. The tall one threw his arms up in triumph and wailed. The younger boys who had lost the competition began to cry, though everyone was commended for the wonderful job they had done. Some fainted on the *manyatta* floor with sorrow for

having failed. No one laughed at anyone who cried. Emotion was respected, and people who collapsed in fits of grief were immediately surrounded by friends who comforted them. Soon there was dancing and singing, and in this festive mood the elders painted my face with red ocher.

The next day, the speckled ox was slaughtered in the forest. Blood from its jugular pooled into the carefully cut sack of its dewlap, and honey beer was added to the mix. All the boys took a turn drinking from this, symbolizing the now indestructible bond that would hold them together as a group throughout their entire lives.

Several days after the ceremony, we ran

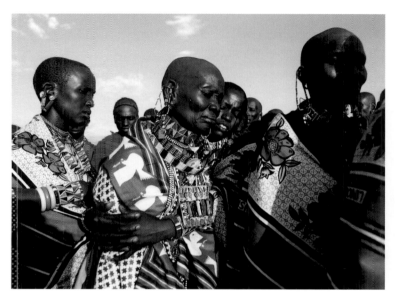

Women weep as their sons are initiated into a new stage of life. After the ceremony, the boys will go home and be circumcised, leaving childhood behind.

into the delegation of elders at the weekly cattle market. When they saw us, they gathered around the car, eager to know when they could get copies of the photos. Each man wore a stiff strap of cowskin fashioned into a ring around his middle finger. These had been taken from the hide of the ox, and were given to all the attendants as a medal. The boys wore them too, a reminder of the bravery required for the painful circumcision ceremony that lay ahead.

OVERLEAF

WAVING THE CATTLE STICKS
Boys are given sticks used to herd the ox to the forest for slaughter at the end of the ceremony.
In the days leading up to the chase, the boys dance and march through the *manyatta* waving the sticks.

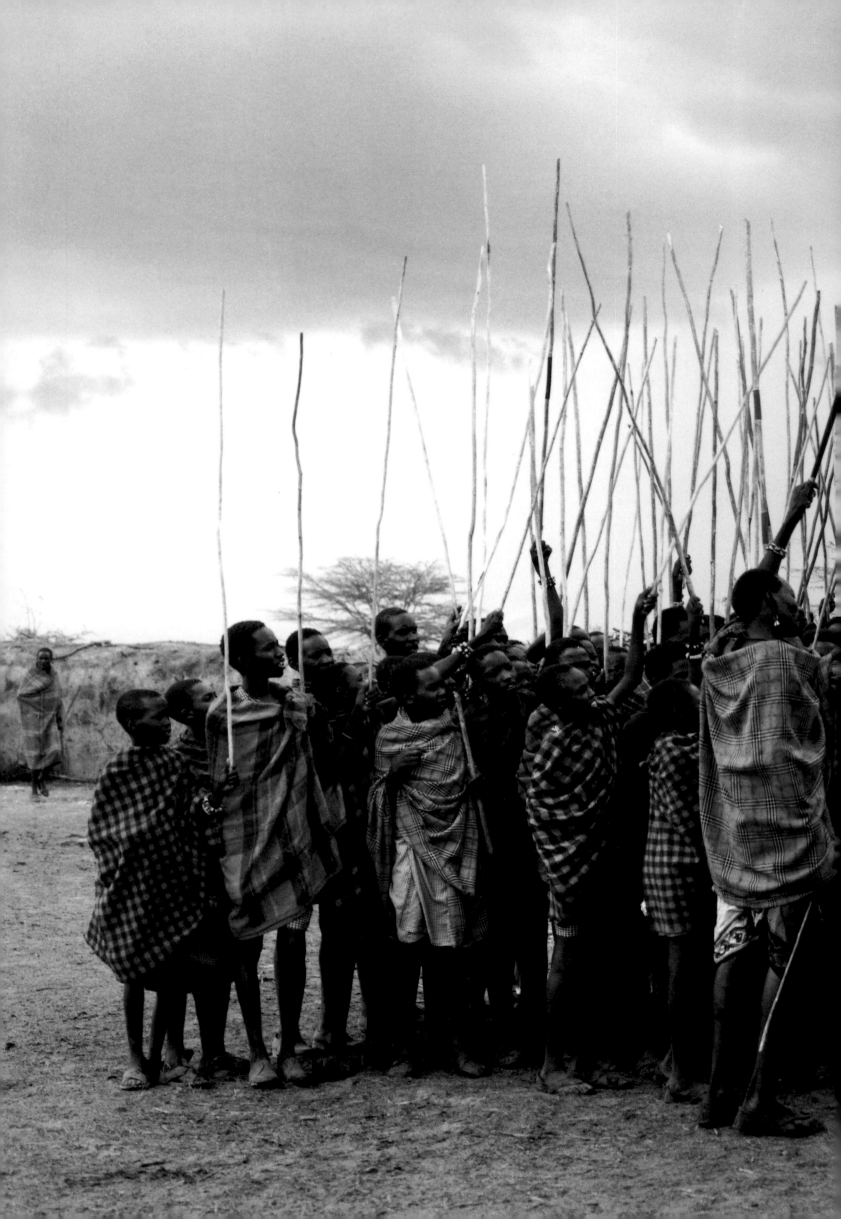

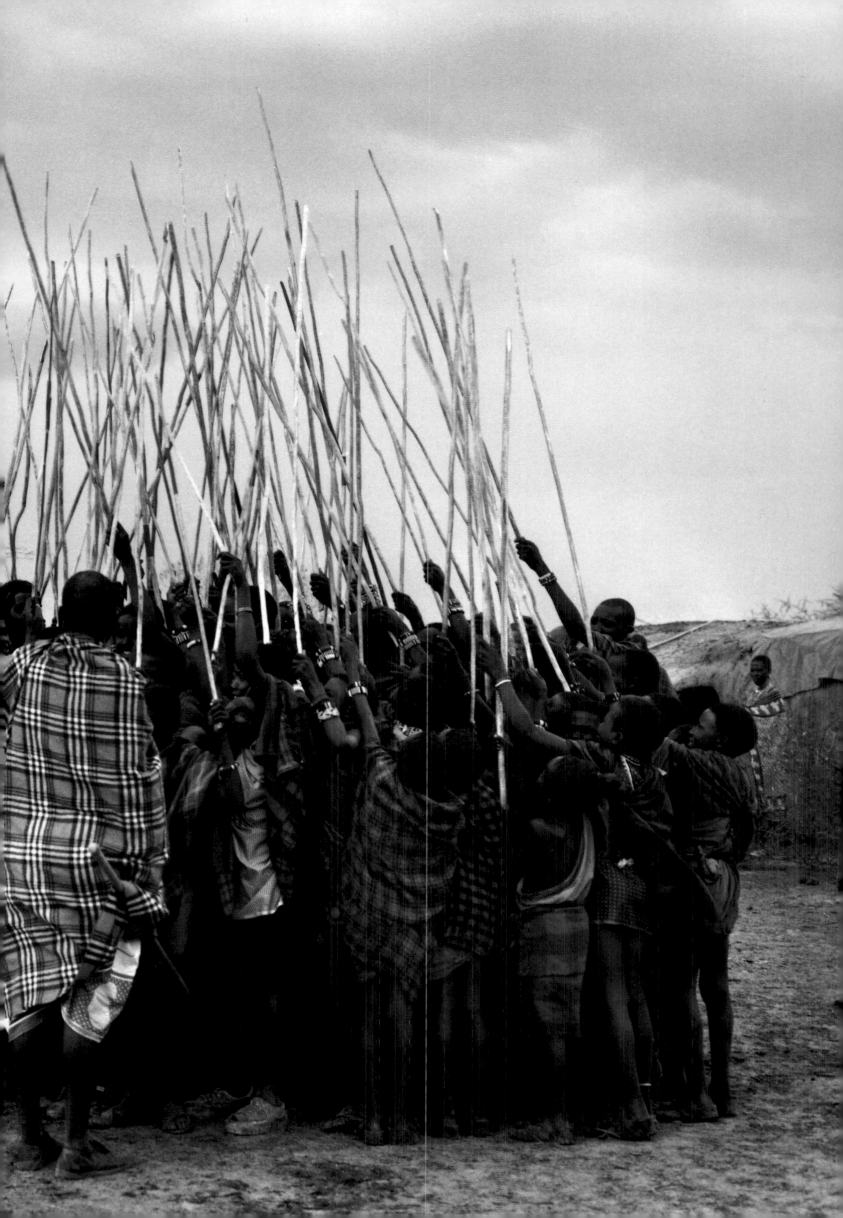

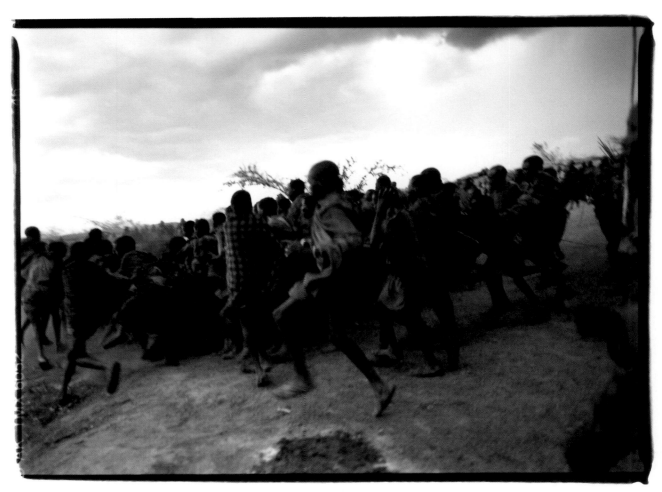

BOYS CHASE THE OX INSIDE THE MANYATTA

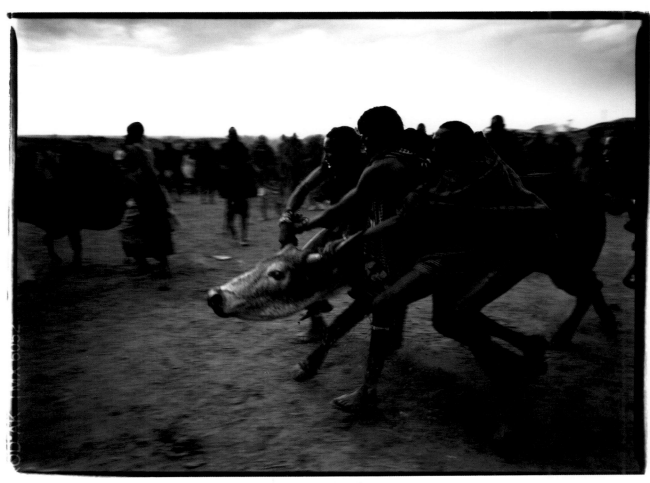

GRABBING THE OX'S HORNS

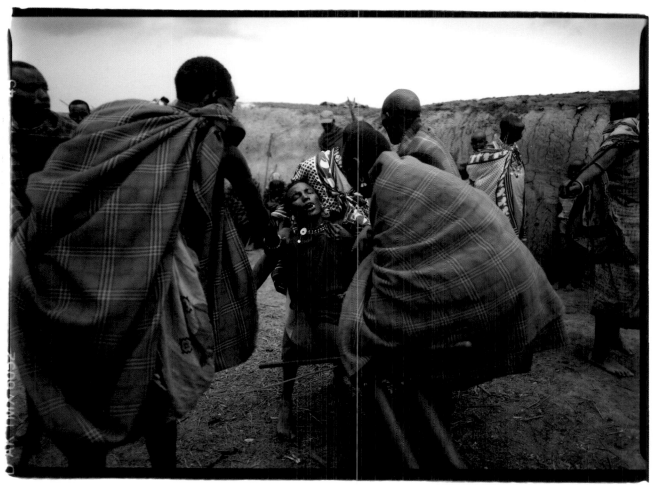

WINNER OF THE COMPETITION IN AN EMOTIONAL SEIZURE

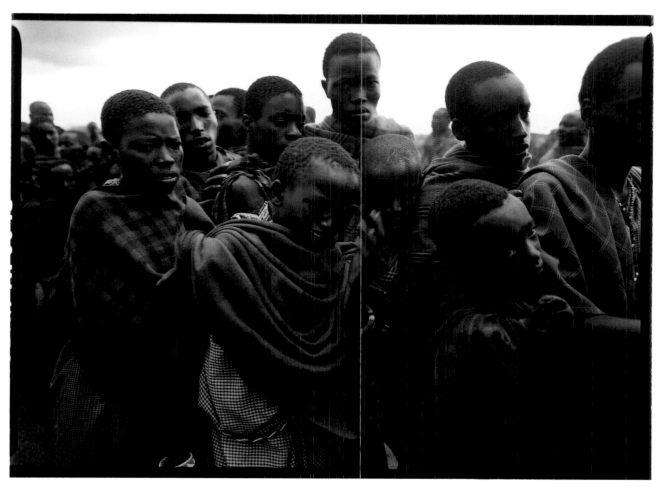

GRIEVING BOYS WHO DID NOT CAPTURE THE OX

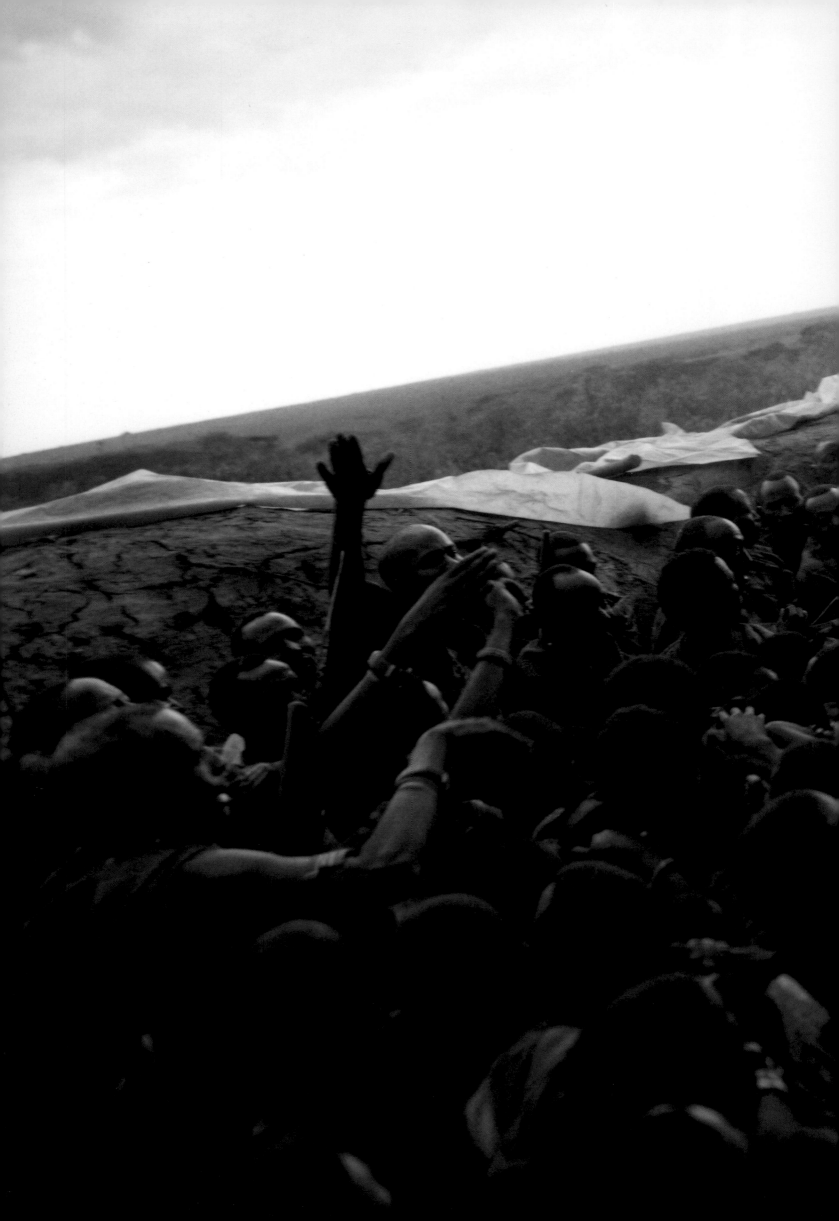

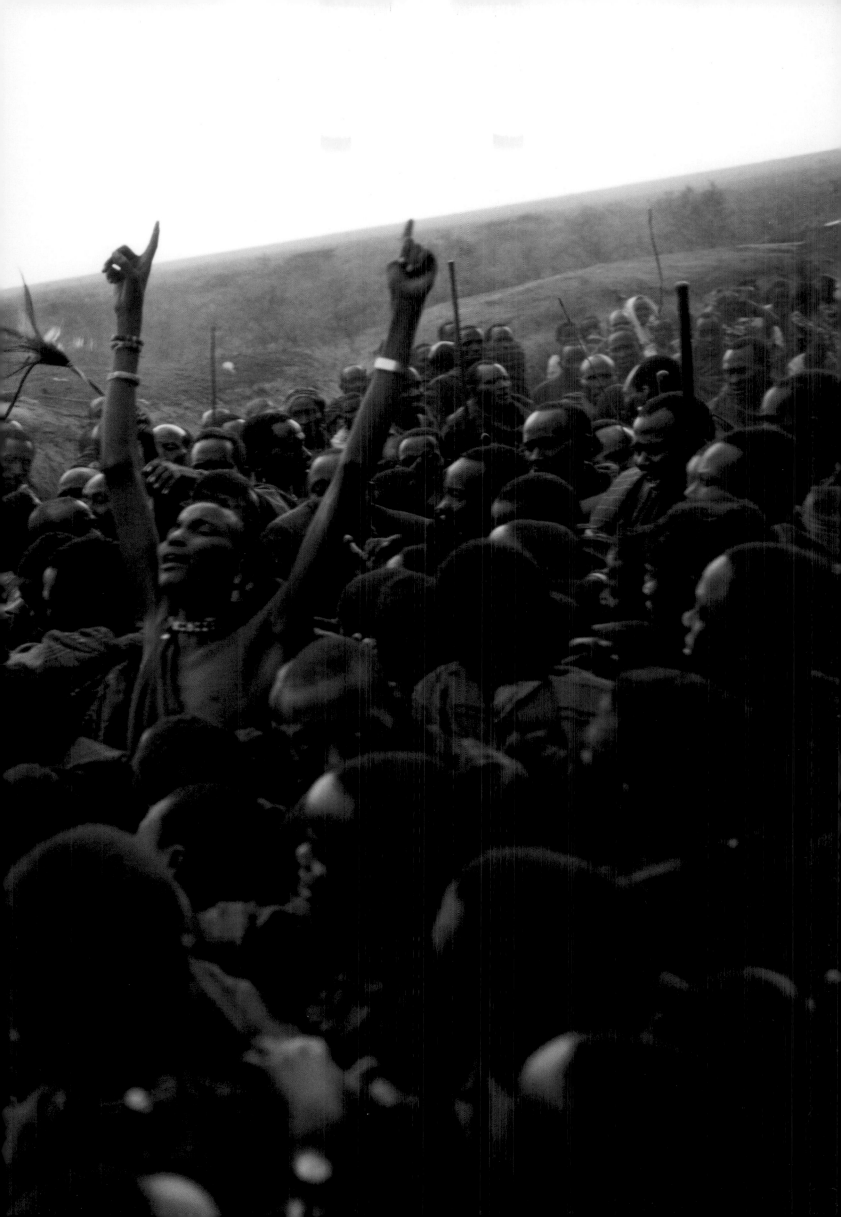

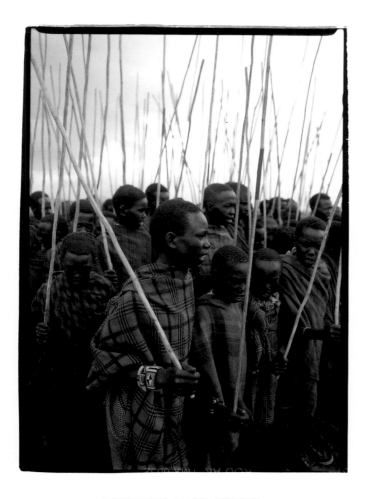

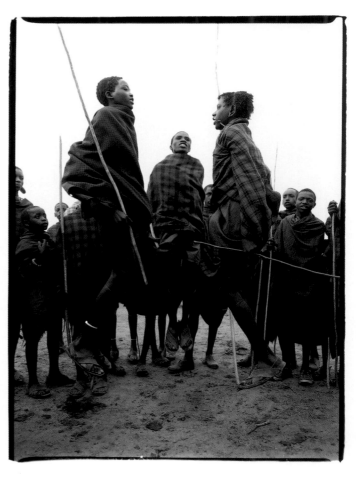

BOYS WITH CATTLE STICKS
Sticks used to herd the ox to slaughter are carried by the boys
throughout the weeklong ceremony.

DANCING BOYS
Boys dance together after the chase for the ox's horns. Two or three
dancers will enter a circle at once, each one attempting to leap as
high as possible. This style of dancing is perfected when they grow
into warriors and can leap three or more feet off the ground.

PREVIOUS PAGE
WINNER OF THE CHASE
A tall boy from Tanzania who walked to Narok district for the ceremony is the first one to grab the
ox by the horns. He is named the winner by the delegation of elders, an achievement that will be
remembered by members of his age group for the rest of his life.

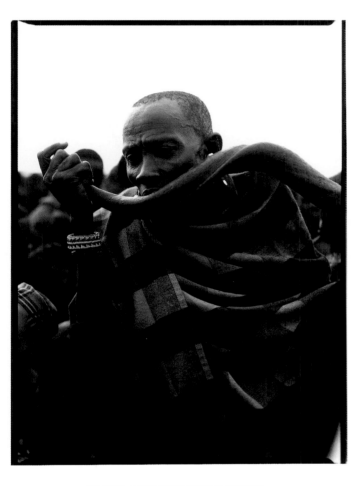

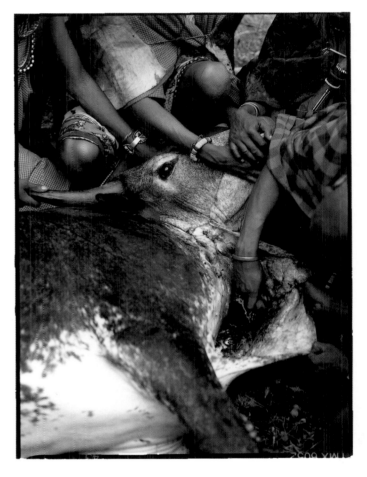

ELDER AND THE KUDU HORN

An elder blows the kudu horn in celebration after the chase for the
ox's horns has ended.

SLAUGHTERING THE OX

The ox is slaughtered for a feast on the final day of the ceremony.
Each participant shares a drink of its blood mixed with honey beer.

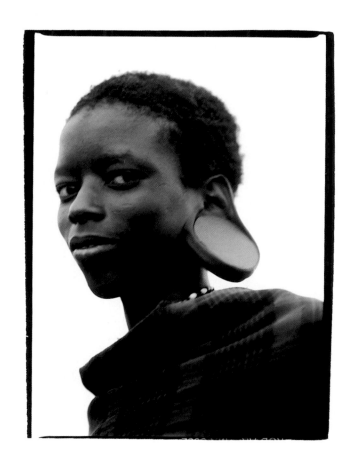

VEXING SONG TO GIVE A BOY COURAGE
BEFORE HIS CIRCUMCISION

Many are the steers of a man
Grey and spotted
And beautifully colored
The sheep fill the pen
Calabashes rest at the foot of the bed
The boy has taken the drink of milk and blood

Listen to the best birds
I will not let the cowards take them
The songbird has markings around the eyes
And the warbler has a black stripe on its back
Just the same as the sparrow
And the weaver has spots
And the starling has blue wings
Which rise upwards towards the heavens

Straight are the trunks of the Mau cedar
But better are those of Mount Memorra
And God throws the boy from the trees
And he bangs his head on the ground
And we all run off from the land
Where the boy is a coward

OVERLEAF

PROCESSION TO THE OX'S SLAUGHTER
On the last day of the ceremony the boys march into the forest to slaughter the ox for a feast. Each
boy will take a drink of its blood and the meat will be roasted and shared by all.

COWHIDE RING

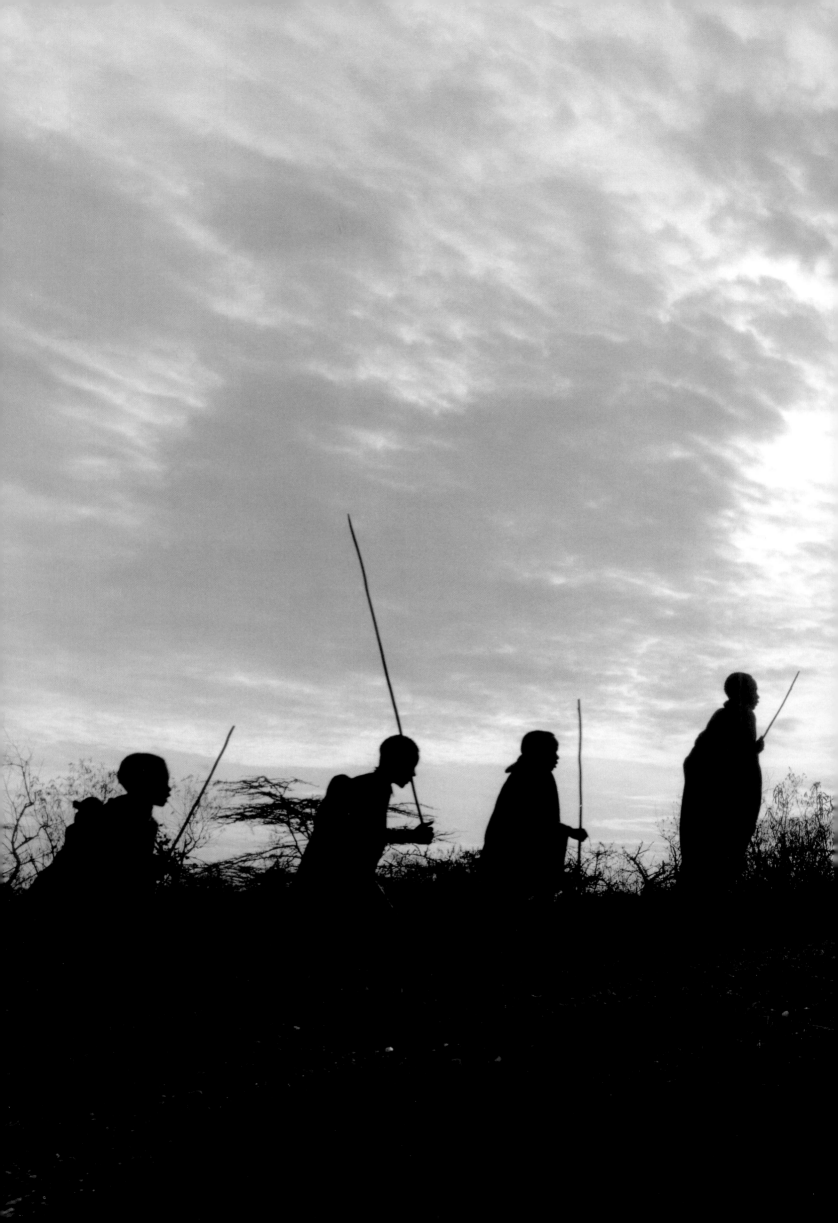

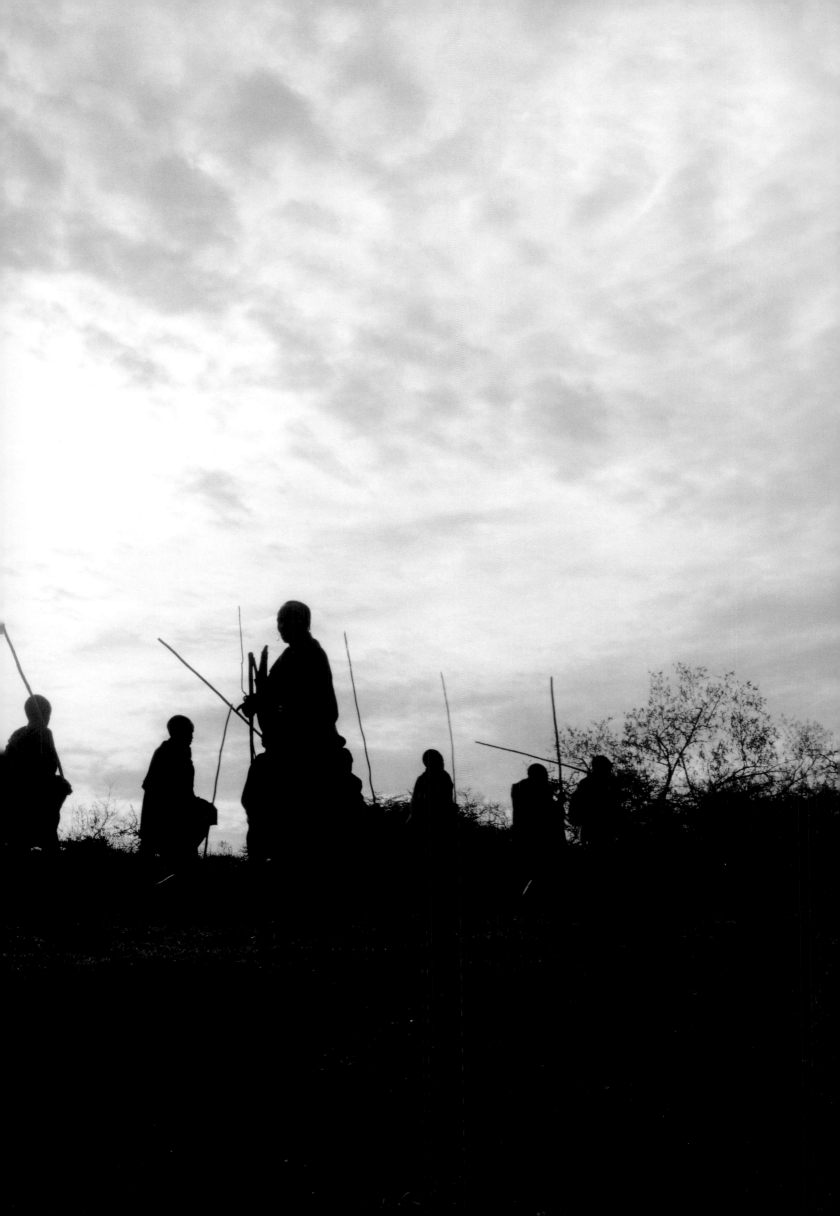

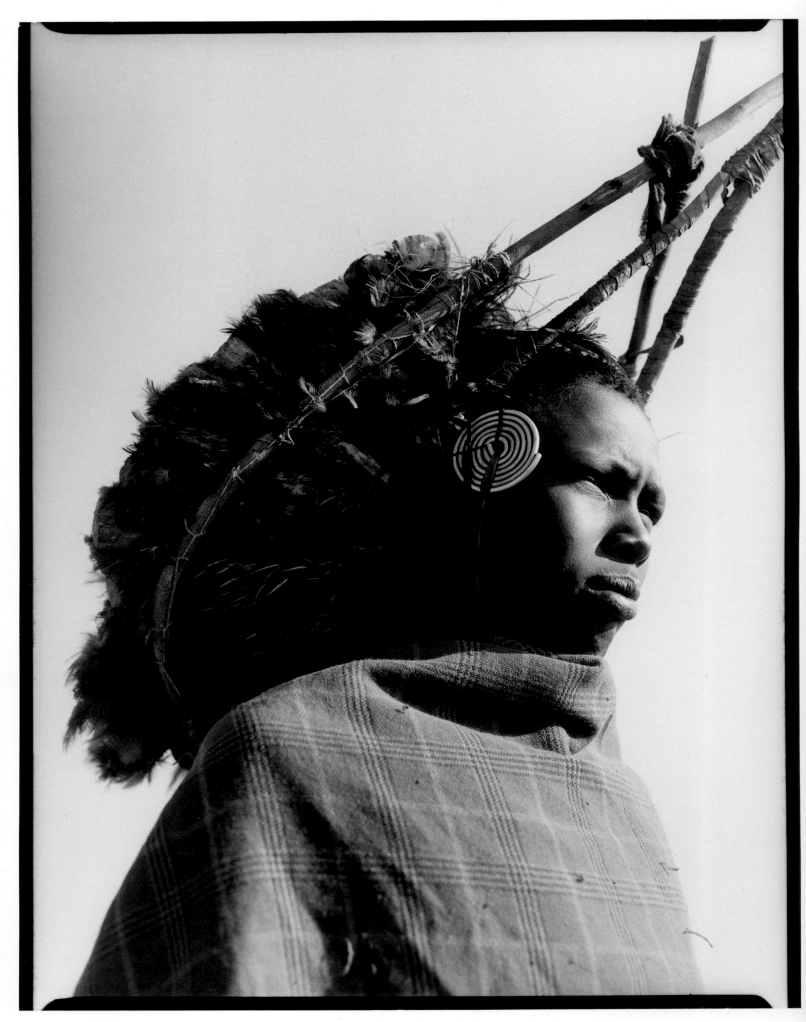

JAMES OLE MPUSIA WEARING HIS CIRCUMCISION HEADDRESS

PASSAGE TO MANHOOD

Circumcisions were the most important rite of passage in a Maasai man's life, ending his childhood in a single, remarkable moment by cutting away his foreskin without any anesthetic. He is not allowed to flinch or cry out in pain. Guests watch closely to monitor his movements. If he should move a muscle of his face in displeasure or pain, the guests will depart immediately, leaving him and his family alone in embarrassment. In the event of such a disgrace, he will not be allowed to become a warrior and will be branded a coward for life.

The circumcisions were private affairs and were difficult to photograph. Women were not allowed to witness men's circumcisions and my presence opened up a moral debate. There was nudity at the ceremony and no one could agree on whether to allow a foreigner to attend such an intimate event. After the circumcisions were over, the atmosphere sometimes changed. Emotions were charged. The young initiates, moody and hurting from the operation, were no longer happy to have their picture taken. Though I was able to photograph several circumcisions over the years, at each ceremony someone strongly protested my cameras.

During my first year, before I had begun working with Tiampati, I drove down to the Loita Hills with a translator who knew the area. I was told that it was the most traditional territory of Maasailand and we immediately found two boys who were preparing for circumcision. Their family gave permission to photograph it and we camped outside their *boma* for ten days awaiting the ceremony. It was bitter cold in the Loitas that year and the wind chapped our lips so badly they bled. At night I slept in two sleeping bags and wore a down jacket to bed. I was amazed at how little clothing the Maasai wore, enduring the cold with only their *shukas.* A few adults had jackets from the secondhand clothing market in Narok, but the children had nothing, and their noses always ran.

We kept a fire burning outside the tents and passed the time roasting corn and chatting with the elders. The Maasai, who had always been reluctant to farm, recently had grown small patches of maize and found that they liked it. The old men would sit by the fire and talk about their warrior days while they turned the cobs over the embers. Younger warriors, busy with braiding their hair, going on hunting parties, or trolling the *bomas* for girlfriends, loved to visit the camp. The car was a source of endless fascination, and they would come to gaze at themselves in the rearview mirrors.

In the days before their circumcisions, the boys invited me bird hunting to collect feathers for the headdresses they would wear while they healed. They took honey from the hives of wild bees so the women could brew beer for the invited guests. At dusk on the evening before the ceremony, the mothers shaved the boys' heads, a silent moment in which their relationship would forever change as the boys went on to become independent adults. At sunrise the next morning, they were numbed with cold river water and circumcised without anesthesia by an elder. It was an intensely emotional event and many of the men cried as they watched. The circumcisions were over in five minutes, during which time the boys remained quiet and calm, never once crying out.

After the circumcision, a bull was slaughtered and guests came to celebrate with food and honey beer. A group of warriors arrived from Tanzania, and when they saw my cameras they demanded a fee for me to take pictures. I refused, having already negotiated a gift of goats to the family. Suddenly one of the warriors grabbed my camera and hit me in the face with it. He raised his *rungu* at me and spoke measured, broken English.

"We don't want you with your cameras. We don't care what the family say. If you photo us, we will kill you. If you do not believe me, make a picture. And you will see. I will kill you."

My translator had disappeared into one of the houses in the *boma* for a cup of tea. Over the ten days we had had numerous difficulties negotiating demands for money and he was exhausted. The Loita Hills were remote and people were wary of cameras. One man, upon hearing that I had photographed his herd of cattle when they were grazing, walked miles to find us. When he did, he parked himself in camp for three days, demanding hundreds of dollars. "It is not free to picture cows," he said.

I saw the hatred in the warrior's face, and I knew that if I didn't back down he would make good on his threat. Finally, he walked away, but he continued to watch me throughout the afternoon. It wasn't safe to stay any longer. The warriors were angry and if they found me walking in the bush or sitting alone in camp they could be unpredictable. I didn't sleep well that night, wondering what to do. I didn't want

to miss the young initiates sewing their birds together into a headdress the following day, but the warriors were in charge of that activity and I knew they would never allow me to photograph it.

I didn't know for sure if the warrior would be angry enough to kill me. I never saw death in the bush, but I had heard many stories. Even the Maasai admitted that the warriors sometimes killed people. Out on the border, the warriors could easily walk back to Tanzania and the Kenyan police would never find them. So in the morning I decided to leave. Things had fallen apart and it was best to head home.

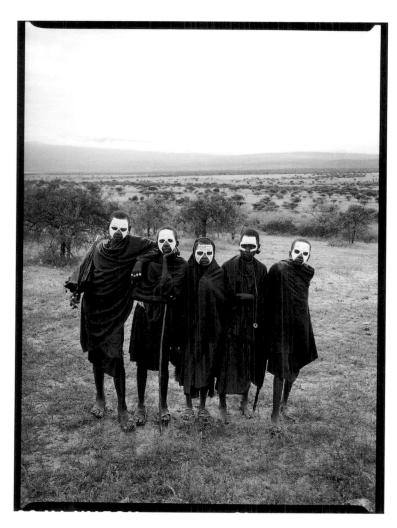

CIRCUMCISED CHILDREN OF TANZANIA
Tanzanian Maasai wear black *shukas* and paint their faces with decorative patterns of white diatomite paste to show that they have recently been circumcised. They will wear this ceremonial costume throughout the healing process until they are ready to become warriors.

OVERLEAF

THE BIRD HUNTERS
Maasai boys flush birds from a tree during a hunt made in preparation for their circumcision. The bodies of the birds are stuffed with a lightweight wood and sewn into headdresses worn while the boys heal from the operation.

FOLLOWING PAGE

THE HONEY GATHERERS
Boys gather honey in preparation for their circumcision party. After smoking the bees out of the hive, the honey is collected and used by their mothers to brew beer for guests.

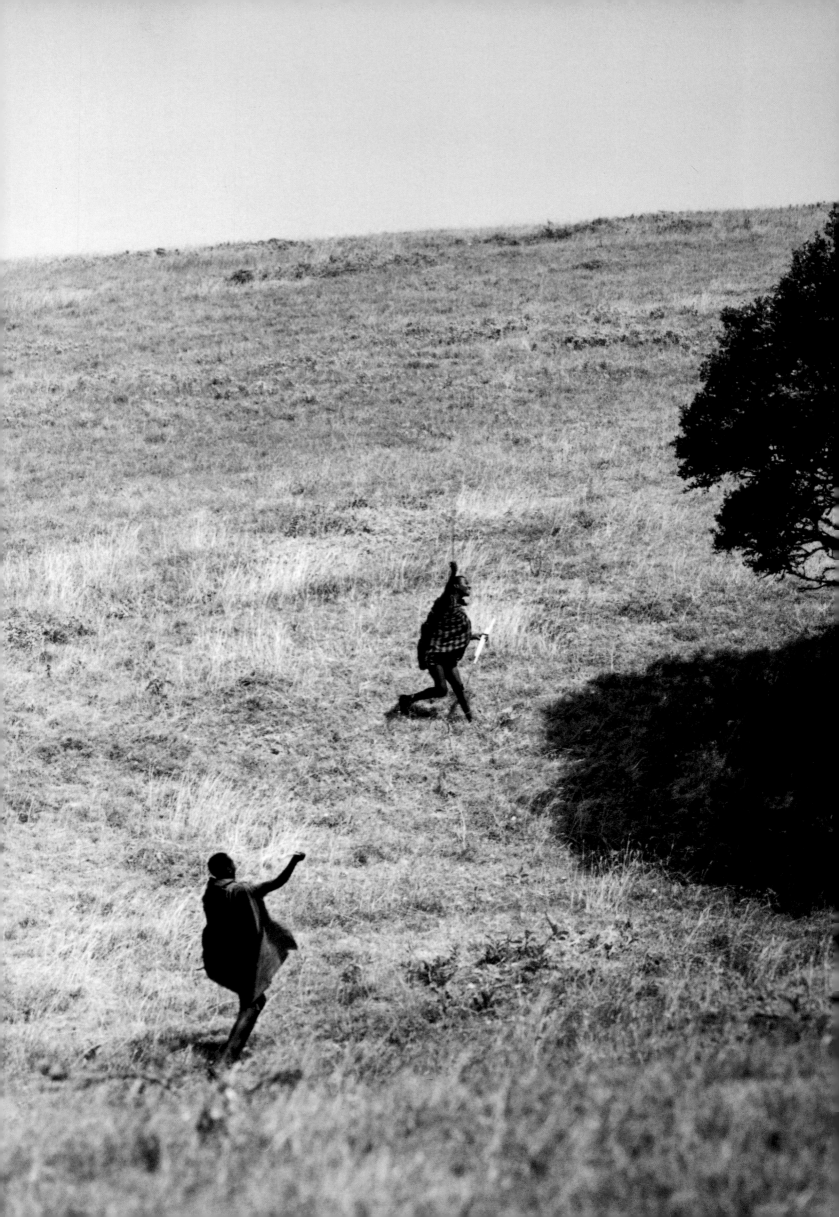

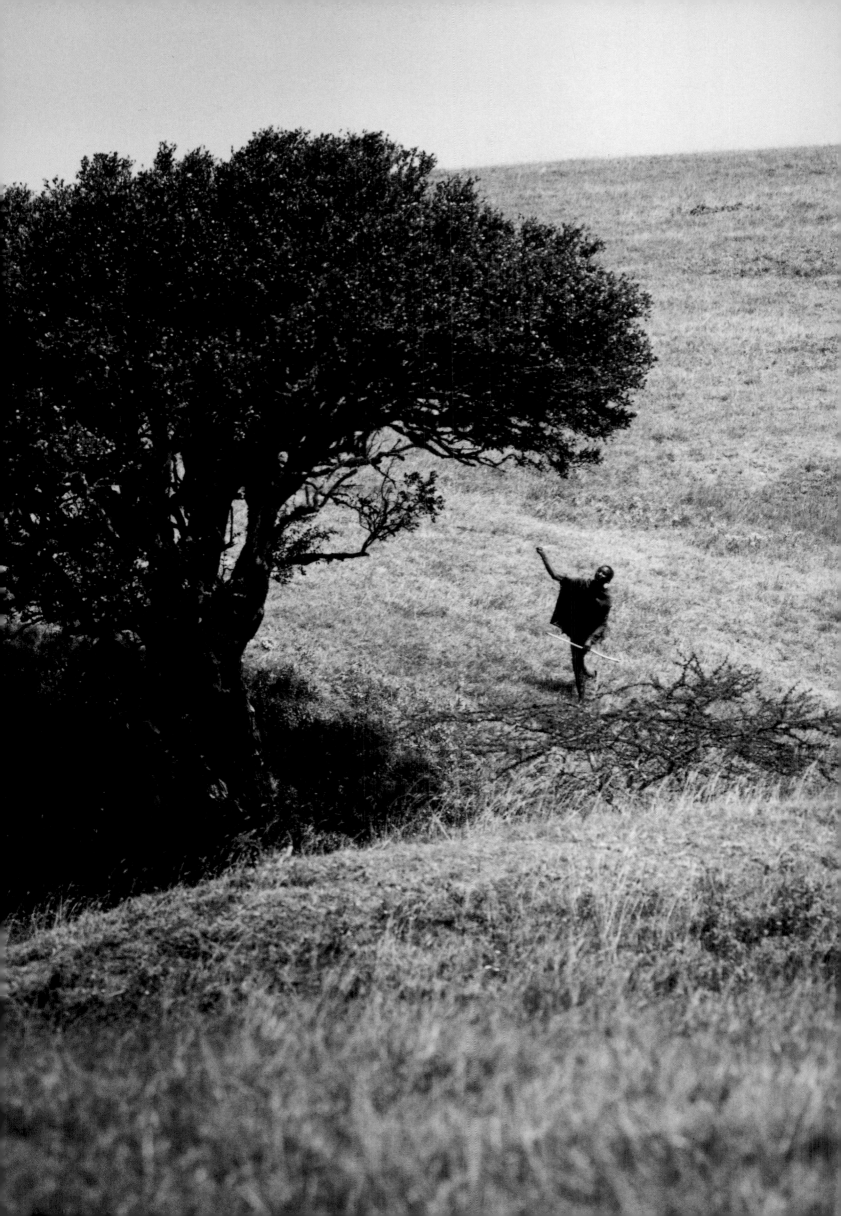

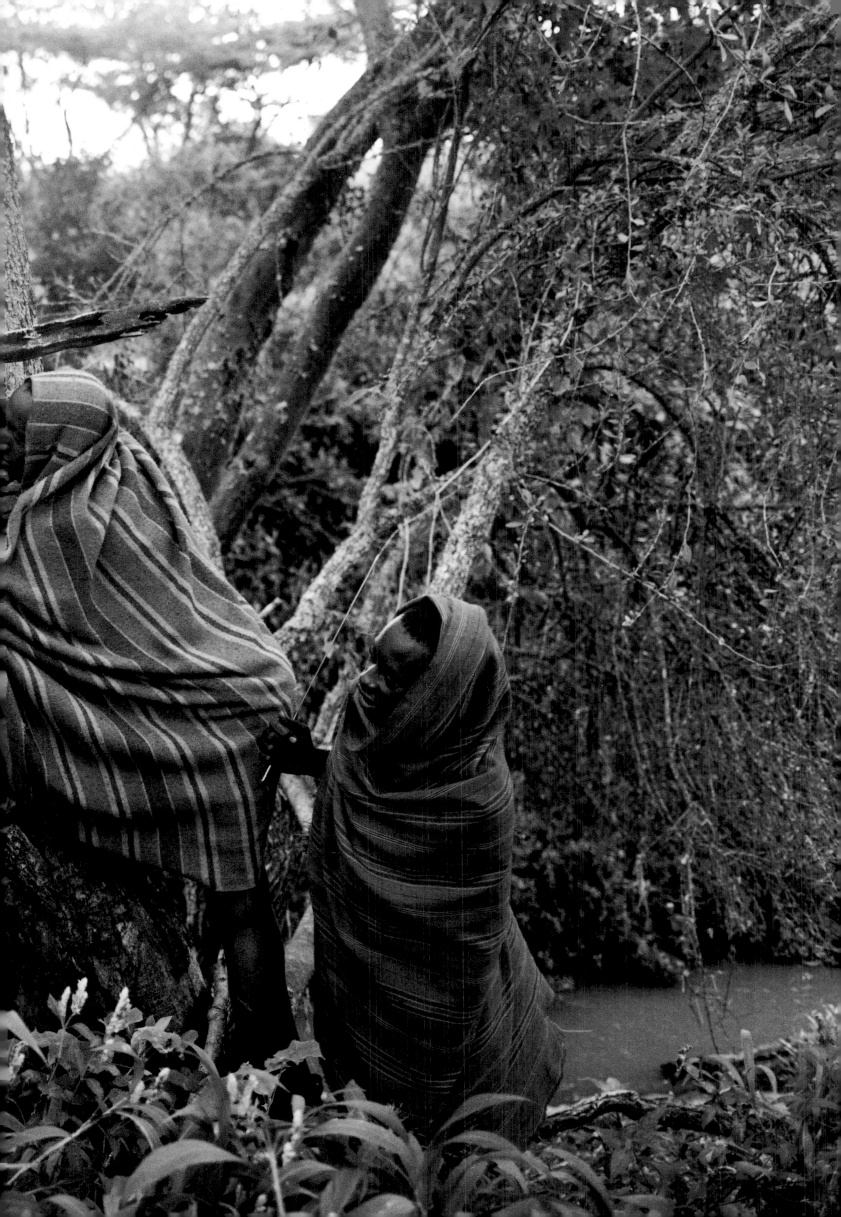

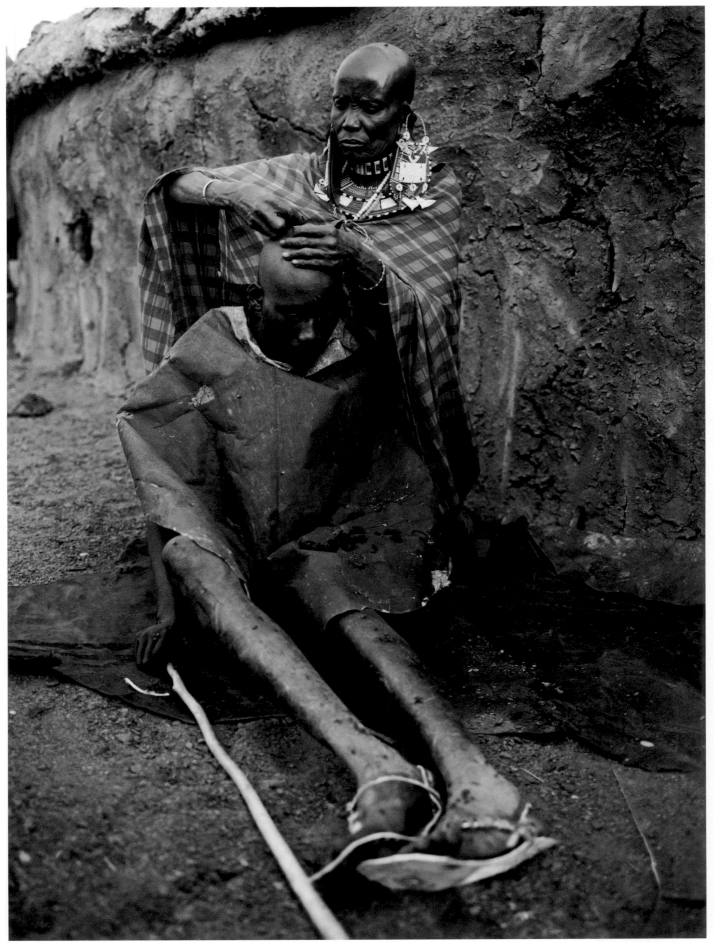

HEAD SHAVING BEFORE THE CIRCUMCISION
Boys' heads are shaved by their mothers or members of their mothers' age group on the evening before their circumcision.
Head shaving is common at many rites of passage and represents the fresh start that will be made as an individual
passes from one of life's chapters to the next.

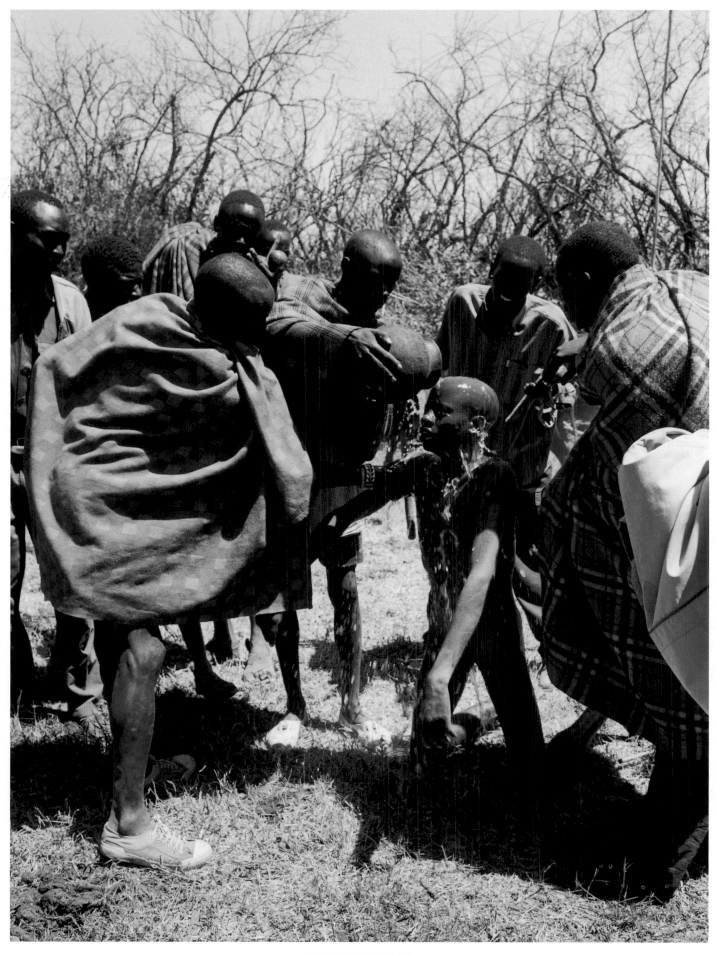

WATER OF THE AX

A ceramic pot of water is cooled overnight with an iron ax head submerged inside.

This cold water is poured over a boy moments before he is circumcised so that it may numb him and lessen his pain.

WORDS SHOUTED BY CROWD AT THE
CIRCUMCISION CEREMONY

You are still a boy, not a man!
You have not been touched yet!
Do not listen to the man with the blade,
Do not move when he makes the cut,
If you happen to flinch,
You will be the first in this family
To be called a coward!

Make it perfect on the boy!
Be careful with the cut!
Be fast with your knife!
Because we are watching
Be swift on the boy!

CIRCUMCISION AT NOON
Male circumcision is performed in the family *boma*. Boys are given no form of anesthetic
and are not allowed to flinch or cry out in pain. Guests watch their faces for signs of displeasure
and if a boy moves during his circumcision he will be branded a coward throughout his life.

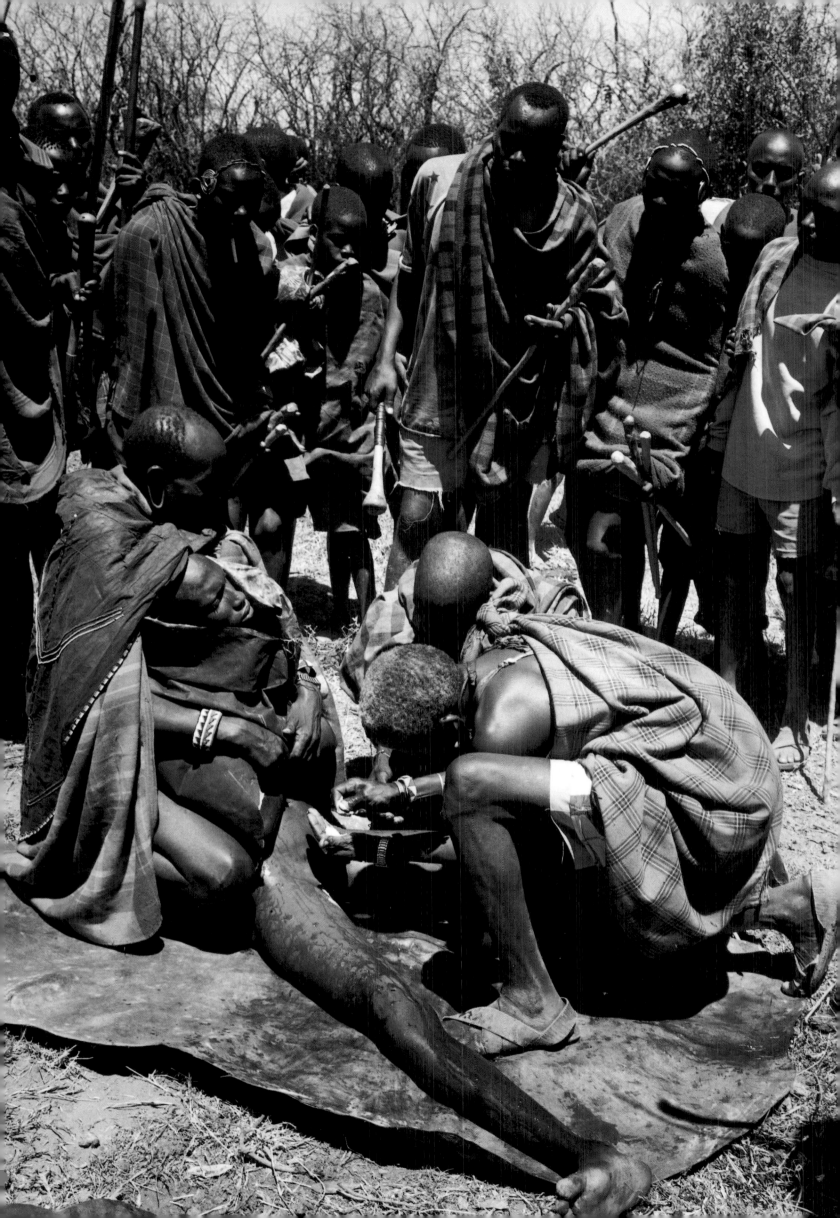

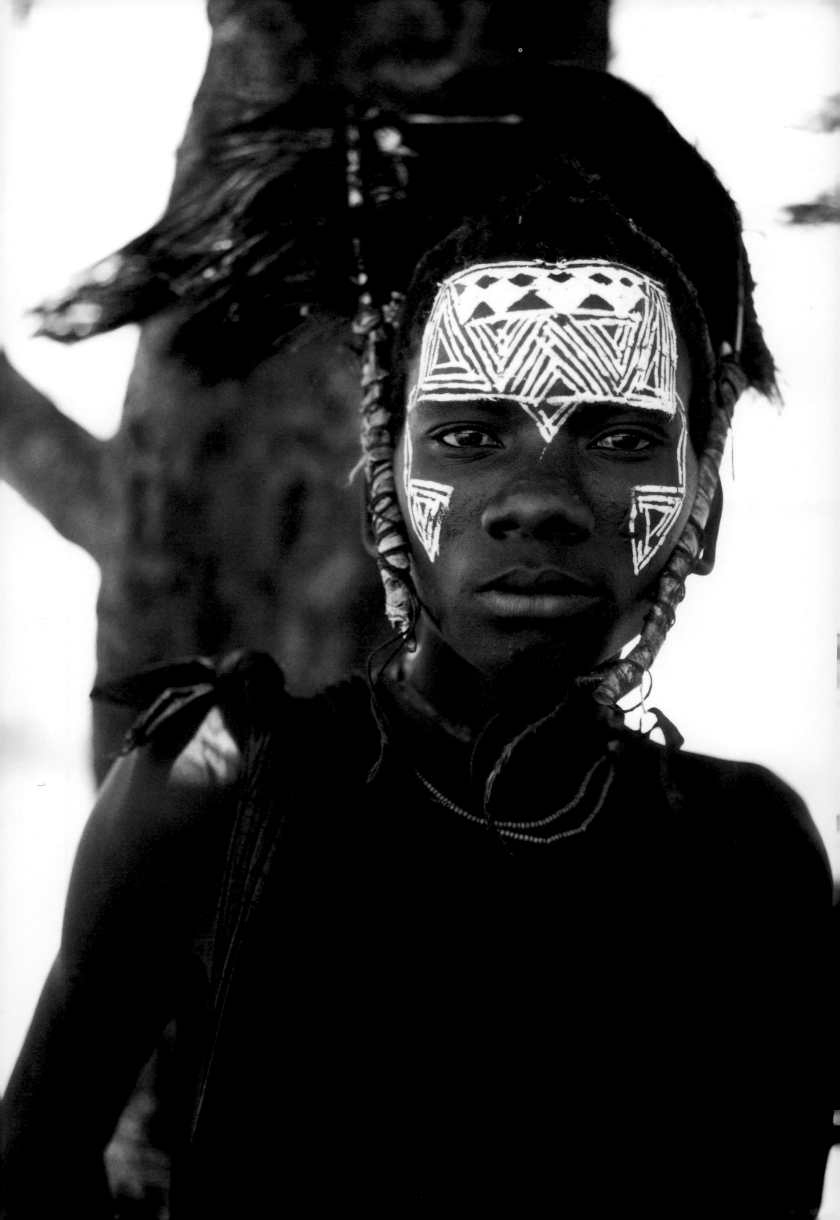

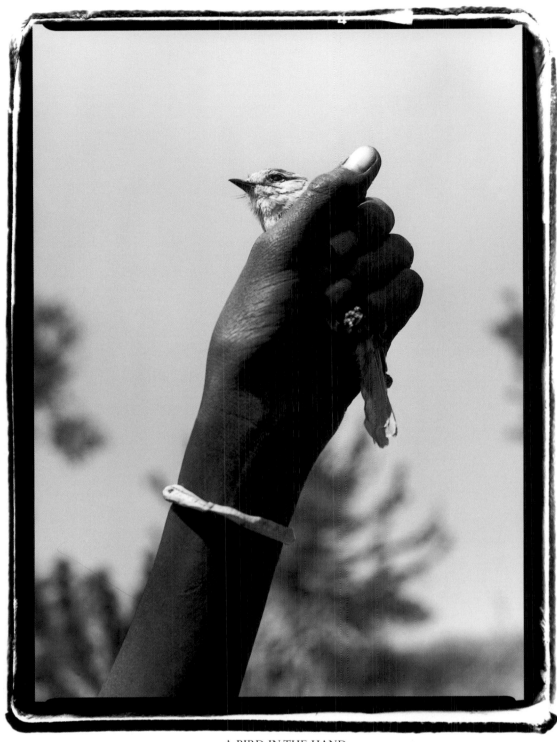

A BIRD IN THE HAND

OVERLEAF

ELDERS BY A FIRE

After circumcision, a group of elders warm themselves by the fire. Matters of
business, delegating responsibilities, and resolving community problems are all duties of the
elders, and committees of these men oversee all major ceremonies.

FOLLOWING PAGE

PROCESSION OF ELDERS

A group of elders proceed to a small ceremony in which one of them
will slaughter a bull in celebration and blessing so that he may circumcise his children.

PORTRAIT OF A CIRCUMCISED BOY
FROM TANZANIA

87

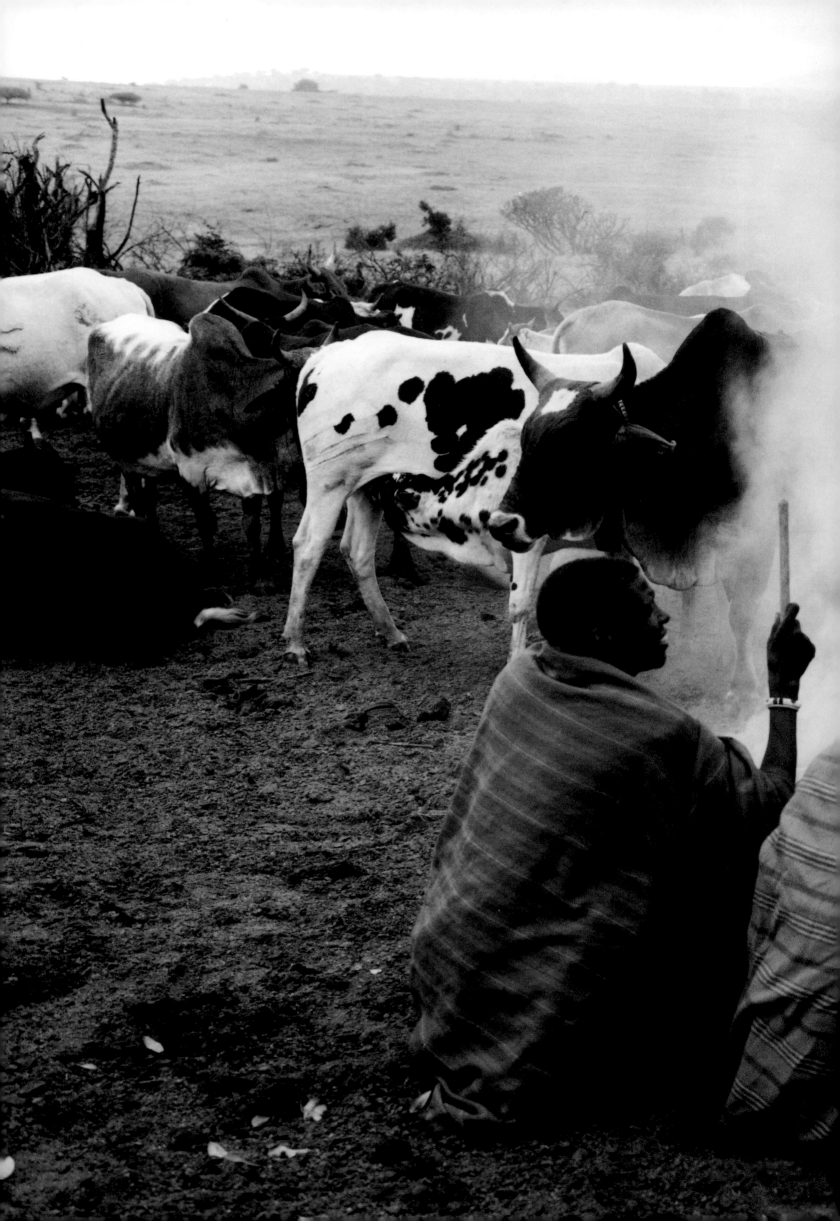

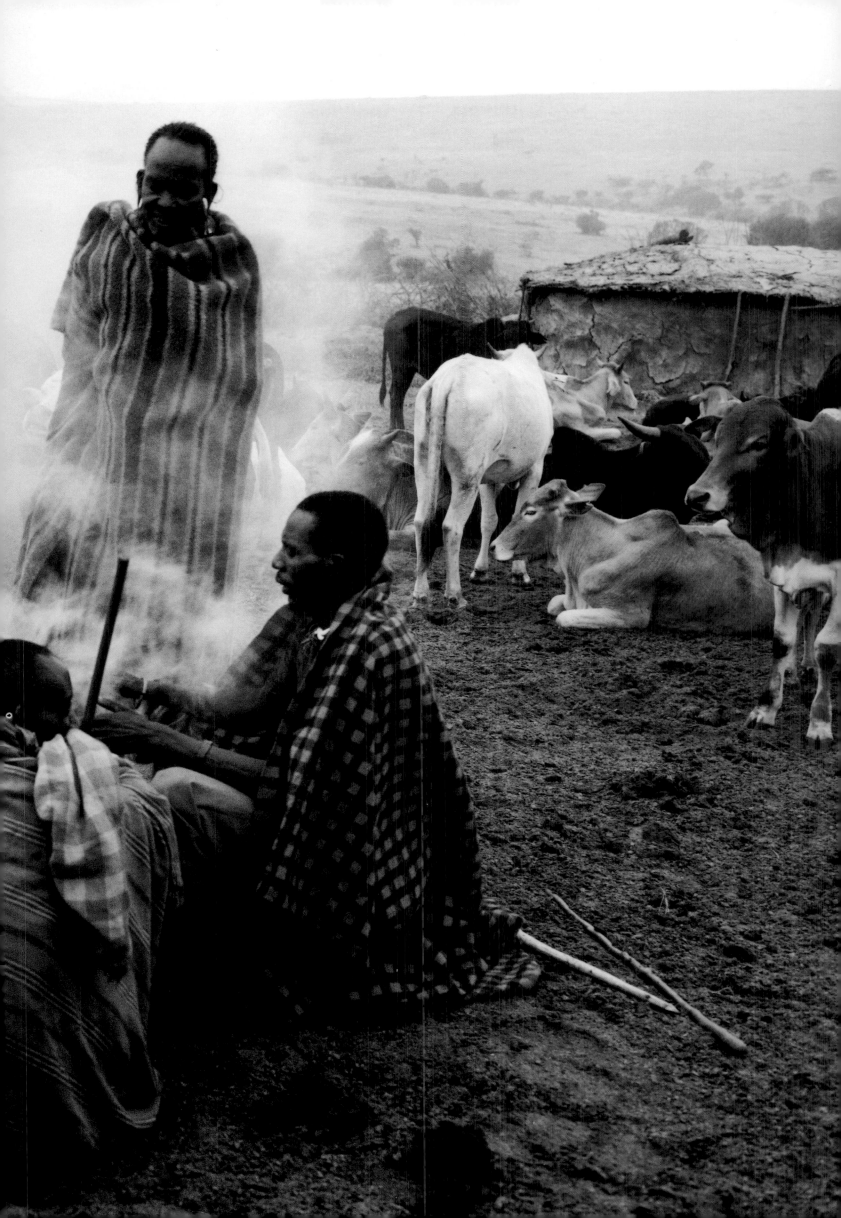

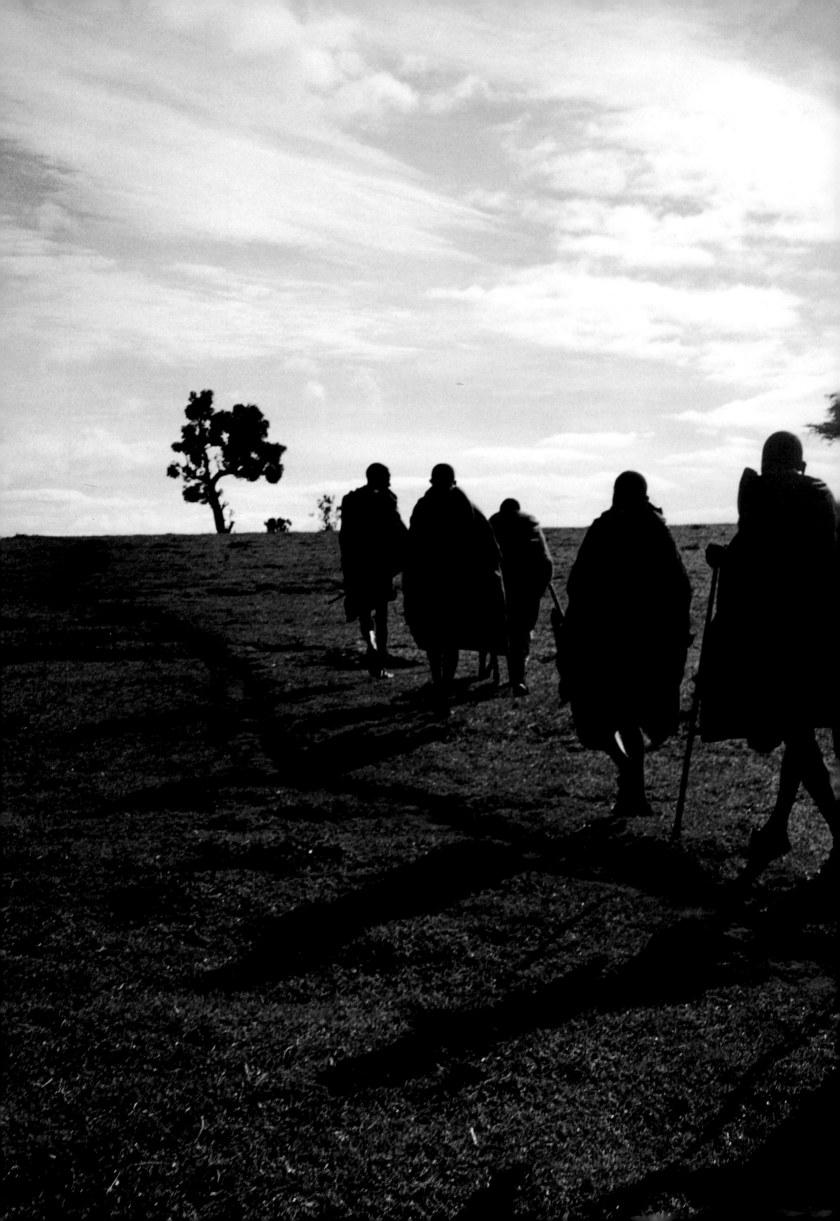

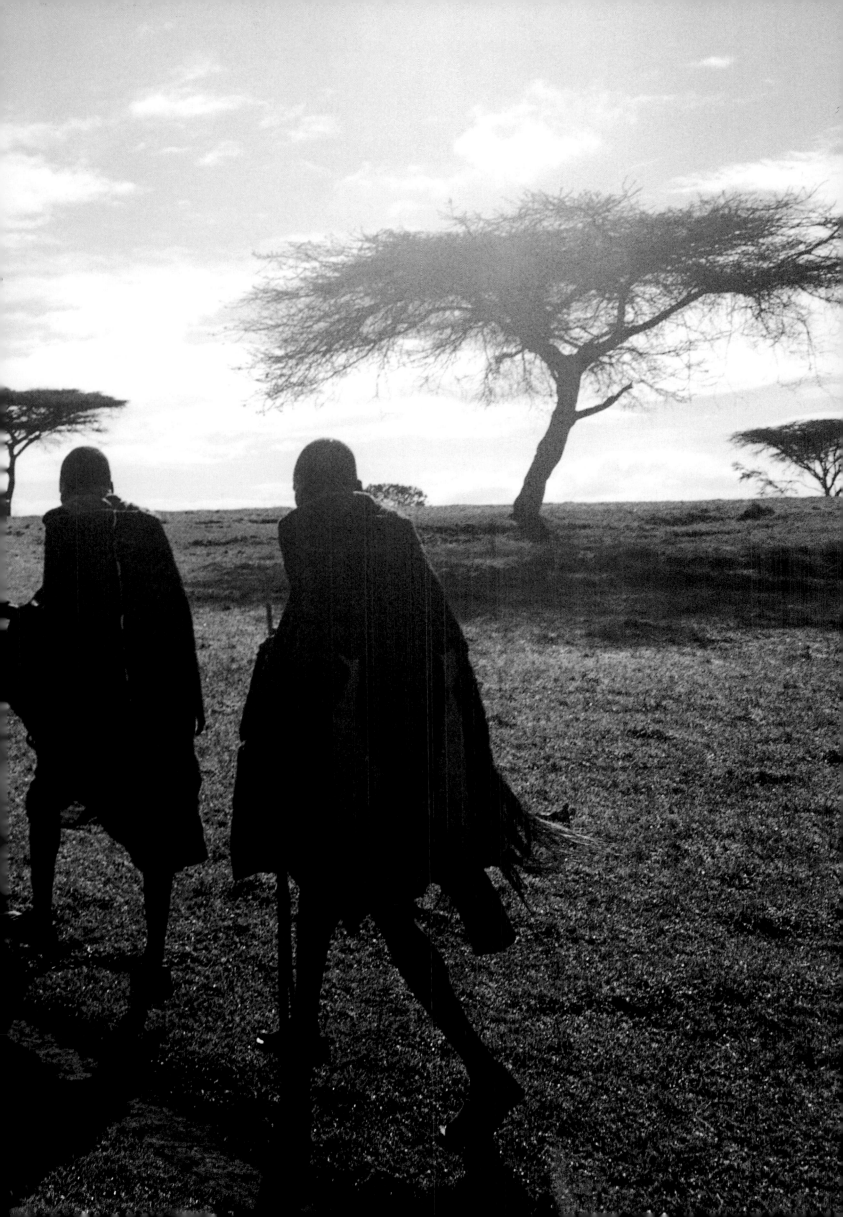

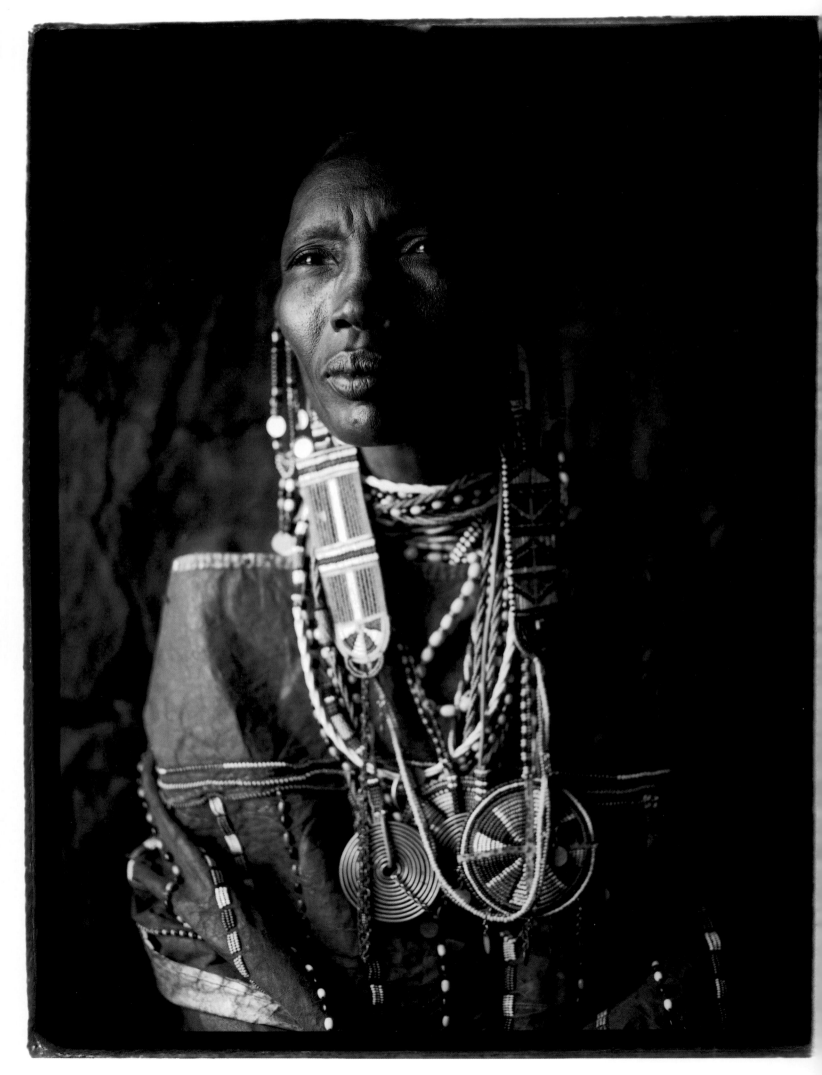

WOMAN WEARING DISC NECKLACES SHOWING THAT SHE HAS CIRCUMCISED HER CHILDREN

NAIPENDE'S
CIRCUMCISION

The strength of Maasai society came from its women. They did all the work except herd livestock. They built the family home, often had their own small businesses, were responsible for raising children, and provided all the elements necessary for survival. They could walk for hours in the baking sun to fetch a jerrican of water, parceling out its contents so that it could sustain an entire family for days. I often saw small girls carrying these heavy containers strapped to their heads or toting bundles of logs nearly twice their own body size. By the time they grew to be young women, they already knew how to manage a home.

Maasai women participate in few rites of passage, circumcision being the most important. It was a well-known practice, but the Maasai were reluctant to talk about it, as it was heavily criticized by outsiders. I knew that no portrayal of Maasai life would be complete without documenting this ceremony and began making inquiries through my contacts in Narok. Weeks went by. Then one day in the marketplace I was told that a girl was being circumcised the following morning in a village across the river. Tiampati and I didn't know the family but we decided to look into it.

As we drove through the bush, I was torn between my role as a photographer and my personal feelings about the practice. Female circumcision was a standard rite of passage for Maasai women. Uncircumcised girls were considered ineligible for marriage, and the world of children, family, and the status that came with taking care of a home would be barred from them. The privileges of adulthood were awarded only to boys and girls who had been circumcised and few people questioned the ritual. Mothers, grandmothers, and the mothers before them had all undergone the practice as far back as anyone could remember, yet they were all at

a loss to explain where the custom had originated or why it was necessary. The most coherent explanation I heard was that it was necessary to curb the sexual appetite of women so that they would remain faithful to their husbands.

The family holding the circumcision was friendly but reluctant to allow me to photograph it. I was able to speak directly with the oldest brother, James, who was a schoolteacher and spoke English. He understood the purpose of the cultural documentation and seemed willing to let me attend, though the question of my contribution to the ceremony inevitably came up. On previous safaris I had been willing to pay cash to make portraits and document ceremonies, but I was not willing to pay money to witness a female circumcision. I knew it would be expected of me and that the girl would be circumcised whether I paid or not. Still, I was uncomfortable with the idea and explained my dilemma to James. Perhaps James felt that a friendship would be more valuable than a gift of money, and as he measured these things, he decided to grant me permission.

In the evening he brought me to meet his sister Naipende, a tall, strong girl nearly sixteen years of age. Her face was serious and she was quiet while the women sat beside the fire peeling potatoes for her circumcision party. She sometimes disappeared from the house and I wondered if she was outside talking with her friends. Many girls who had just been circumcised came to attend the ceremony and would be preparing her for what was to come. Naipende had never been to school and knew that for her life to continue in the traditional Maasai way she would have to endure the circumcision. Her friends would have been a comfort to her, reassuring her of recovery.

At dawn, young girls from the village cut a hole in the thatched roof of Naipende's house. Under the instruction of the circumcisionist, a stubborn old woman carrying a bag of razor blades and medicinal pastes, the hole was made just big enough for a small shaft of light to enter the otherwise dark calf pen. There, on the dung floor where calves slept at night, Naipende would be circumcised. She waited quietly outside, wrapped in a beaded cape of leather, her head cleanly shaven. Was it any consolation that she would be rewarded for her pain with presents of beads, gourds, or, best of all, gifts of precious livestock?

Tiampati was not allowed to witness the ceremony, so when the hole in the roof was finished I moved inside the house alone. Moments later the women took their places inside the dim hut, and Naipende stripped off her clothes. The room was suddenly packed with women and girls of all ages. A woman sat behind Naipende and cradled her in her arms, clasping her hand over Naipende's mouth. In a flash of what must have been searing pain, the first cut was made. The small hut was filled with screams and hot breath. Young girls covered their ears, while older women murmured in serious, hushed tones. Naipende never stopped screaming at

the old woman. A second cut was made, then a third, fourth, and fifth, all with a flimsy, thin razor blade. A pool of blood collected on the cowhide, as if poured from a tap. Halfway through the operation, the older women tried to distract Naipende with a joke. Everyone but Naipende laughed.

Despite the violence of the ceremony, there was an almost palpable feeling of love among the women in the hut. Everyone stood by to help Naipende and monitor her condition, and when the five-minute ceremony was over they applied a chalky paste to her wounds and lifted her off the floor. Throughout the day Naipende lay in the darkness of the hut, first tearful, then quiet and subdued. People said that it took about ten days to heal from circumcision, though that was hard to imagine. A year later she would marry and start a family, but the days she spent healing in the hut were full of fear and pain. Naipende's childhood was over and the crowd celebrated with honey beer and goat meat.

Three years later, on my last trip to Kenya, I met a Maasai woman in Narok who was campaigning against female circumcision, and arranged for her to give a talk to the women of Naipende's village. She put a female anatomy model in the car and I drove her out to the hills past the river. Dozens of women gathered beneath the shade of the olive trees where we had camped and listened as Agnes explained the dangers of female circumcision. She, too, had been circumcised and was able to speak to the group of women with frankness and humor. None of the women beneath the tree had ever been to school or heard someone speak so openly against female circumcision. They were fascinated by the model and reached out to touch it when it was passed around. As Agnes and I drove back to Narok, I felt inspired by her lecture beneath the tree. It was a beginning, and that was something. But I also knew that the debate over female circumcision was likely to go on for years in Maasailand. Although educated young women have begun protesting the ritual, it is the senior elders who control the practice and promote its continuation. They are deeply entrenched in their beliefs, and only when they are gone will it be possible for a new generation of Maasai girls to be spared the rite of passage.

OVERLEAF

CARRYING BRANCHES FOR THE CIRCUMCISION BED

Women collect bundles of leafy branches in preparation for a girl's circumcision. The branches will be stuffed under a thick cowskin hide, making a soft bed for the girl to rest upon while she heals from her operation.

FOLLOWING PAGES

WAITING IN THE BOMA

Men and cattle wait in the *boma* while a girl is circumcised at first morning light. After the circumcision, the cattle will be let out to pasture. Female circumcisions are exclusive events for women only and men are not allowed to attend.

THE WOMEN'S SHADOWS

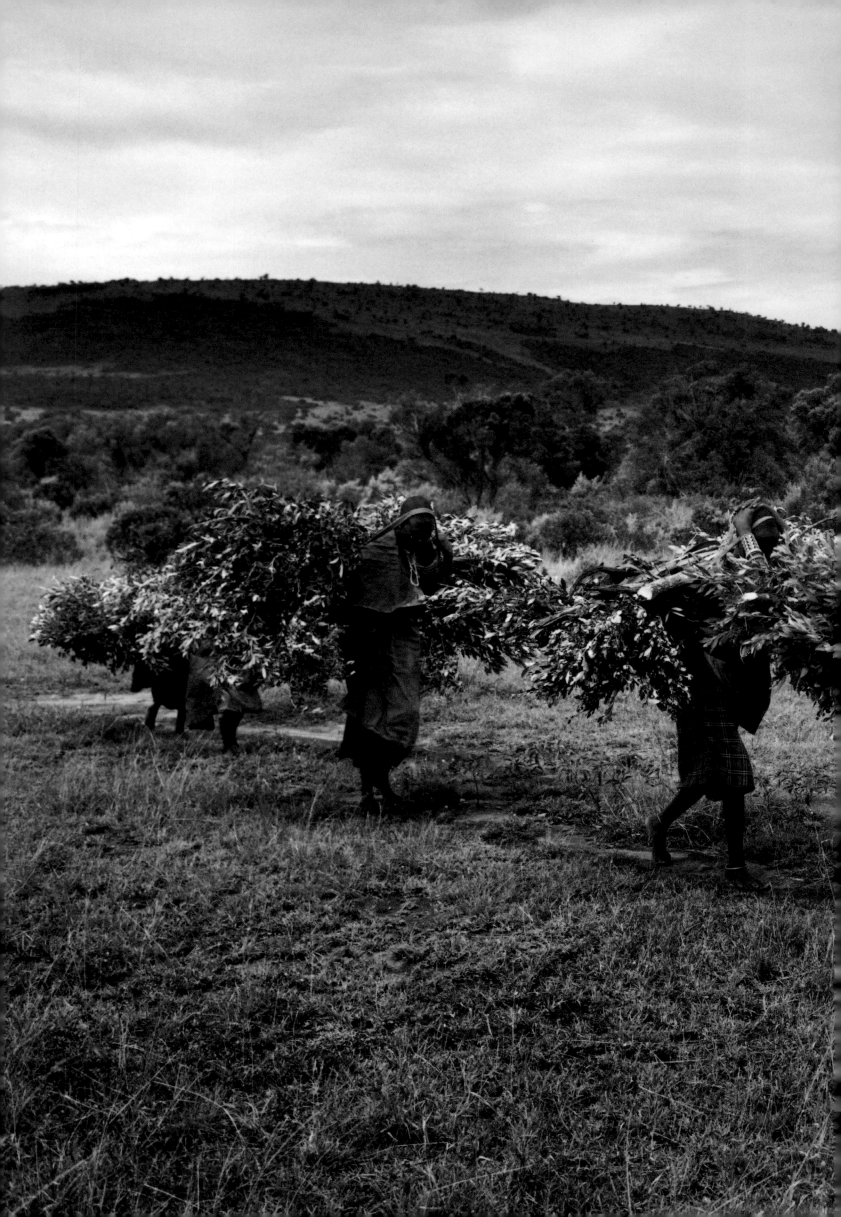

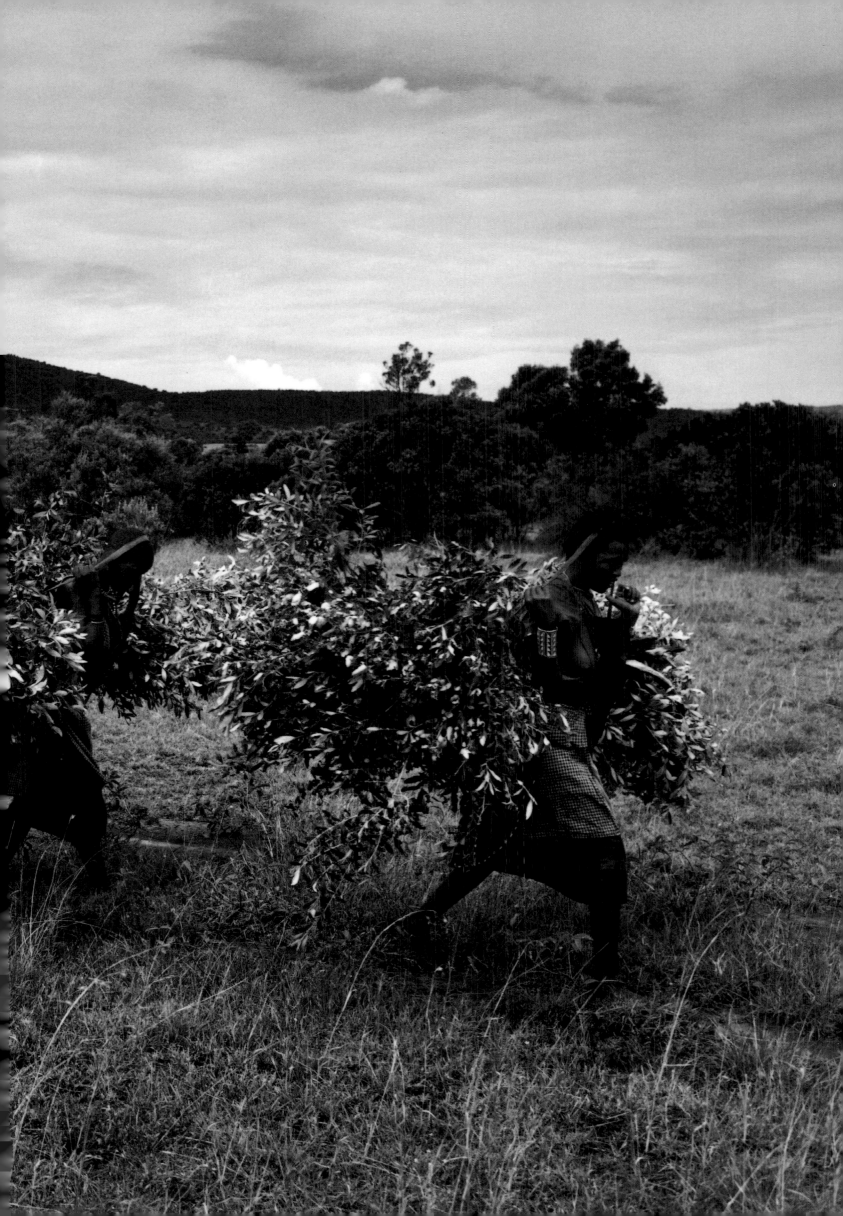

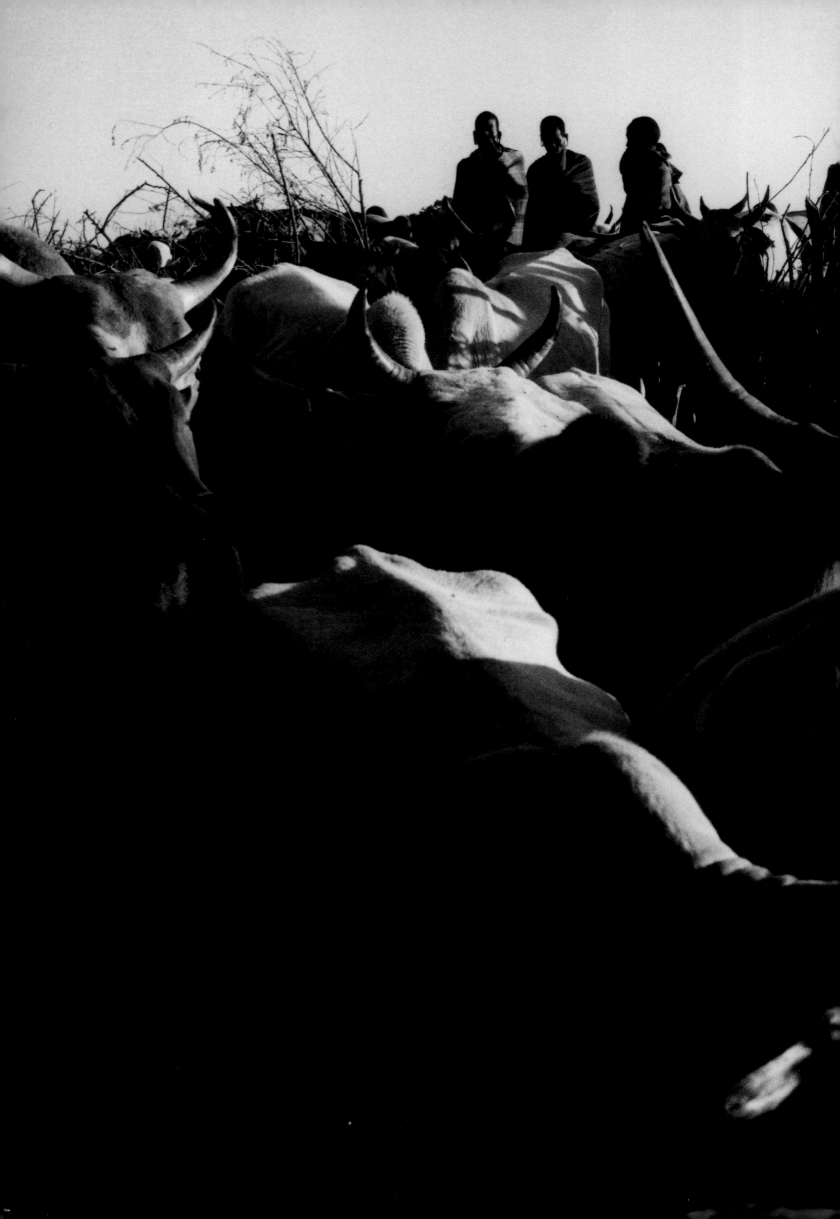

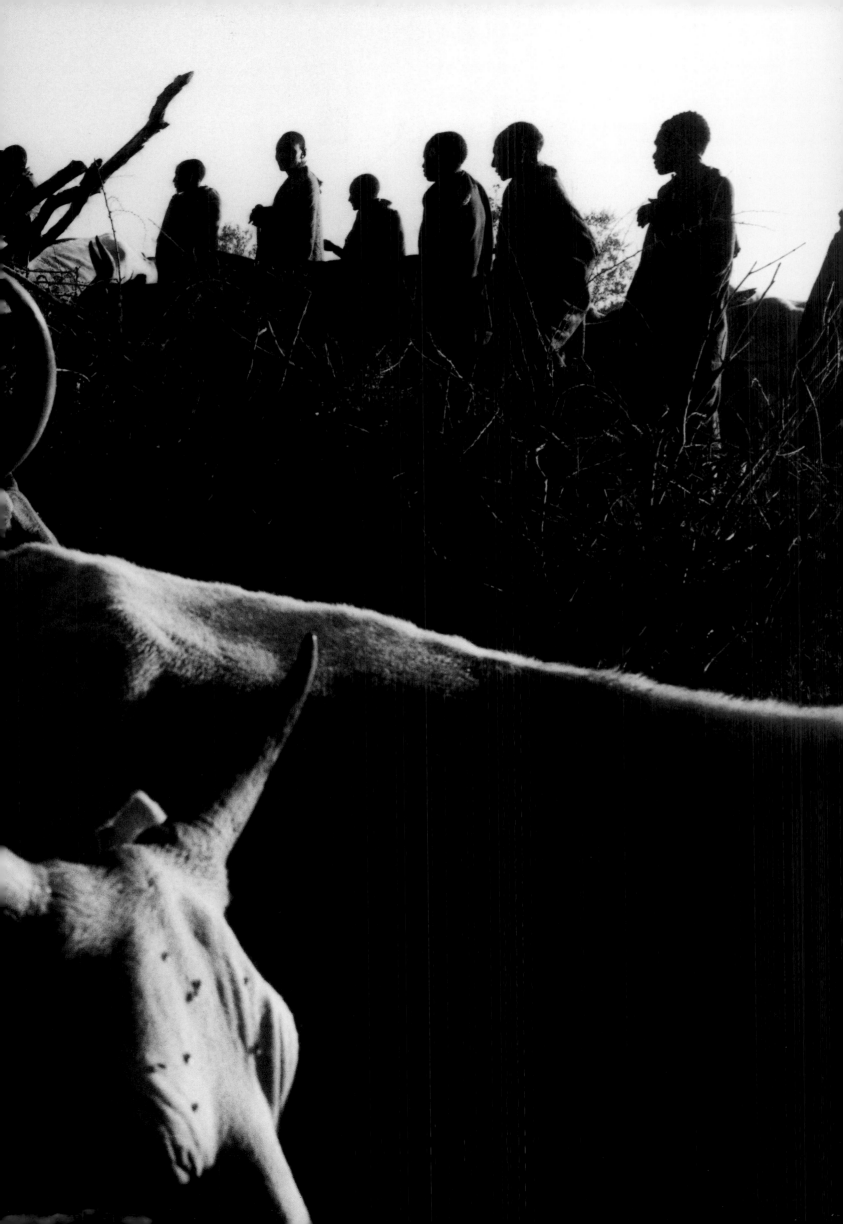

THE ROOF CUT
Female circumcision is performed in the calf pen of the family home.
In order to light the ceremony, a hole is dug in the rooftop of this windowless room.

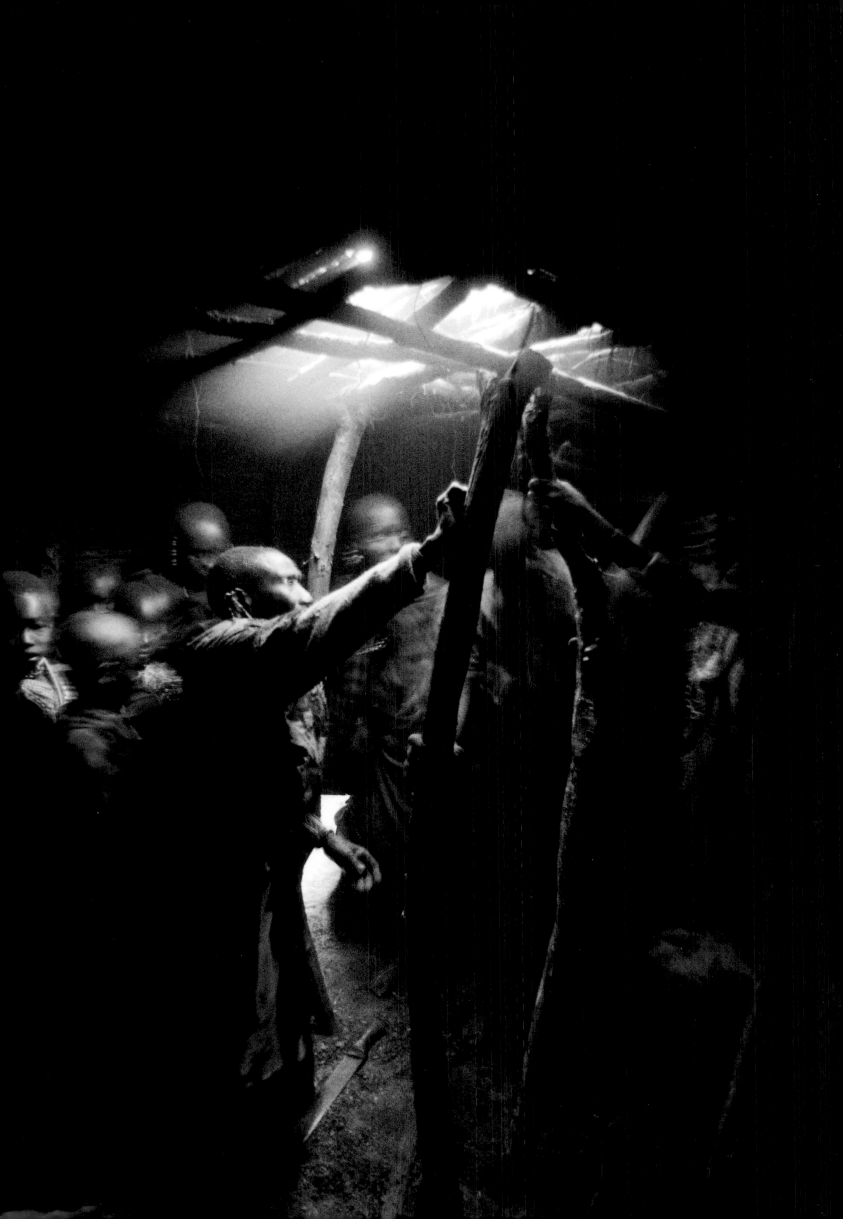

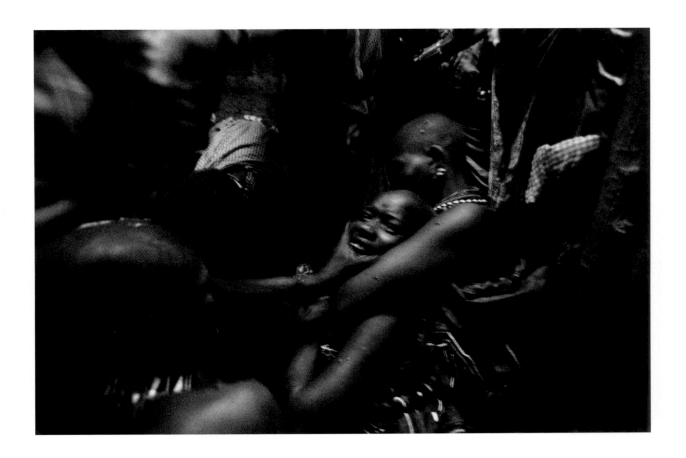

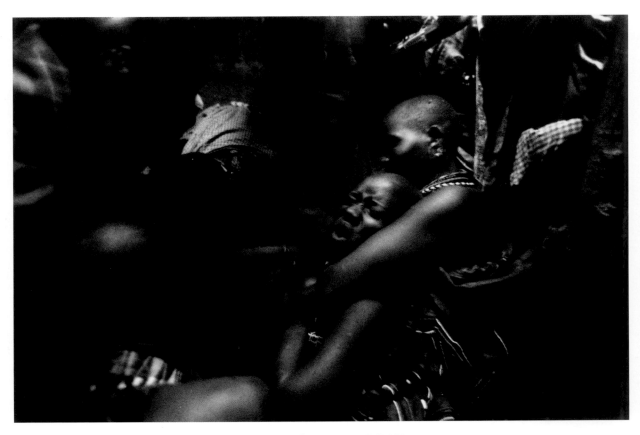

NAIPENDE'S CIRCUMCISION

CIRCUMCISION OF A THIRTEEN-YEAR-OLD GIRL

A young girl is circumcised so that she will be eligible for marriage. Once the wounds from the circumcision have completely healed, Maasai girls enter into traditionally arranged marriages with older men.

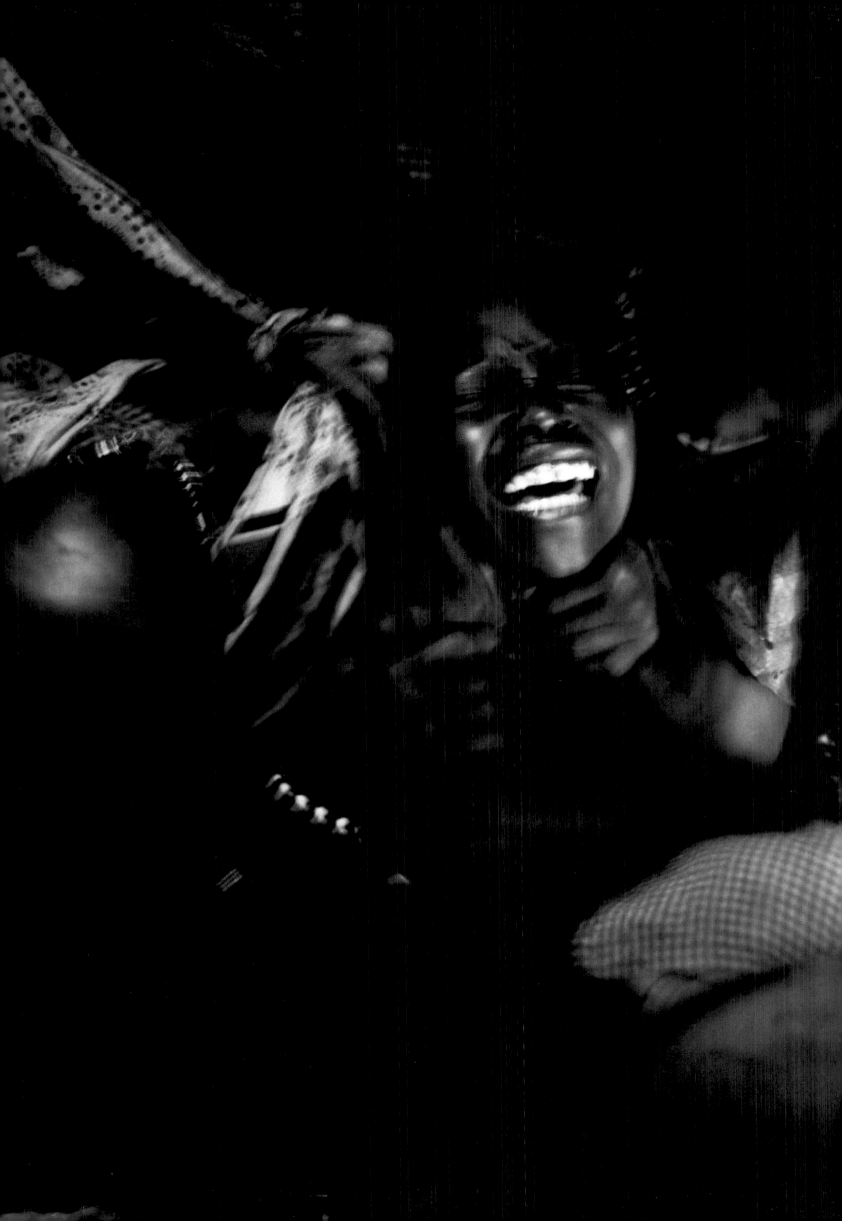

RECOVERING FROM CIRCUMCISION

OVERLEAF

NAIPENDE'S HOME AFTER HER CIRCUMCISION
Branches mark the entrance of Naipende's home so that passersby
will know a circumcision has taken place.

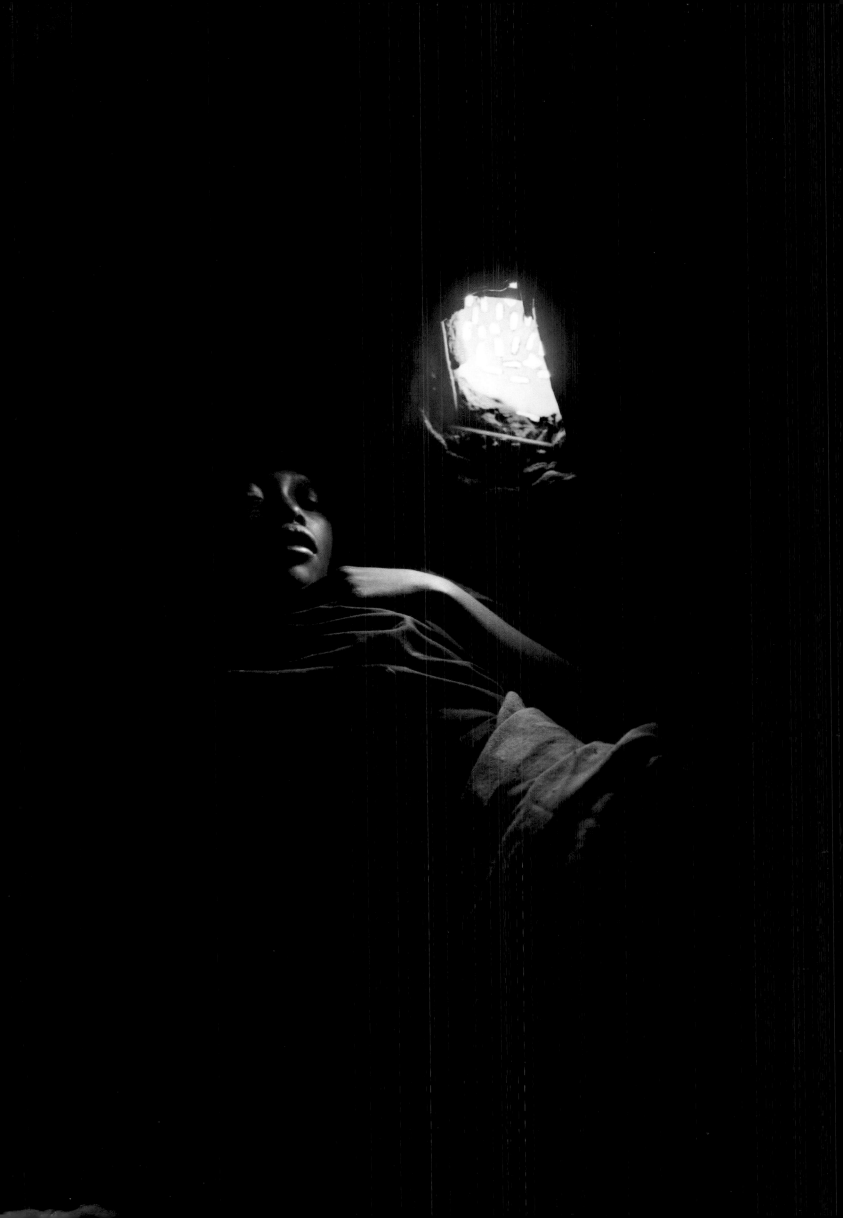

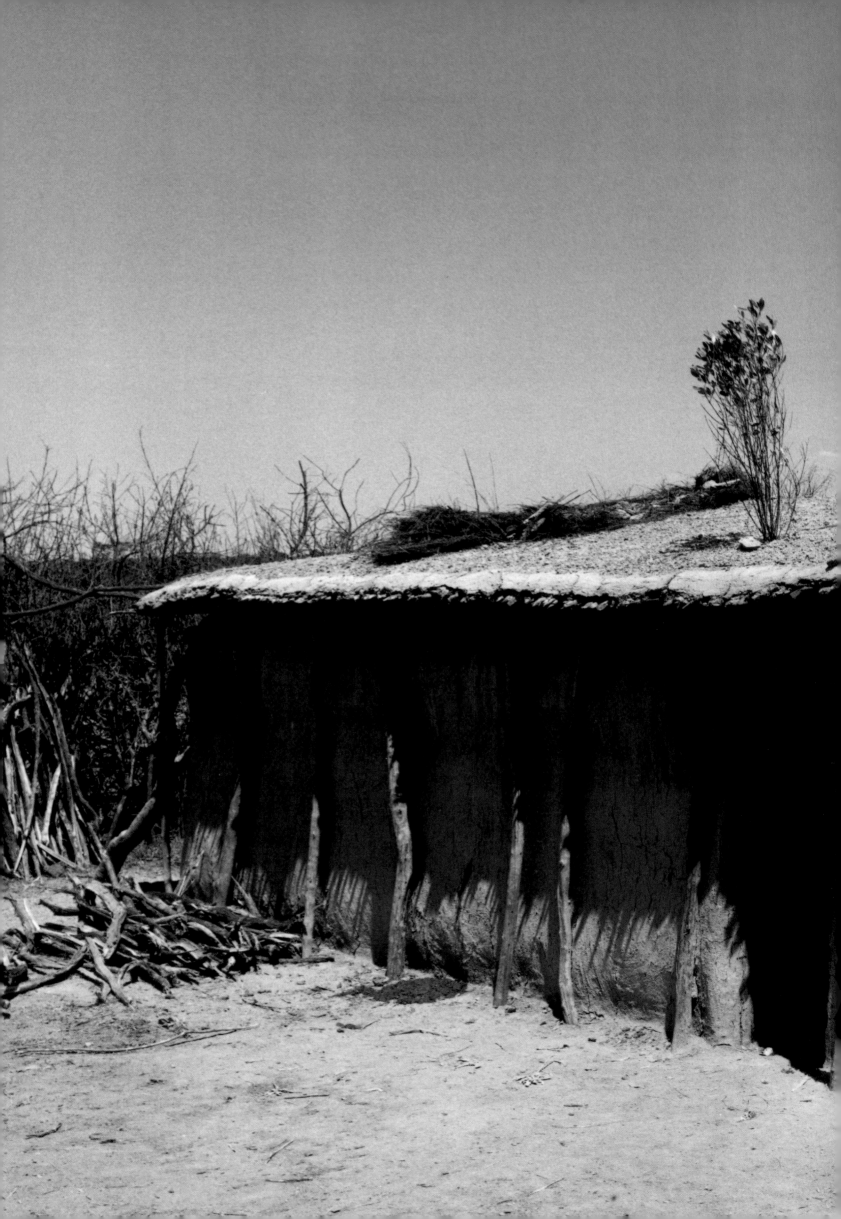

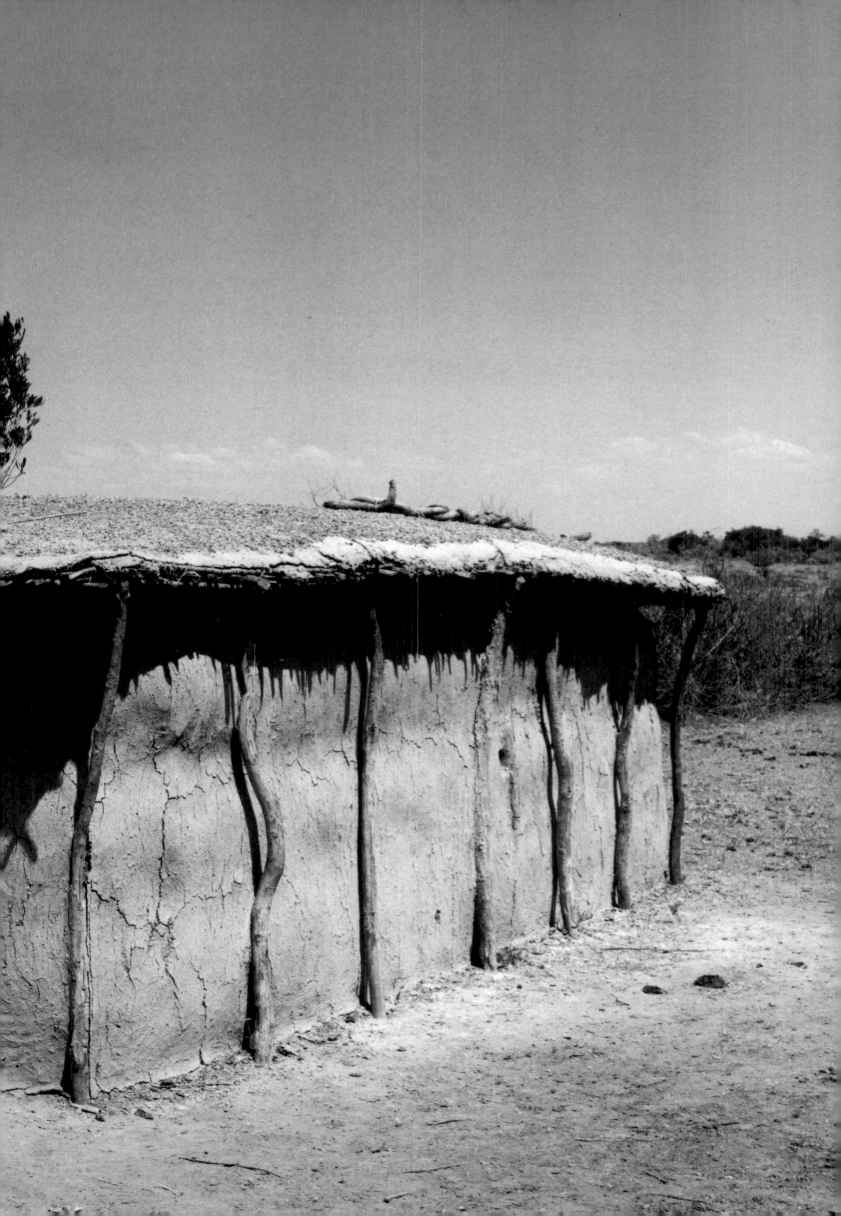

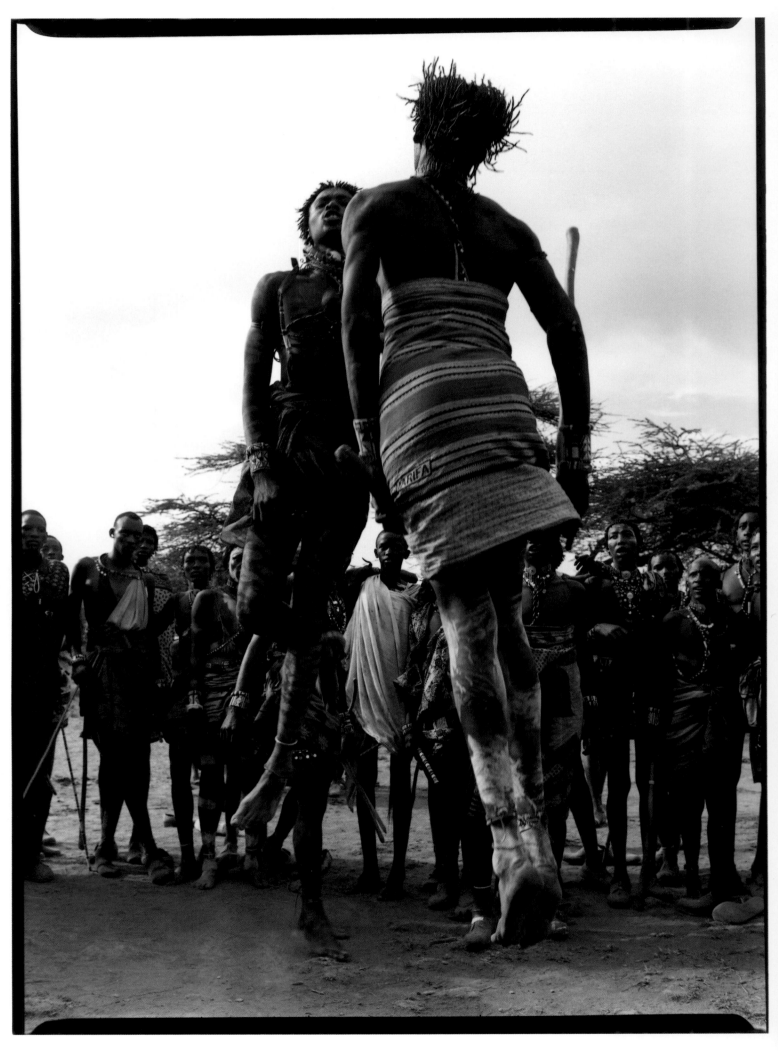

LEAPING WARRIORS
Warriors dance inside a circle, each attempting to jump as high as
possible before a crowd of impressed onlookers.

WARRIORS

The time spent as a warrior was the most exciting period in a Maasai man's life. After being circumcised, the young men were no longer responsible for herding cattle. They grew their hair long and went to the blacksmith to order custom-made spears and knives. They moved from *boma* to *boma* searching for girls, planned raids to steal cattle, hunted wild game, and went on meat-roasting parties in the bush. They were tall, flirtatious, and confident. They were the most beautiful of the Maasai people, in a stage of life when they were heavily adorned with beads and weapons and finely braided hair. In many ways, their military service to the tribe had been rendered obsolete. Cattle raiding and lion hunting were illegal, punishable with a prison sentence. Out in the bush, though, where there were no police stations and security was scarce, the warriors were good to have around. A *boma* was defended if there were warriors in camp.

The warriors were most well known for lion hunting, which I heard happened around the Maasai Mara game park. When stray lions mauled cattle, warriors were dispatched to hunt them down. This was done very discreetly in Kenya, where wildlife conservation was important for tourism.

I photographed the warriors as often as I could in the studio, but they were hard to find. They would drift through camp and loved to ride in the car, thrilled with the sensation of the wind on their faces. Sometimes I gave them driving lessons, the seats packed with warriors and their spears. They sang about love and made up songs about the gearshift, then they would disappear, drifting across the bush for days before anyone would see them again. The best way to photograph warriors was to find an *eunoto* ceremony, the ritual marking their retirement after seven years of military service.

BEETLES

OSTRICH FEATHER
HEADDRESS

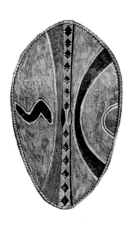

WARRIOR'S SHIELD

Tiampati knew of a warrior graduation being planned in the Suswa Plains just an hour outside of Nairobi. After two months of negotiations with elders, we left Nairobi once again with the car full of equipment—pots and pans, lanterns, tents, film, diaries, notebooks, water, matches, mattresses—everything we needed for the weeklong ceremony. Setting up the tents on the hot Suswa flats attracted visitors from the *manyatta*. The warriors browsed through the boxes of supplies. When they looked at my hair they spat on the ground and said "lion," referring to its length and sandy color. It was generally agreed that their ochered braids were more beautiful, but still they ran their fingers through my hair for the better part of an hour. At night, Tiampati and I tried to cook rice and beans but were besieged by an army of amber-colored beetles that dropped from the trees onto our heads and into pots of food. Children wandered over to look at us. Many had never seen a white person before and were dragged into camp by playmates wanting to gauge their reactions. One nervous girl looked at me and began wailing, becoming so hysterical that they finally had to let her go.

The next morning, more than four hundred warriors gathered in the hills and began their procession to the *manyatta*, marking the start of their graduation from warriorhood. At the head of the procession a young man blew a kudu horn, alerting everyone within earshot that the ceremony would begin. Many of the warriors wore bells that jangled when they walked, filling the bush with the sound of chimes. They had painted their entire bodies with white diatomite chalk, and wore all the jewelry their girlfriends had given them over the years. When the warriors reached the entrance to the *manyatta*, their mothers doused them with honey beer and milk to bless their path and to calm their nerves. But the warriors dropped to the ground, screaming and collapsing in emotional seizures. The most privileged years of their lives were over and they were sad to see them come to an end.

When the Maasai see one another passing into adulthood or leaving their warrior days behind, they weep openly and have fits of grief, convulsing in seizures, foaming at the mouth, screaming in short breaths, even collapsing in the dirt. Something will trigger it—the sight of boys gathered to be named a new age set, the procession of retiring warriors, the memory of lost children aroused at fertility blessings. Emotions are high at ceremonial occasions and dozens of people may faint at once.

Members of an older age group who had come to watch the ceremony also convulsed with grief. One raised his *rungu* high in the air and screamed at the procession, "You are not the only beautiful ones! We were warriors once too! We were brave and beautiful so you are not the only ones!" He then fell into the dust, was gathered into the arms of his friends, and wept.

Boys from a nearby school came to watch the ceremony and stood on the sidelines wearing pants and white button-down school uniforms. They seemed wistful,

watching all the beauty and ritual they had missed, but also arrogant, reminding themselves it was better to be civilized. Later, an enormous truck filled with missionaries arrived. They pitched a flock of brightly colored tents next to the *manyatta* and scrambled to take pictures of the warriors. After so long preaching to the Maasai about the sins of their customs, it seemed strange to now be coming to admire the very culture they were trying to dismantle.

Warriorhood was not popular with everyone. Missionaries were eager to see the Maasai dispense with old customs that hindered their conversion to Christianity, and many modern Maasai were abandoning the culture in favor of education. It was impossible to be both a full-time warrior and a full-time student, and many boys were struggling to make the break for civilization. James Mpusia, a student I befriended and sponsored over the years, was one of these. When we met, he was sporting a halo of dead birds, which meant he was recovering from a circumcision. This had been performed over his school holidays, and he was eager to get back to class and finish his studies. But whenever the warriors caught him walking in the bush, they tried to kidnap him. That was how they recruited and increased their numbers. James was very worried.

"When I get out from school, oooh! There are those thugs who are just moving in the forest. They say, 'That boy from Mpusia's family, nowadays he is not in school so we must attack him.' It's the *wazee,* the old men, who tell those warriors where I am. I can't even relax at home because I can even be attacked there. Just while I am minding my business and enjoying my tea. They are very serious about it. They will be following you wherever you move. When you are going to the shops, those warriors will follow you and you cannot see them. You only know once you find yourself kidnapped! If you use your tactics to try and escape, you are nowhere. They will kill you."

To look at him, one would never imagine that James was a student. Aside from his headdress, he was wearing the traditional plaid *shuka,* decorative coils of copper on his head, a few beads around his neck, and he was carrying a toy set of bows and soft-tipped arrows, which were designed for flirting with girls in a game of Cupid. When circumcised boys saw a girl they liked, they shot a pretty, beaded arrow at her. On his feet, James wore two slabs of tire shreds with an open-toed slipper on top. He was enjoying his time off—the ceremonies, the young girls, the meat-roasting —but once he had safely passed through his circumcision, he was finished with the culture. He wanted to become a pilot.

"When you are a warrior you just waste your time for nothing. You are in danger at all times. You can be killed by a lion and you can be killed by people when you are in a war. You know, a lion is not a joke. The warriors go for the hairy ones and you can easily lose your life in that practice. So it's better for me to go to school and

FLIES

IVORY
SNUFF BOX

CHAIN NECK
ORNAMENT

continue my education. I am more civilized than they are. But the old *wazee* don't like people who are civilized. When they see that you are breaking away from the culture, they don't want you. In my culture they send the people they do not like to school and they keep the ones they love at home. Once you are educated, they hate you. So when you see people in the Maasai community who are educated, they are hated by their families. I'm not really missing the culture. When you follow this culture you are just lost like a sheep."

Maasailand was slowly going the way of the pen. At the end of the *eunoto* ceremony, the warriors walked a bull to the top of a nearby hill and slaughtered it in the shade of the forest. Hundreds of warriors lined up to drink its blood, mixed with honey beer. The mothers shaved off the warriors' long hair, and as their braids fell to the ground the warriors held their heads low and cried again.

There was not a single lion mane worn at the *eunoto,* suggesting that the celebrated Maasai practice of lion hunting had passed into history. The warriors would now return to their homes, bald-headed and sad, retired from their life of privilege. They would marry and have children and build herds of their own. The ceremonies continued but they were changing too. A few years later I witnessed an *eunoto* for school students who had never even been warriors. Their parents had hoped to keep them in touch with the culture, even if just in a perfunctory way. There would not be another *eunoto* in the area for seven years and it was hard to imagine where the Maasai would be then.

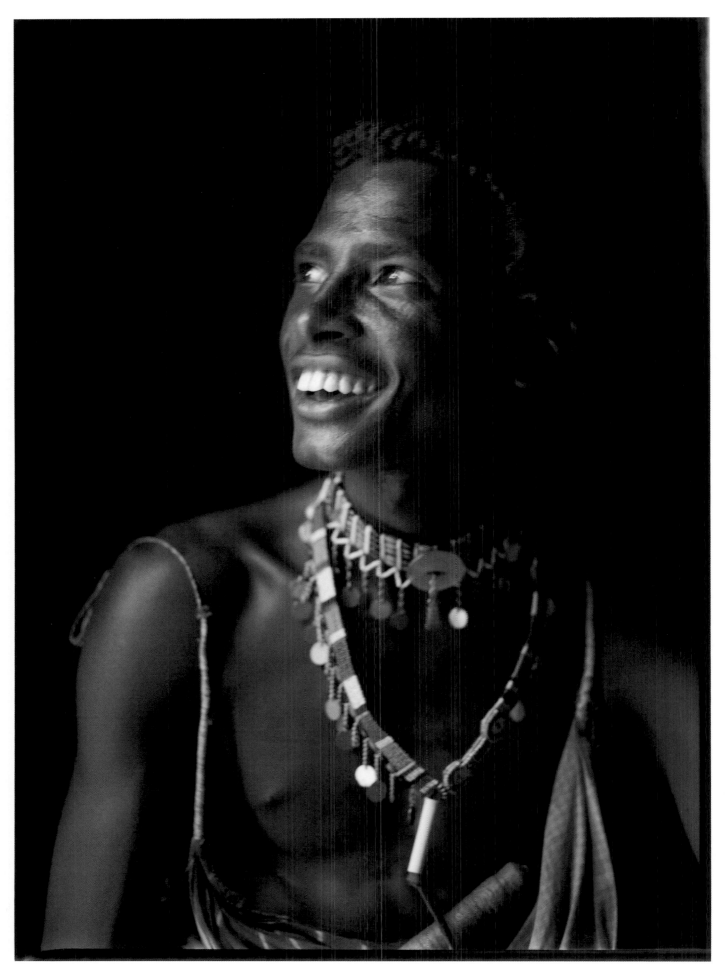

WARRIOR AT THE EUNOTO

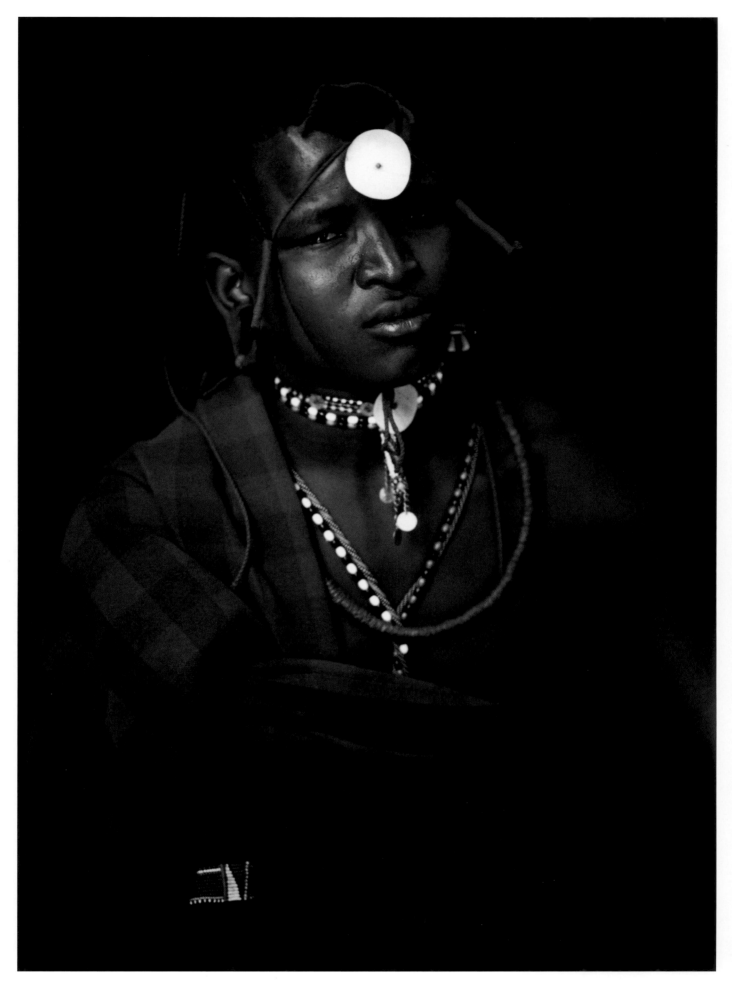

KUMOK NKISHU OLE KISHIKH

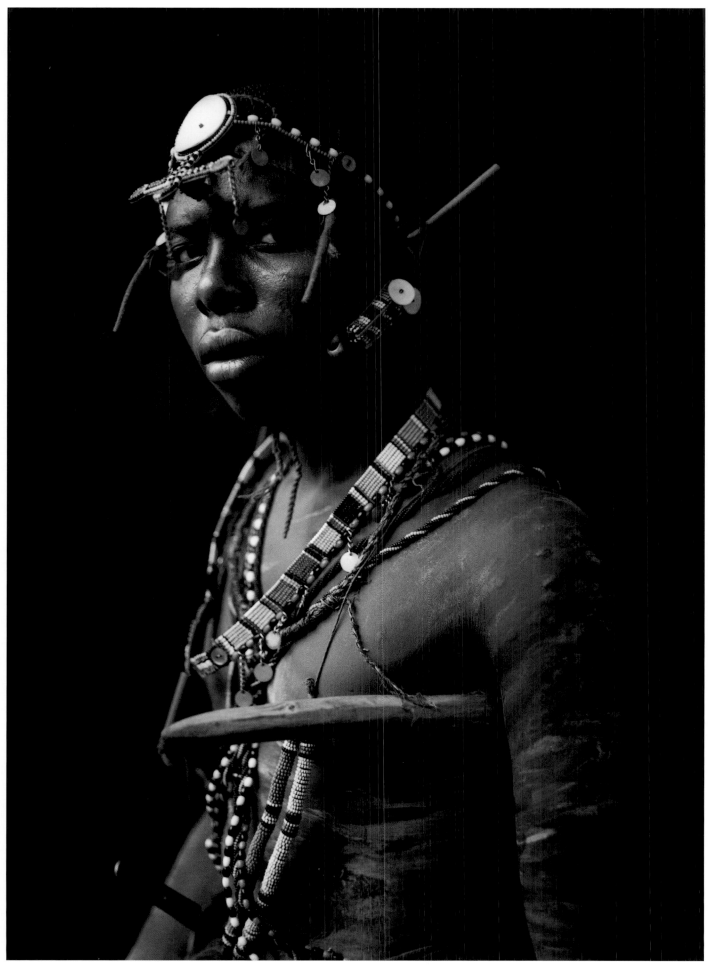

SIMANKA OLE DUKUMY

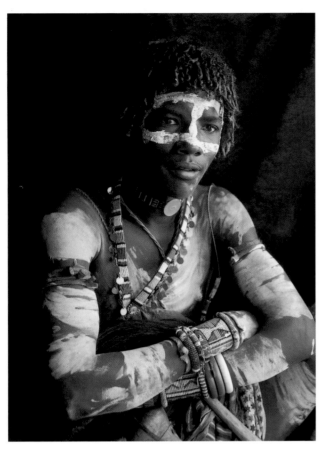

WARRIOR PAINTED WITH DIATOMITE

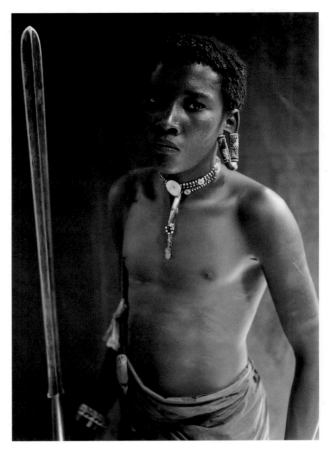

MOLONKO OLE PUTAINY

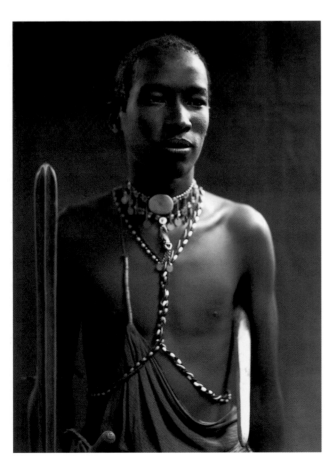

SANKAU OLE SHONKO

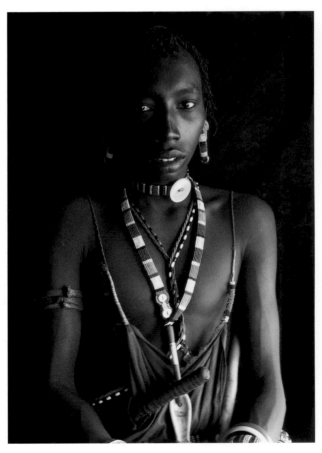

WARRIOR AT SUSWA

118

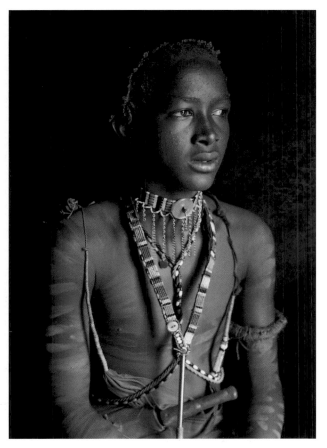

WARRIOR WITH OCHER IN HIS HAIR

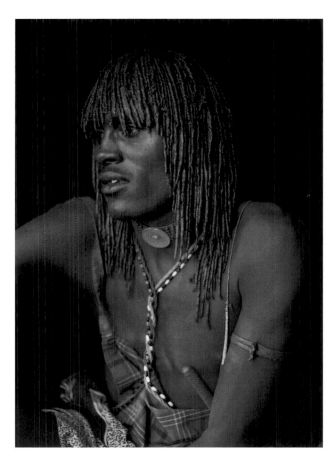

WARRIOR AT THE EUNOTO

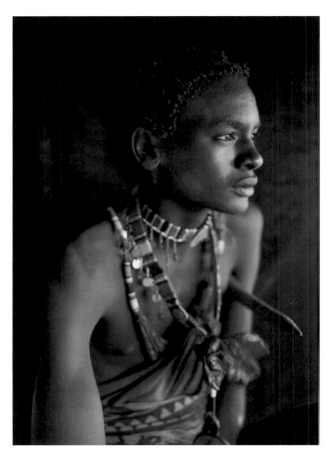

WARRIOR CARRYING A RUNGU

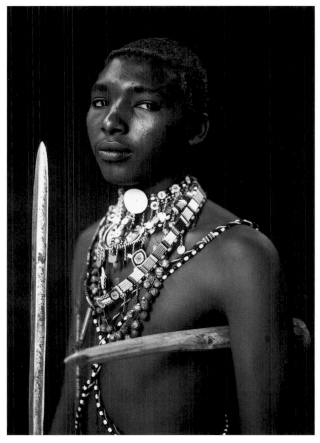

LENKOKOIYA OLE NKIMINISI

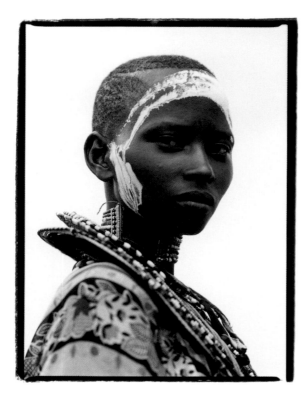

LOVE SONG FOR A WARRIOR

We will kiss the warrior to the mouth!
He has ambushed a home with the presence of a car,
Ole Medidiki ambushed with courage!
With the help of the sword he has brought us the herd,
If the women don't praise the warrior,
I will do it alone, knowing what I have.

PROCESSION OF WARRIORS AT THE EUNOTO
At the start of the graduation ceremony, four hundred warriors
march in single file to the ceremonial *manyatta*.

OVERLEAF

WARRIORS MARCHING TO THE MANYATTA

FOLLOWING PAGE

WARRIORS ENTERING THE MANYATTA
As warriors enter the *manyatta* they are greeted by their mothers, who douse them with
honey beer to keep them calm. Saddened to see their warrior days coming to an end,
the graduates are stricken with emotion. Many cry, hyperventilate, and foam at
the mouth before collapsing in a state of emotional seizure.

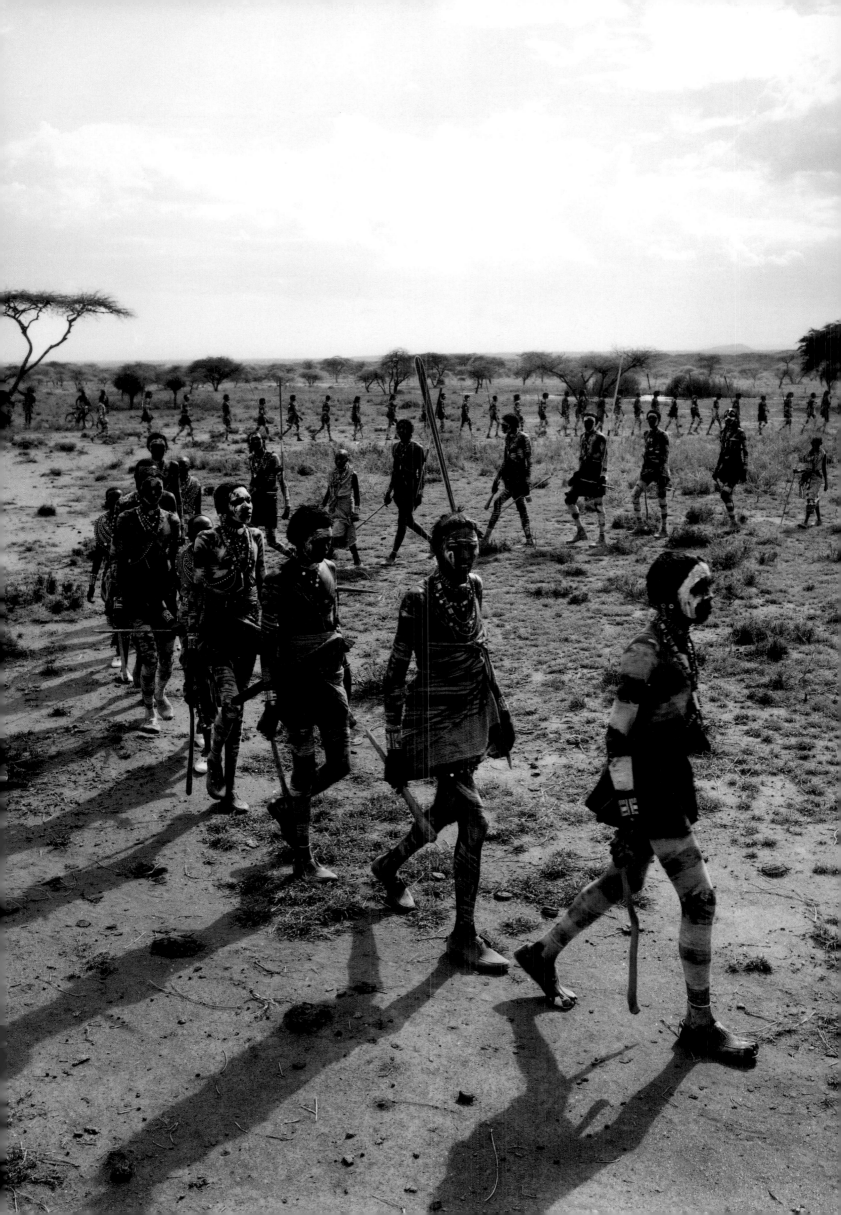

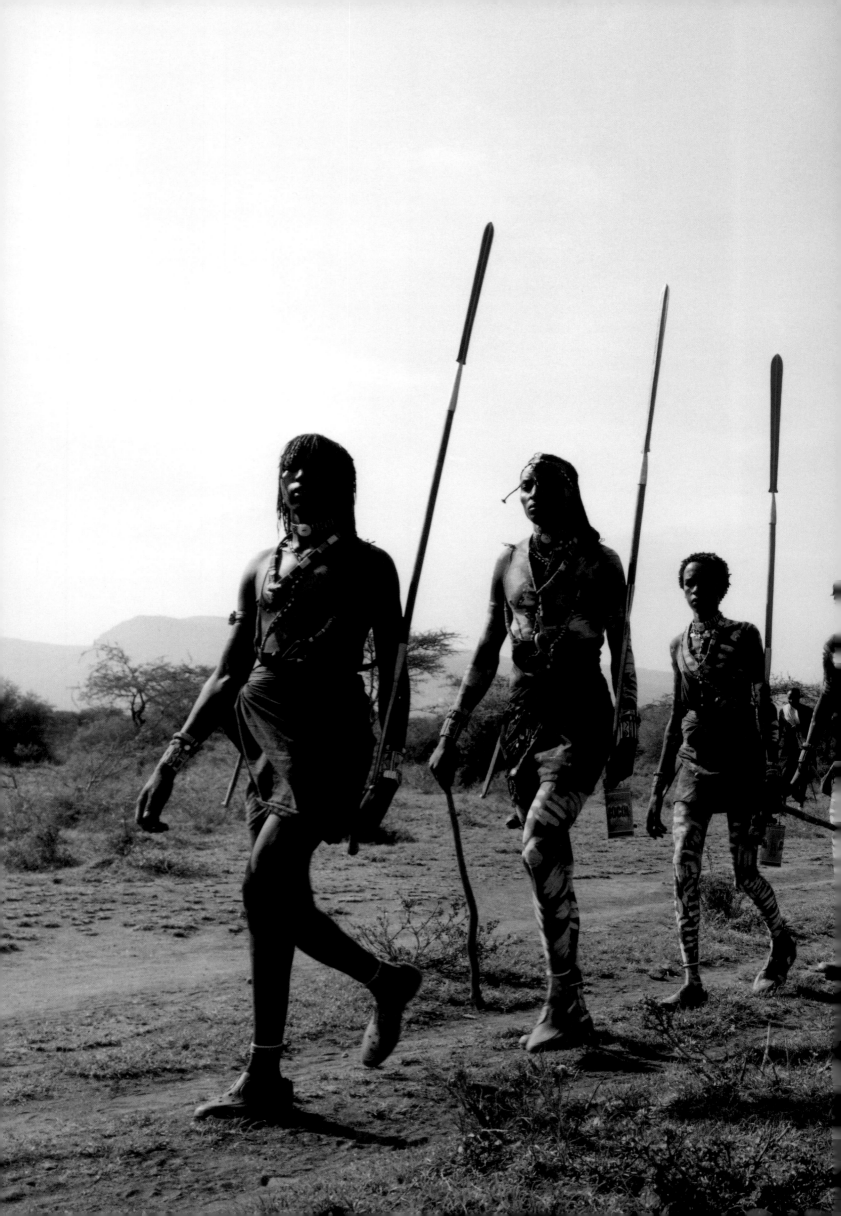

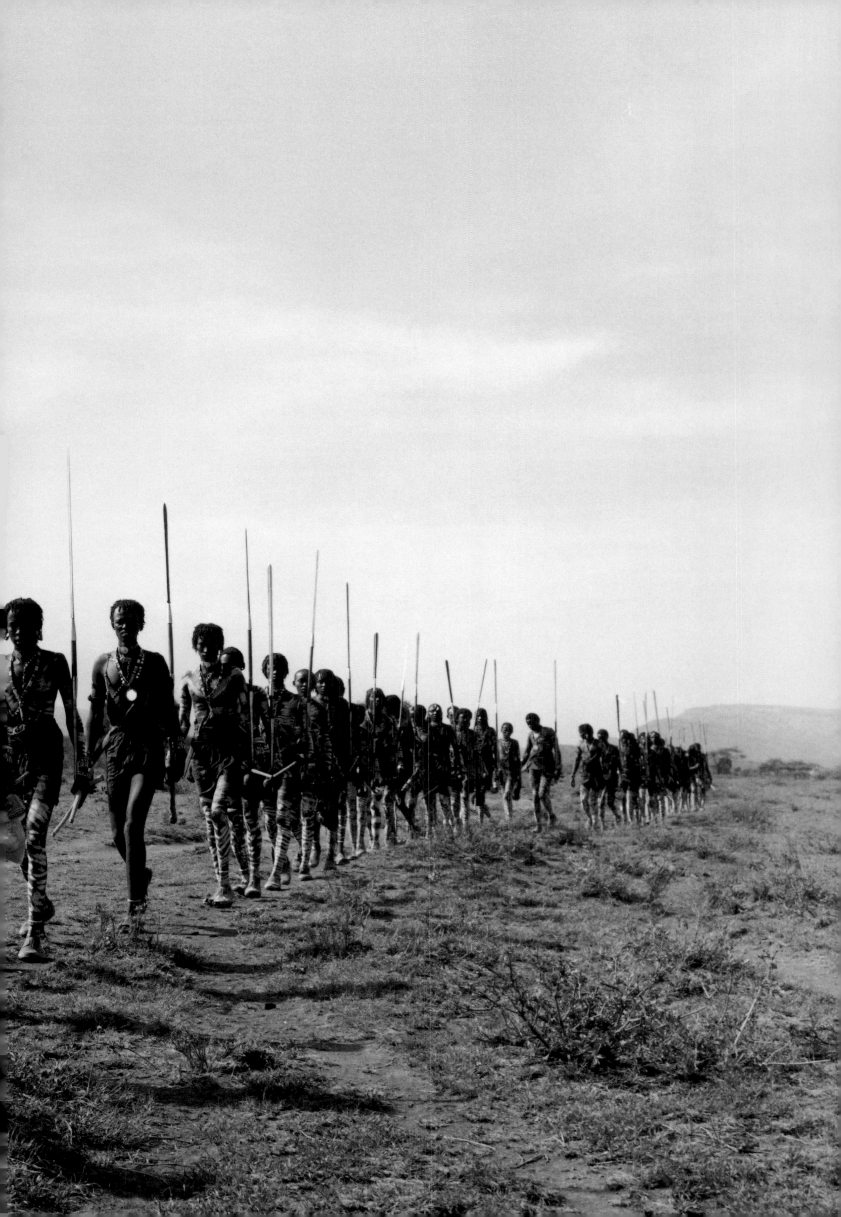

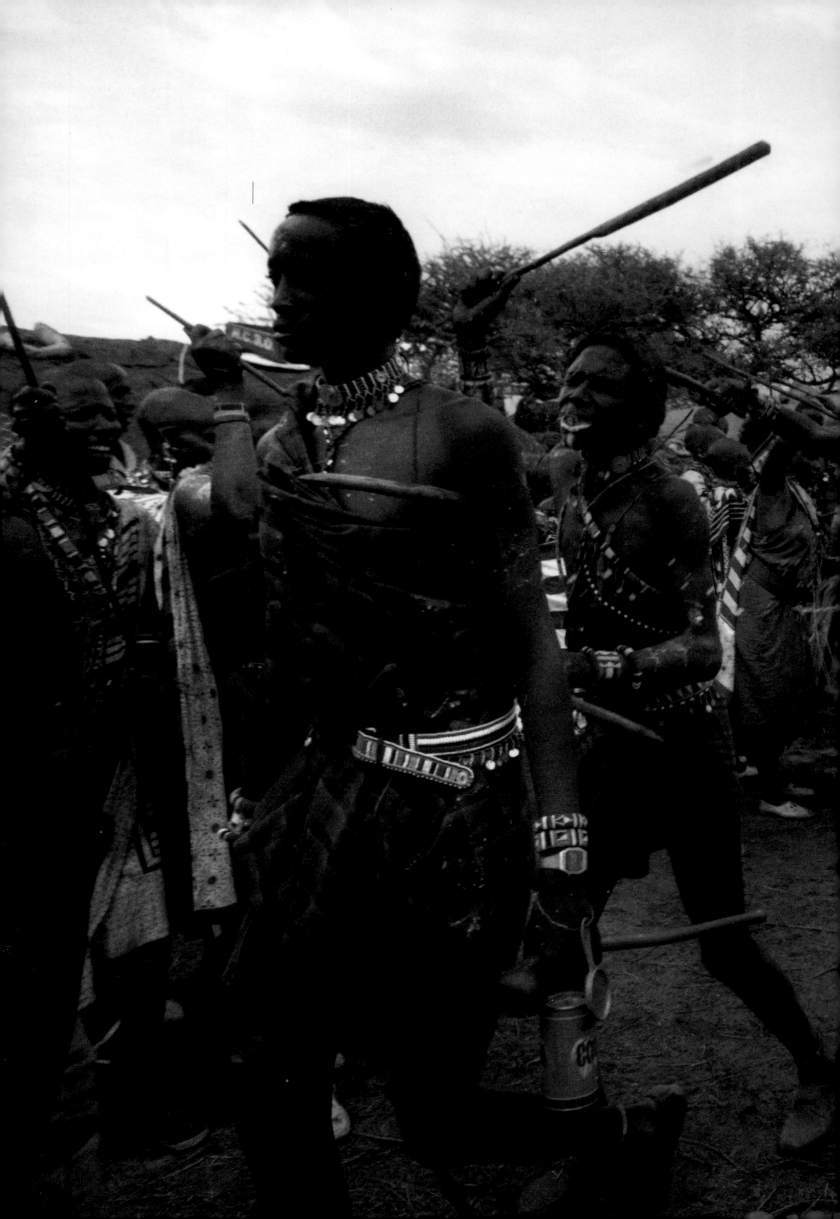

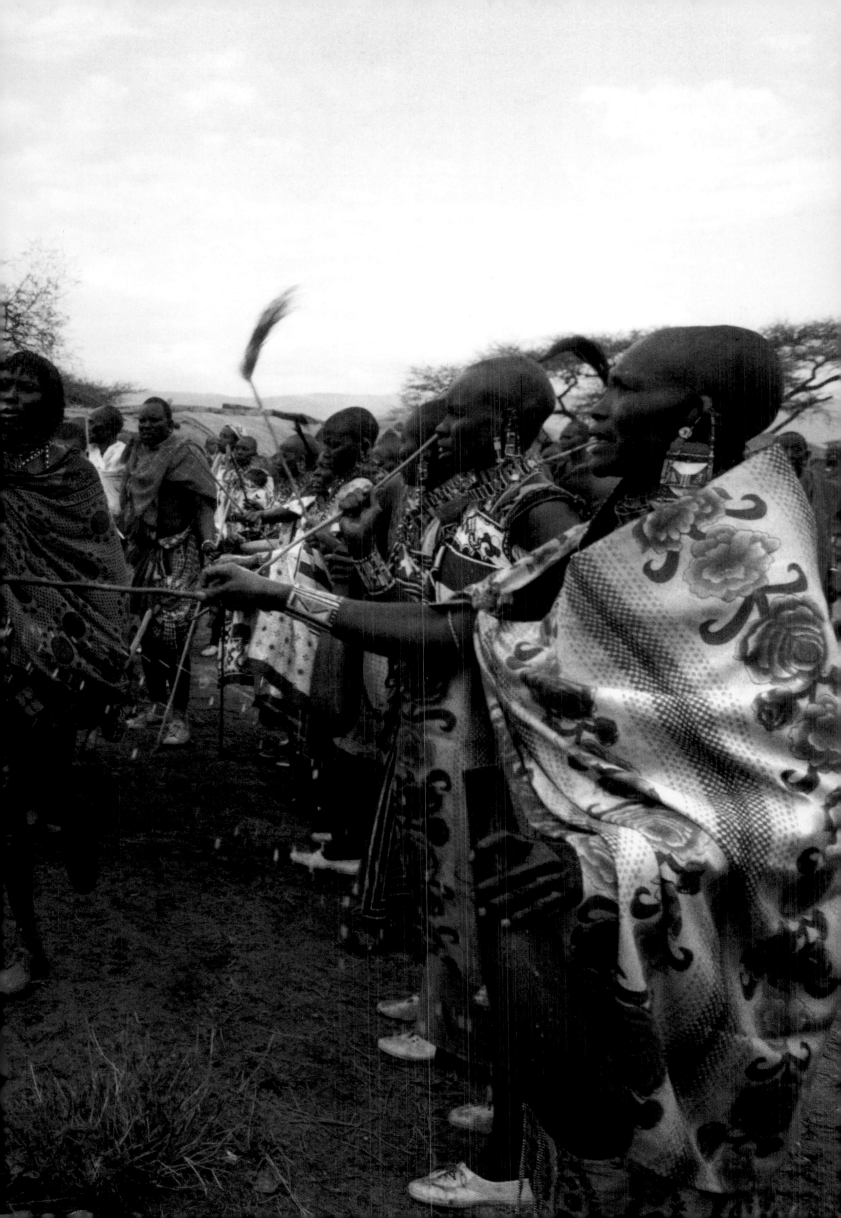

WARRIOR SONG

It has been all day trying to remove the arrows from the body of the warrior,
The warriors have raided so many white cows that the boma does not need firelight,
The moonshine on the white cattle's backs lights the village,
Nice Loita girls greet the warriors after the raid,
If I come back with cows after a raid may I sleep with a girl of my age group,
They have used all their arrows to kill their enemies,
Others can only be shot with headless arrows,
The warriors with ostrich feathers kill a man with a gun,
Because we never give back what we raid,
We have released our toughest warrior to come to you, you people with uncut ears,
He is so tough that he goes to the village and leads the rest to get the cows,
The bush makes a bullet sound,
And after the battle the enemies are running away.

EMOTIONAL SEIZURE OF A WARRIOR
A warrior foams at the mouth before collapsing in an
emotional seizure at the start of the ceremony.

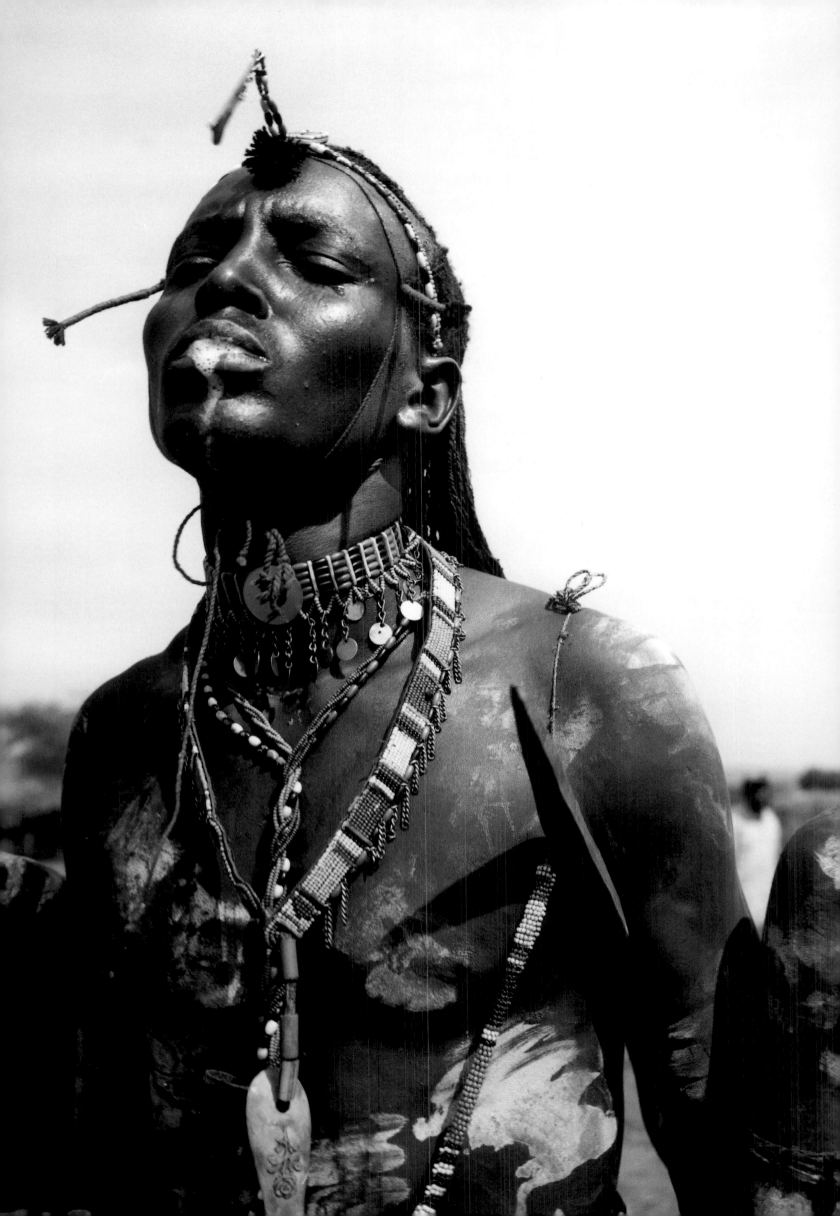

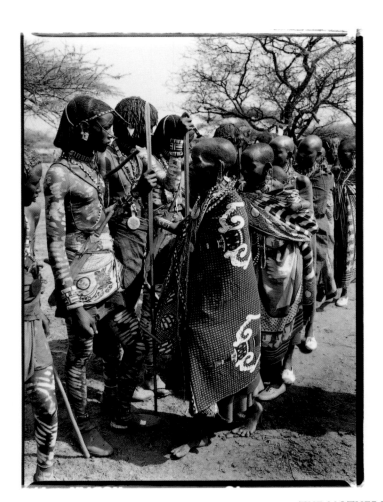
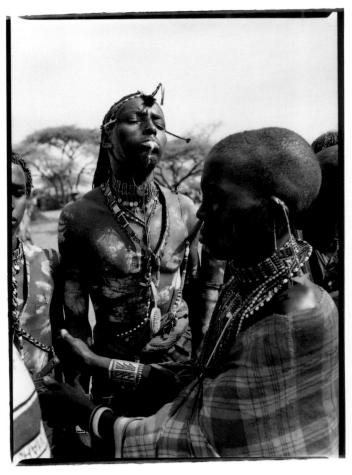

THE MOTHERS' GREETING

Warriors form a line to be welcomed to the ceremony by their mothers. This powerful moment is the first of their many farewells to warriorhood throughout the week.

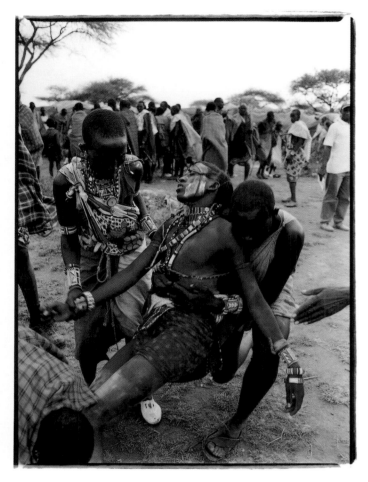

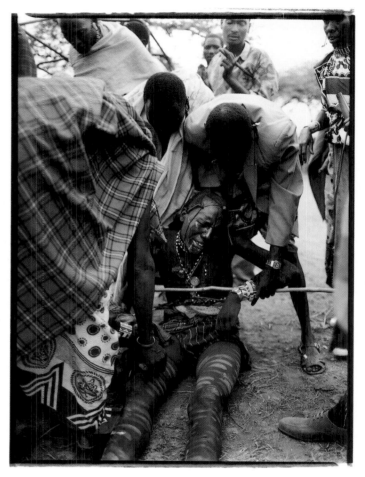

EMOTIONAL SEIZURE
Overwhelmed by the gravity of the ceremony, the warriors collapse in emotional seizures and are soothed by family and friends.
These spells last for approximately fifteen minutes, after which time the warriors are calmed and can rejoin the event.

OVERLEAF

WARRIORS DANCING THROUGH THE MANYATTA
Throughout the weeklong ceremony, warriors parade through the *manyatta,* singing and dancing before the crowd.

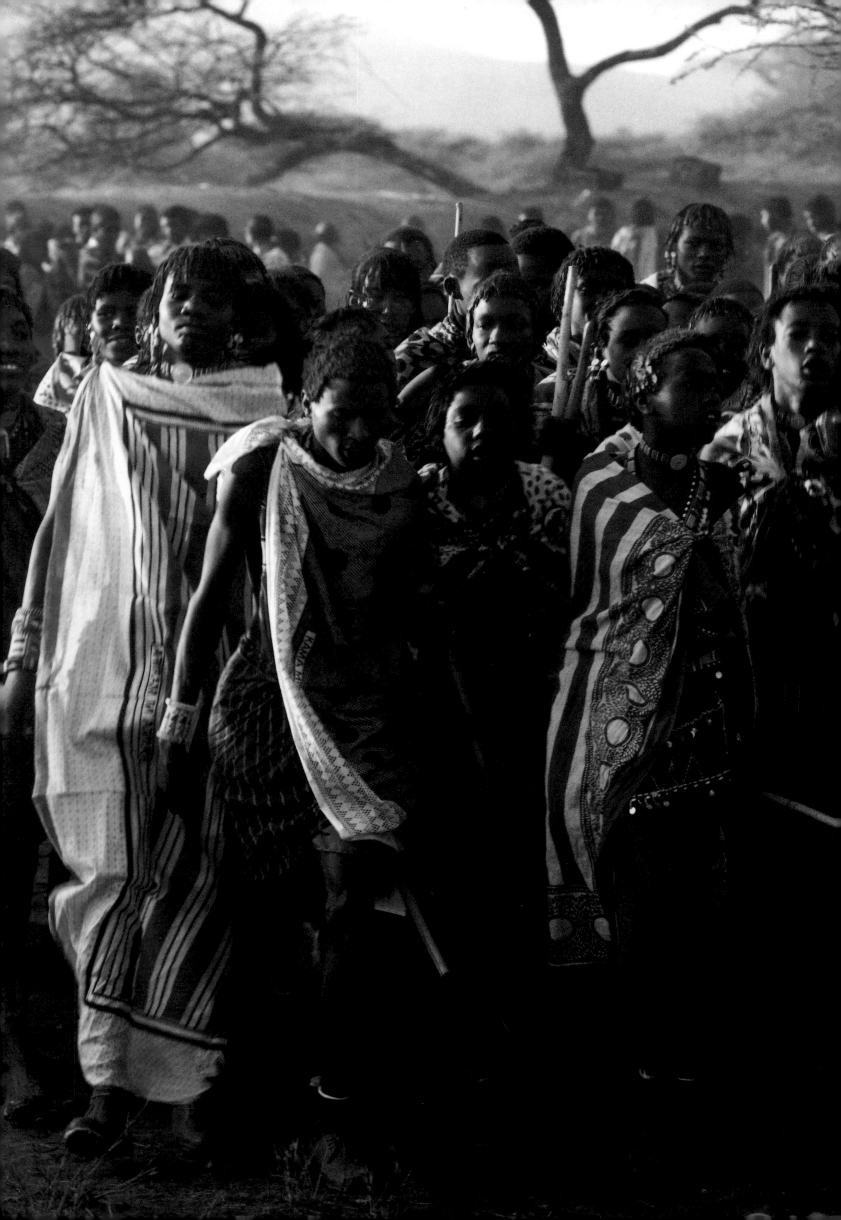

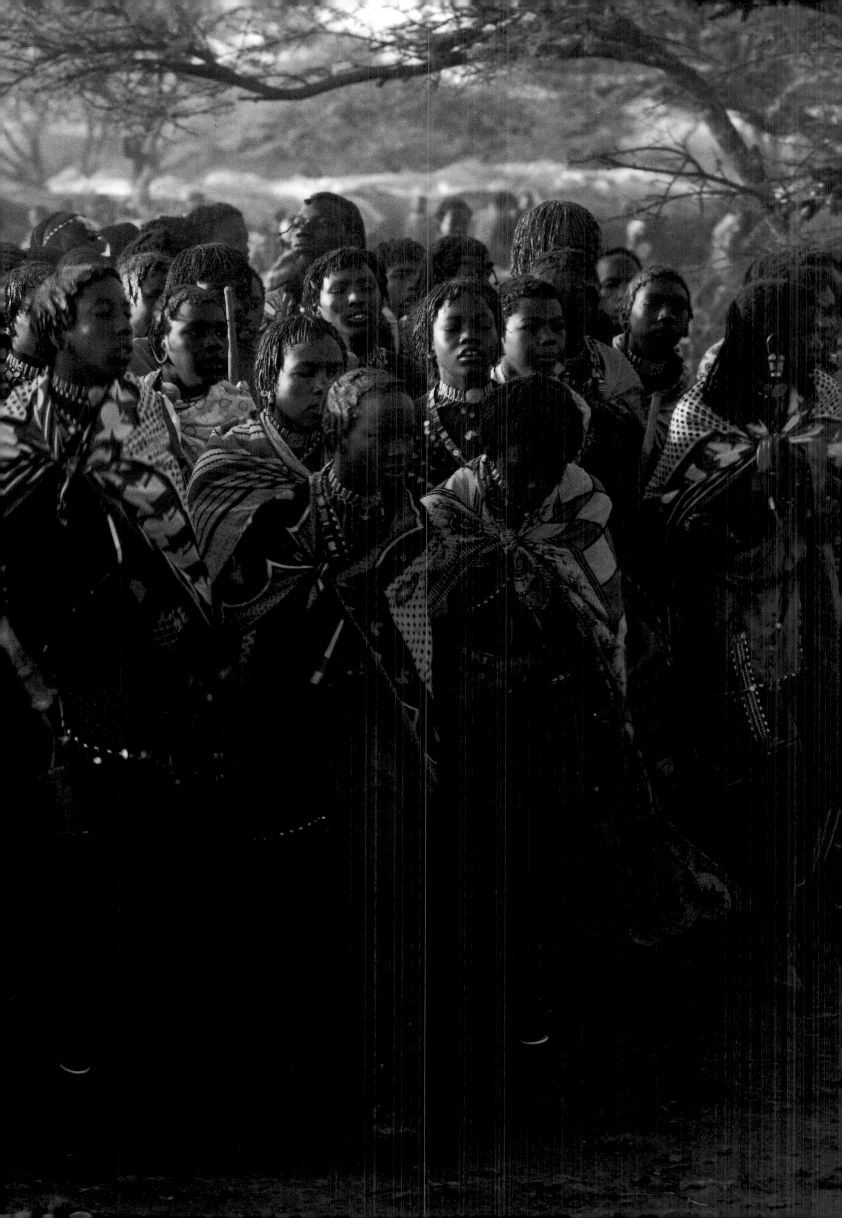

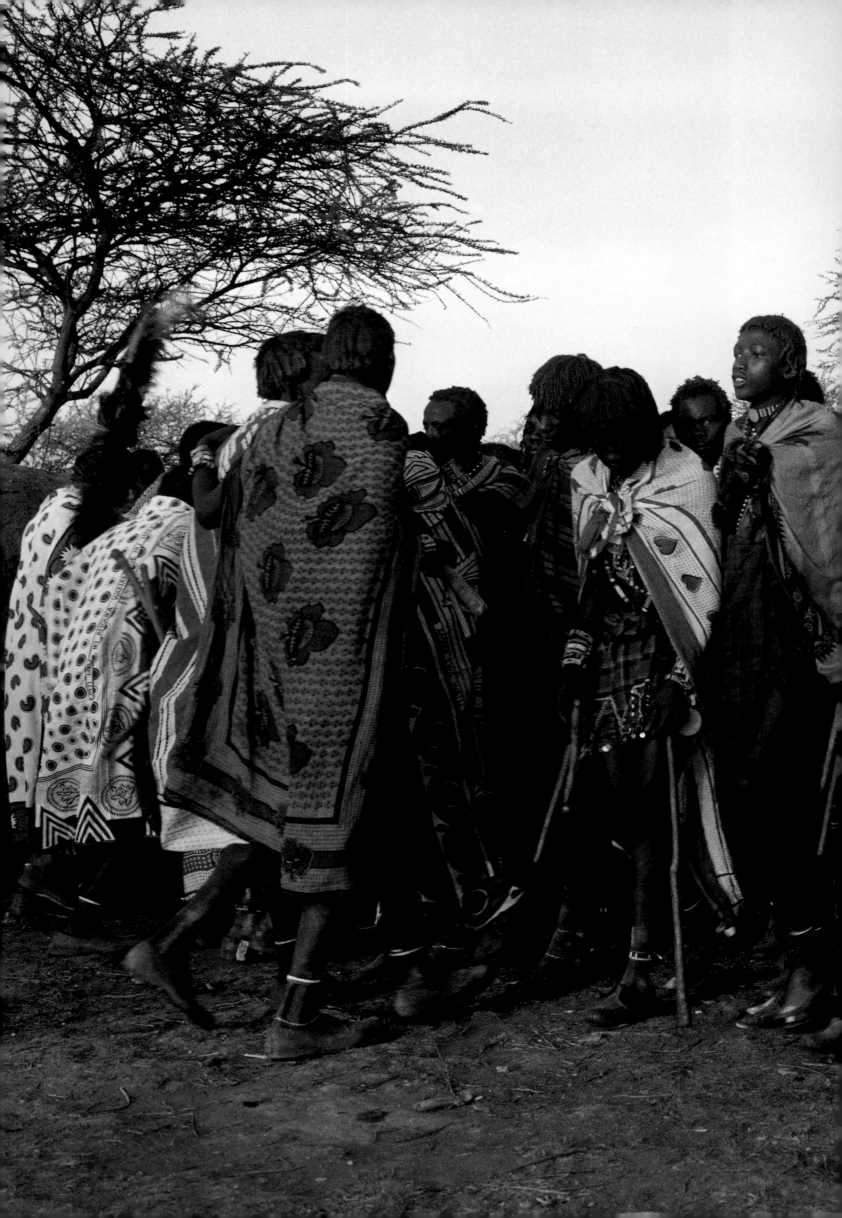

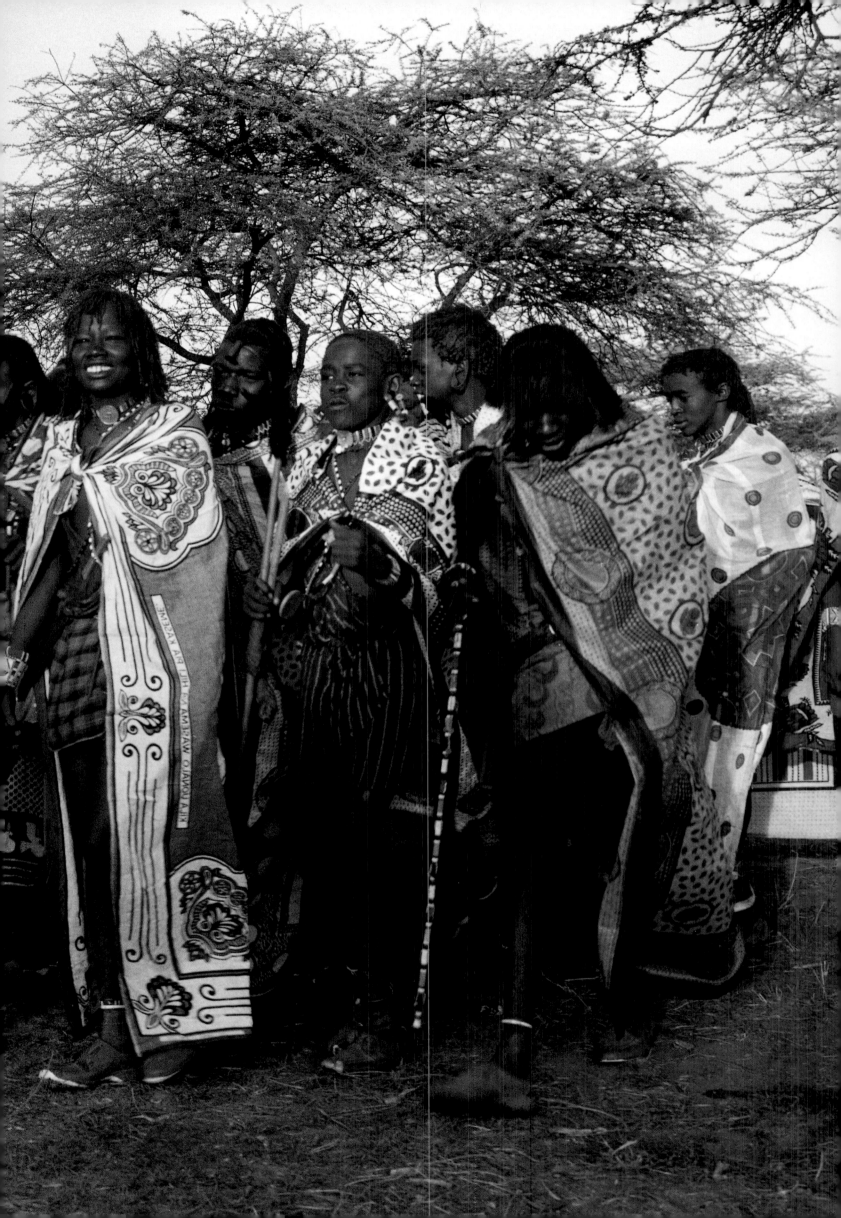

WARRIOR BLESSING

Greetings heavenly dawn!
I come here, the blessed of the blessed, still resting beneath the tree.
No wild animals or vultures' wings will tamper with us.
No rhino horns or sharp spear heads will separate us.
I pray for prosperity
Let it come to us in slow, uphill motions.
Let it come to stay.
Wild beasts and vultures hush — your expectations were not met.
for we are still alive.
Bless us with babies and cows,
on the slopes and on the plains,
when we search and when we don't.
Give us prosperity by surprise.
Keep us until the wrinkles of old age.
Good-bye heavenly dawn,
until tomorrow when we shall meet again in peace
and in the golden rays of prosperity.

WARRIOR BLESSING
In a form of blessing, a warrior sips from a cow dung trough filled with honey beer and herbs, filling his mouth
with the liquid before spitting it out. Graduates receive blessings from elders throughout the week of the *eunoto*
ceremony, cleansing them of bad luck as they make a fresh start in life as junior elders.

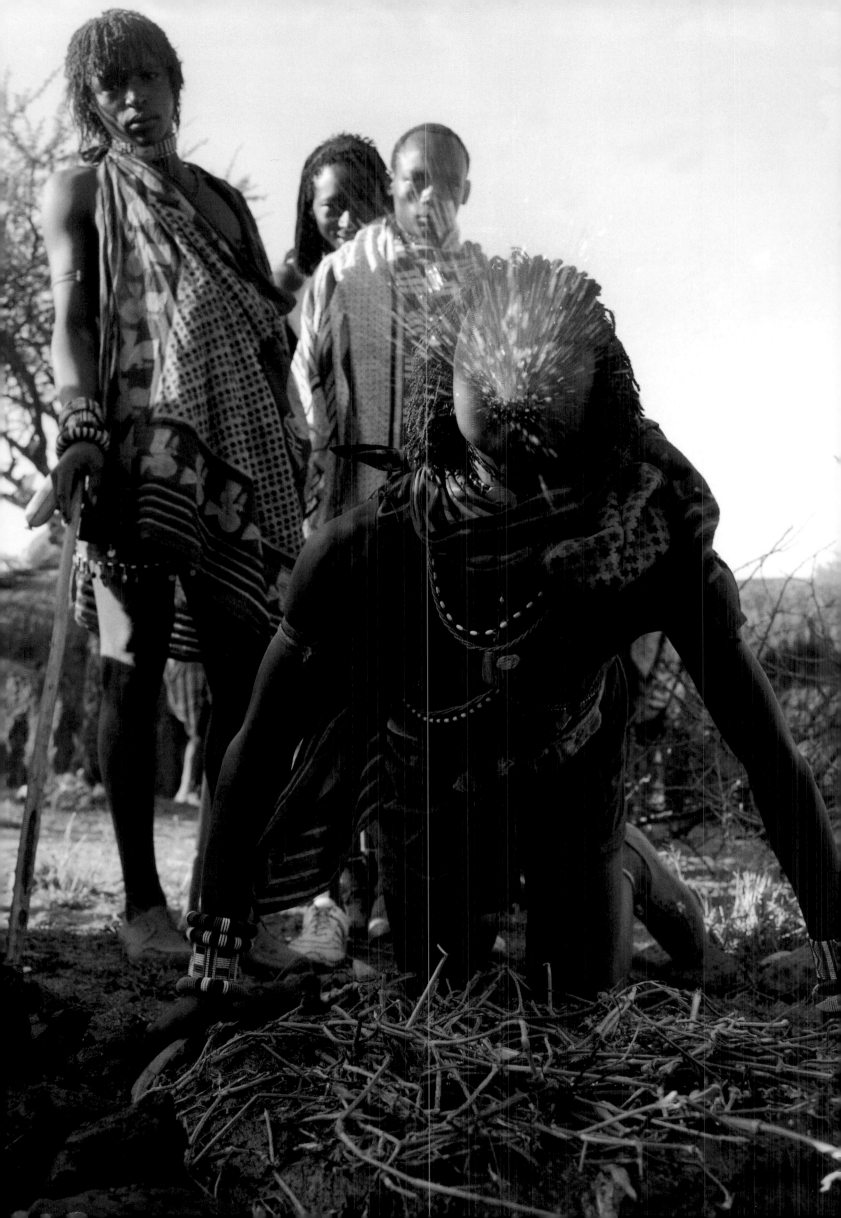

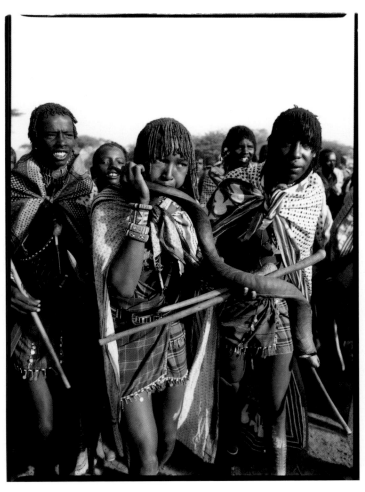

CALL OF THE KUDU HORN

The repetitive tones of the kudu horn are sounded in celebration to alert members of the ceremony at the start of the events.

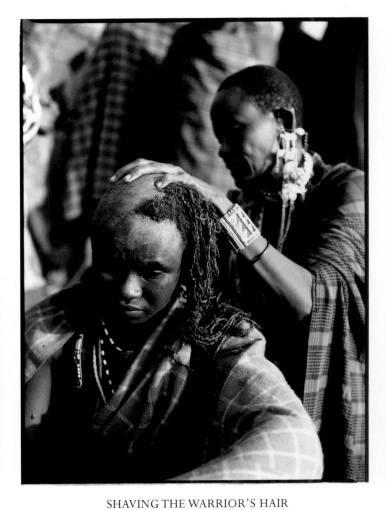

SHAVING THE WARRIOR'S HAIR

Warriors are the only members of the Maasai community to wear long hair, which they often weave in thinly braided strands. This is considered extremely handsome and the warriors decorate their hairstyles with beads and metal medallions. At the end of the graduation ceremony, their mothers shave away these long braids, removing the symbol of their warriorhood as the young men retire.

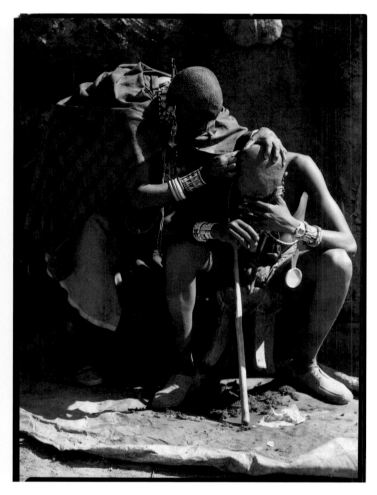

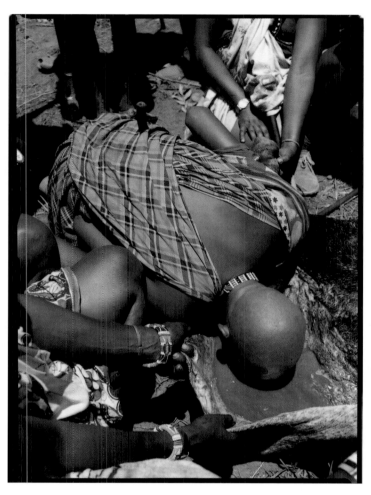

PORTRAIT OF A SHAVEN WARRIOR
The last braids are shaved from the warrior's head to signify a fresh start.
This is a sad moment for the warriors who grieve over the end of their
years of freedom.

DRINKING THE BULL'S BLOOD
At the end of the *eunoto* ceremony a bull is slaughtered for the graduat-
ing warriors. Each member drinks a mixture of the blood and honey beer
before the meat is roasted for a feast.

OVERLEAF

BLESSINGS FROM THE ELDER
A community elder spits a brew of honey beer on each
of the retired warriors as a blessing before the end of the ceremony.

FOLLOWING PAGE

FINAL GATHERING OF WARRIORS
Graduating warriors gather in the *manyatta* for final prayers and
blessings before departing from the ceremony to begin life as a junior elders.

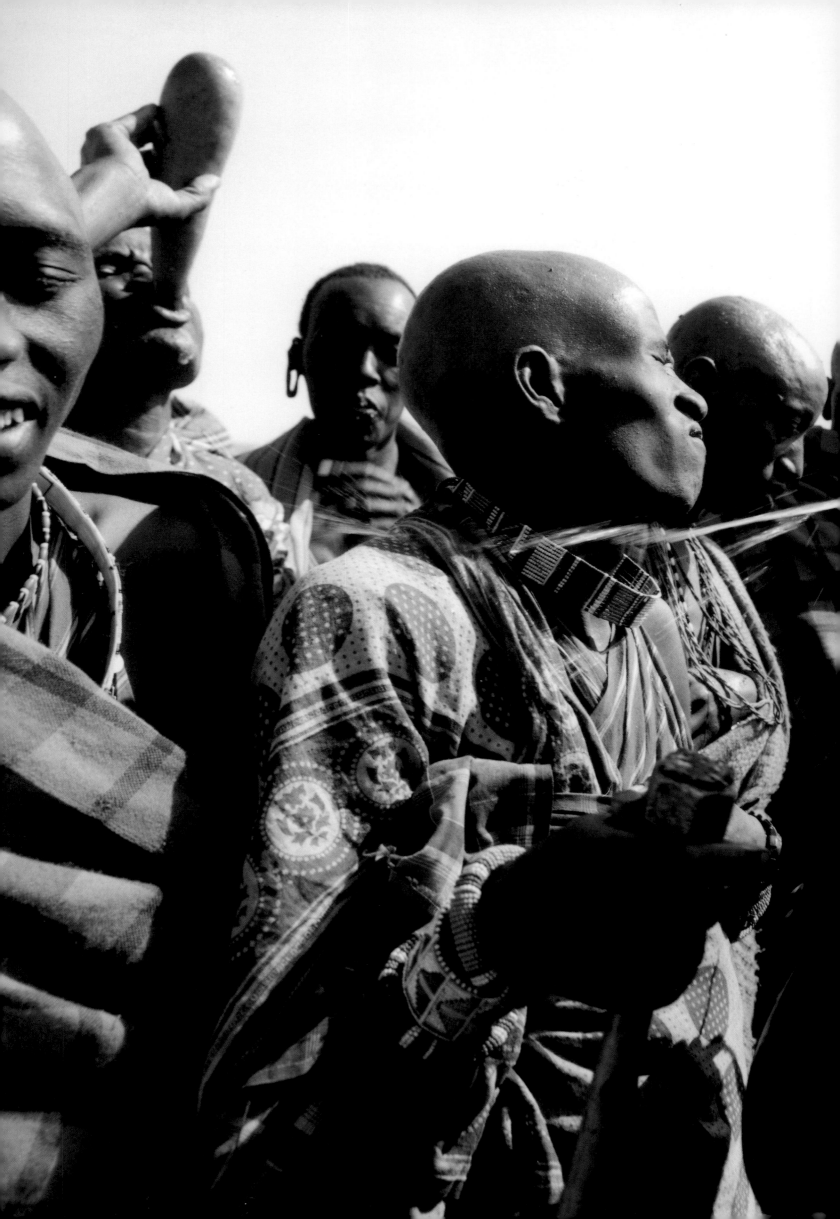

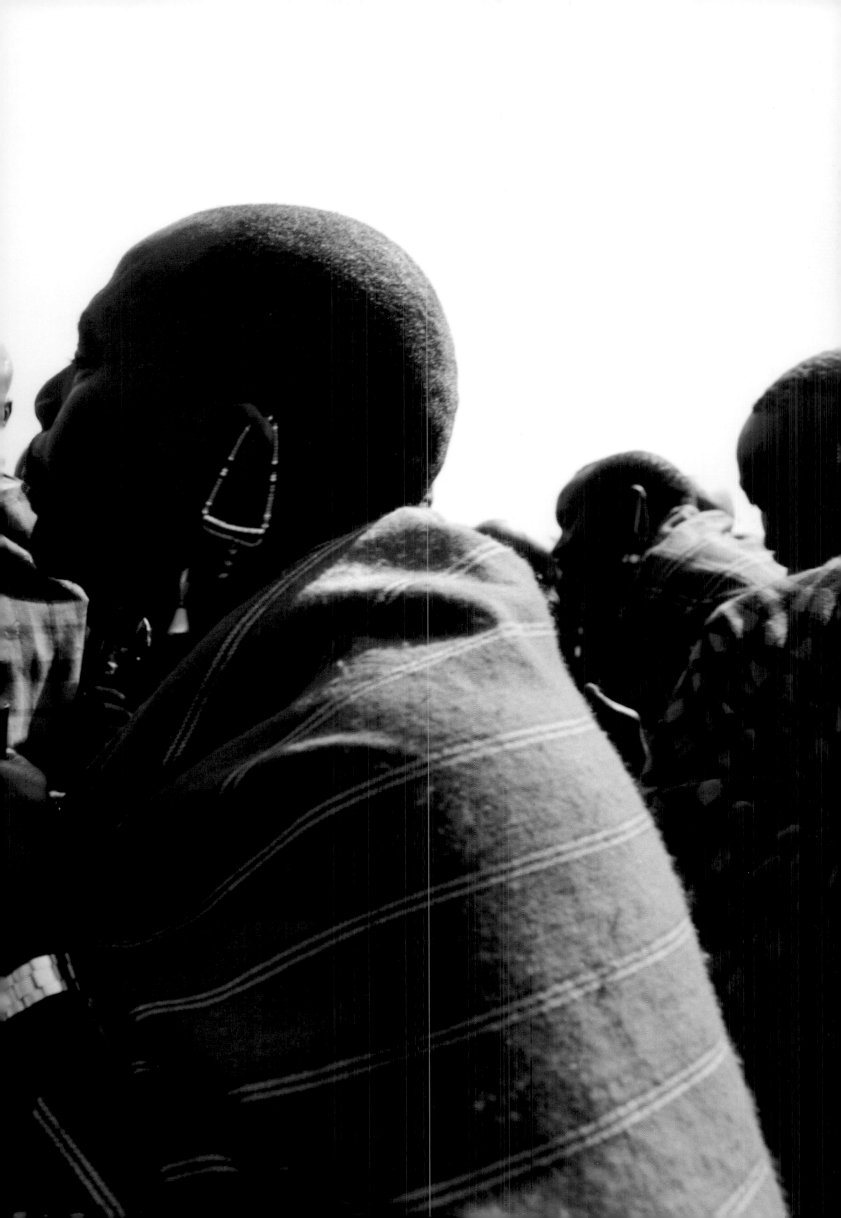

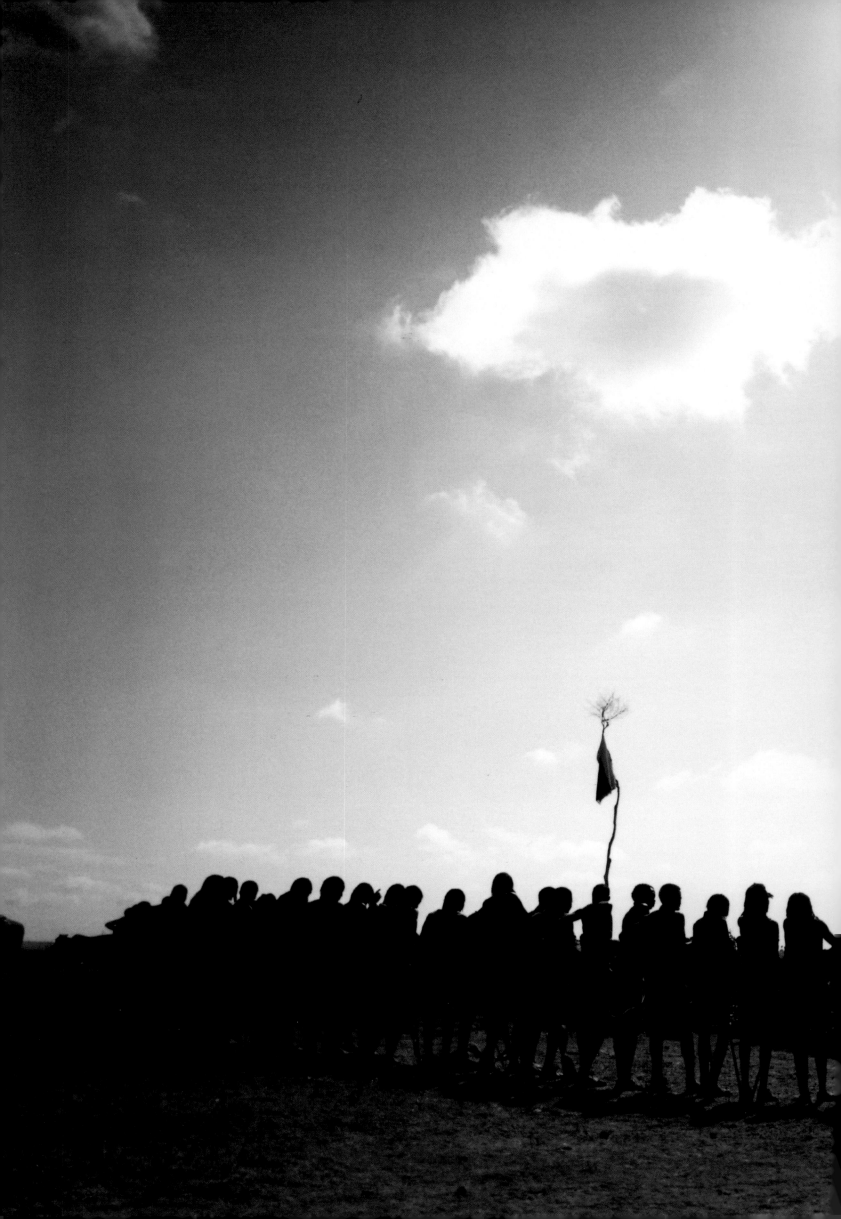

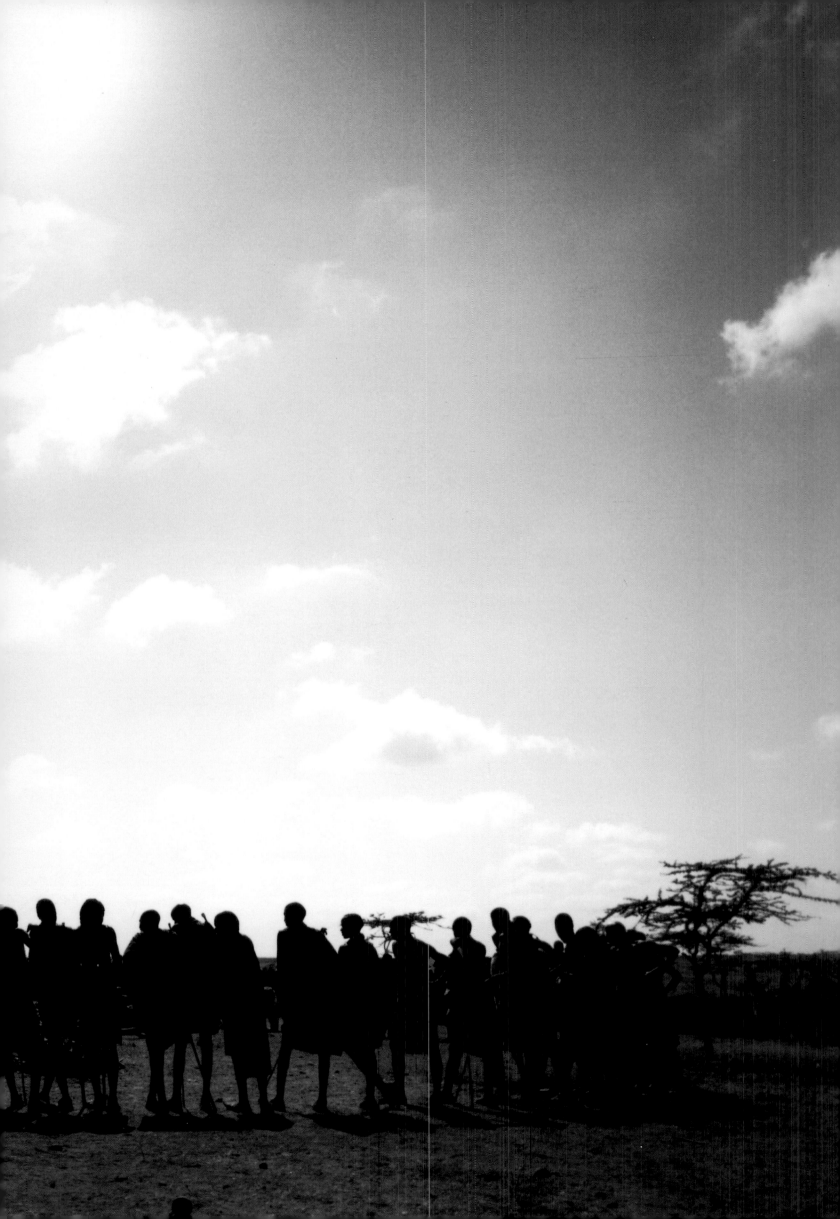

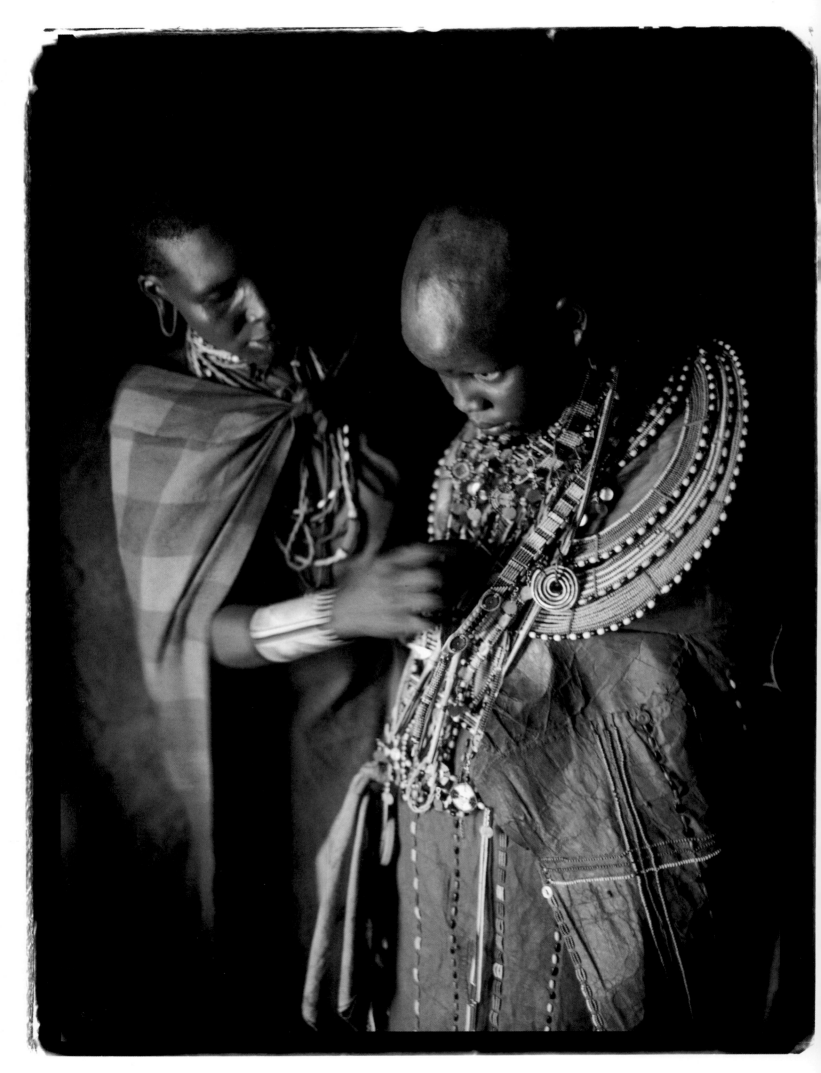

THE BRIDE NAMASARI
Namasari, a fourteen-year-old girl, is dressed by her mother on the day of her wedding.

BRIDE PRICE

Tiampati and I heard about a wedding through a chief we knew in Ntulele. He said it would be a very traditional event, so we packed the car and headed out to photograph it. That night we set up the canvas tent in the chief's *shamba* and slaughtered a goat for dinner. Sometime after midnight a herd of elephants passed through camp. We lay very quietly on our mattresses and listened while they grazed on cactus, wondering what to do if they got any closer. I could make out large black shadows moving very slowly through the bushes by our tent. After a while the sounds grew fainter and we knew that they had moved on.

In the morning we found the wedding party of Patita and Namasari Saigilu. It was an arranged marriage, like most Maasai weddings, and the bride looked miserable. Patita had fallen in love with Namasari when Namasari was nine years old. He had spent five years collecting goats and cows for the bride price, and finally he had arranged a wedding with her parents. When we arrived Namasari was slouched on the ground, surrounded by women who were shaving her head and fastening colorful beaded bracelets to her wrists.

Namasari underwent her circumcision the year before and would now leave her parents' home to become Patita's wife, bringing an end to her life in the family *boma*. She bore the weight of this sadness throughout the ceremony, her eyes always looking down, her head bowed in submission. After marriage, there would be no festive initiations or ceremonies to look forward to, only a fertility blessing in which women prayed for children and had the placenta from a slaughtered, pregnant cow rubbed on their thighs to promote fertility. As a Maasai woman, Namasari's wedding was her final ceremony of passage into adulthood.

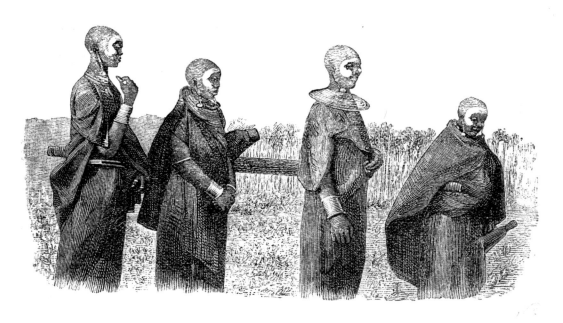

Patita, on the other hand, was ecstatic. He was madly in love. He and his best man smeared themselves with ocher and diatomite while Namasari sulked inside her hut as her mother dressed her up in elaborate beaded collars, headgear, and a beaded leather cape.

The wedding was a solemn occasion. Namasari's friends and family gathered in the morning to watch her depart. There was no exchange of vows. She walked through the *boma* gate, where a crowd had gathered, and never looked back. Her path was blessed with honey beer to ensure her safe passage, while Patita's best man marched ahead to remove twigs, rocks, and other obstacles from the trail.

They had planned to walk through the bush in a traditional wedding procession but Patita suddenly had a better idea. To make the ceremony special, it would be nice if I gave the wedding party a lift in my car, a worn-out 1972 Land Cruiser. Patita and Namasari sat in the front while everyone else piled on the flatbed in the back. Tiampati was squeezed on the floor with the wedding party. During the drive, Patita adjusted and fussed over Namasari's cape and jewelry, insisting that I drive not more than ten kilometers per hour. If it was not to be a slow and solemn pedestrian affair, then at least it should be a slow drive. Patita grandly put his arm around his bride and announced that he was happier than he had ever been in his life. "I never imagined I could marry someone so beautiful." But Namasari wasn't won over yet; she still looked somber and was sad to leave home. With one hand on the steering wheel, I picked up my camera and took a picture of the bride and groom.

At Patita's *boma,* Namasari ceremoniously stepped over a cow dung trough filled with honey beer, urine, and milk. Her new family coaxed her through the entrance with gifts of livestock, a Maasai tradition at all weddings. When I went to visit them a year later to deliver the wedding pictures, I found that Namasari was pregnant.

As we caught up on all that had happened since the wedding, Patita reached over and squeezed Namasari's shoulder. He ran his hand over her forehead and stroked her head. For the Maasai, who were private in matters of love, it was an unusual gesture.

I marveled over her luck; romance was hard to find, especially in Maasailand. Many women were not so fortunate. I remembered a shy woman who fled from sight whenever she saw my cameras. Her husband had once driven a machete into her forehead. Once healed, the gash ran nearly an inch deep above her eyes. She had finally won a divorce and now lived in a *boma* with her sisters. The husband went unpunished and continued to live in his own home with the family cattle and children. Women often became very quiet when their husbands were present and hurried to finish their chores at the end of the day so that they would not be punished. Tiampati explained that beatings were seen as a necessary discipline and were accepted by the Maasai.

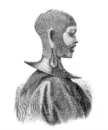

MARRIED WOMAN
WITH
EAR ORNAMENTS

Whenever I was alone with women, we talked about men and married life. I was still troubled over the idea of arranged marriages and failed to see how they could make anyone happy. It was in these conversations that I began to see how the practicalities of Maasai life helped to smooth over the catastrophes of love. Not all things were final in relationships, and while time and ceremonies pushed the Maasai forward in life, some things were never left behind.

At one ceremony I met a woman named Meeyu who had a long, elegant neck and fine features. She was a beauty by any standard, but that kind of thing never counted for much in Maasailand. No one person was better than any other person. If you singled someone out because they were good-looking, people thought you were rude. So Meeyu ended up the fourth wife of a man twenty years older who drank honey beer from morning until night. Finally they had a baby, and whenever I saw her she was kissing its cheeks and chatting to it.

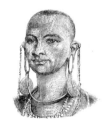

MAASAI MARRIED
WOMAN

Inside Meeyu's house, a group of women waited until all the men had left and we started talking. I couldn't understand how they could be happily married to old men they hadn't fallen in love with in the first place. The women shrugged at my questions.

"We have boyfriends," they said.

"Do your husbands know?" I asked.

"They know."

"And it's okay?"

"We do it quietly. We meet the boyfriends out in the bush. We were in love with them before we were married and they were warriors. They are still around. We do it all the time."

"And you love your husbands too?"

"Completely."

"Do your husbands have girlfriends?"

"They do."

NECKLACE

"And do you care?"

"Oh, no. But if we meet them or run into them in the bush, then we must beat them."

I slumped on the bed. "If I had to marry someone I didn't love, I'd think my life was over."

Several hands waved the air dismissively. "Why? It's hard at first, but you get used to it." Then whispers. Meeyu leaned in. "You just go meet the ones you love in the bush. Really, they are not gone. We see them all the time."

"Don't you wish you could marry the one you love?"

"That is every girl's dream," they all agreed.

"Can you ask your parents to help you marry the one you love?"

"We can. If your mother is very clever, she can manage that for you."

"Has anyone you know ever done it?"

A hushed debate ensued. A name was proposed but then taken down. The women pointed their fingers wildly when another name came to mind. People squinted and scanned the air above their heads for answers, as if it held the name of at least one woman who had lived the dream.

"No. Nobody. There was one. Almost. But not really."

Among the Maasai women, I learned about love, survival, and friendship in Maasailand in ways that were never expressed by the men. The women's lives were very harsh, with painful circumcisions, arranged marriages, even abuse at home, so the idea of epic love affairs in the bush seemed like a gem. A romance with a warrior seemed like one of the few loving and carefree experiences they could ever hope to have.

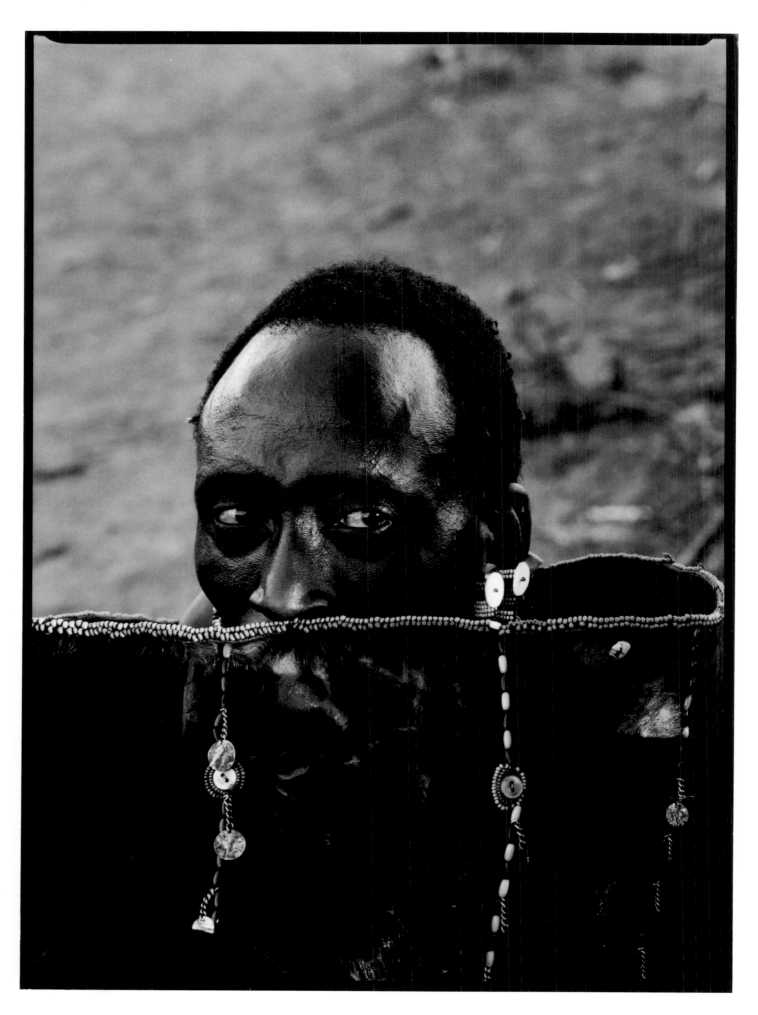

THE GROOM PATITA SAIGILU

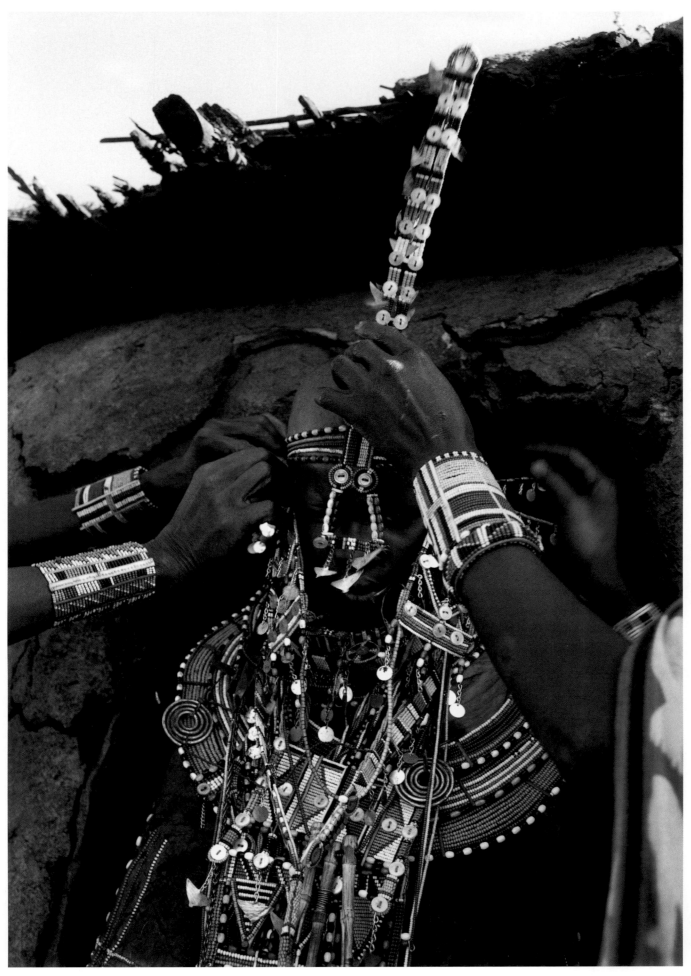

DRESSING THE BRIDE

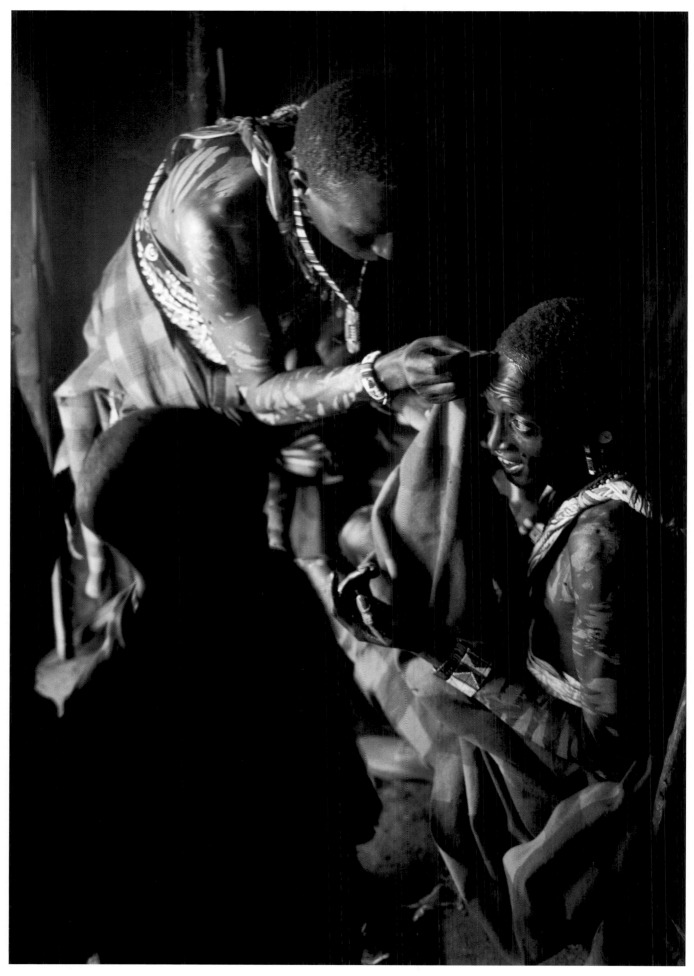

PAINTING THE GROOM

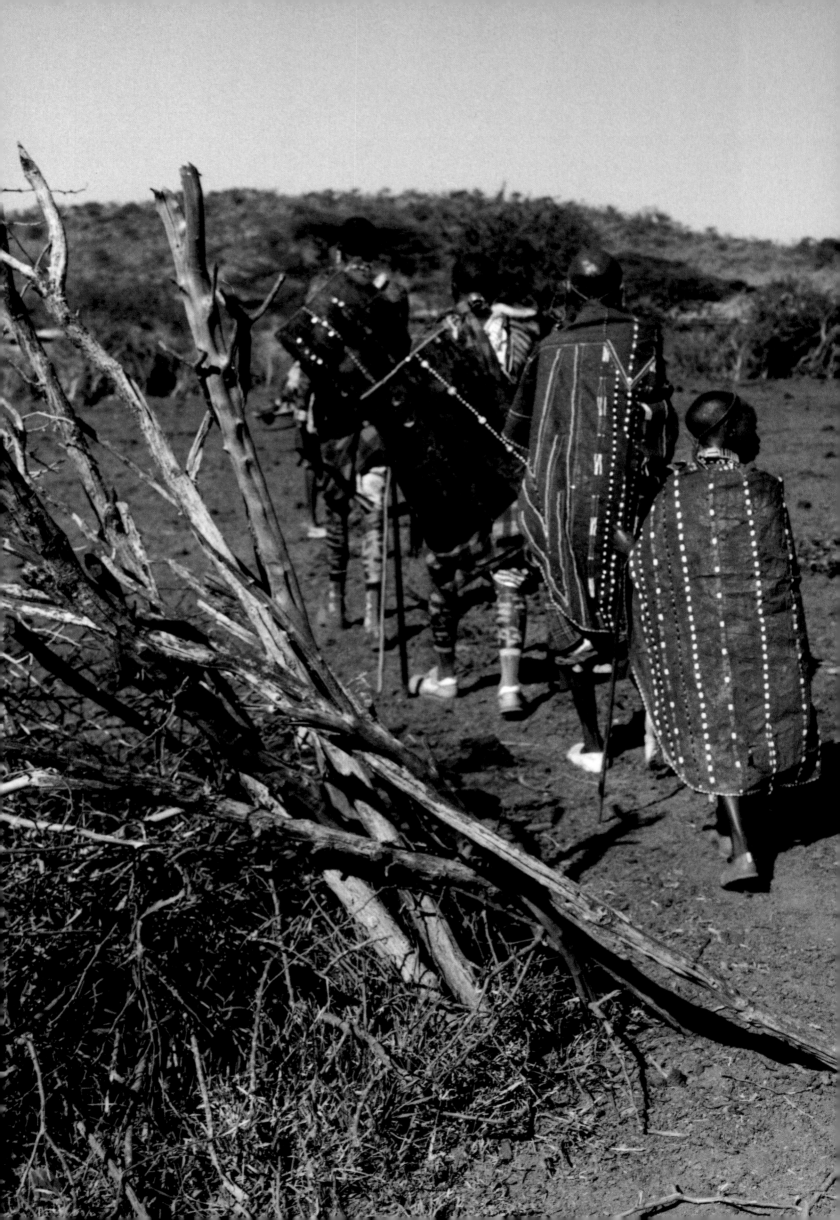

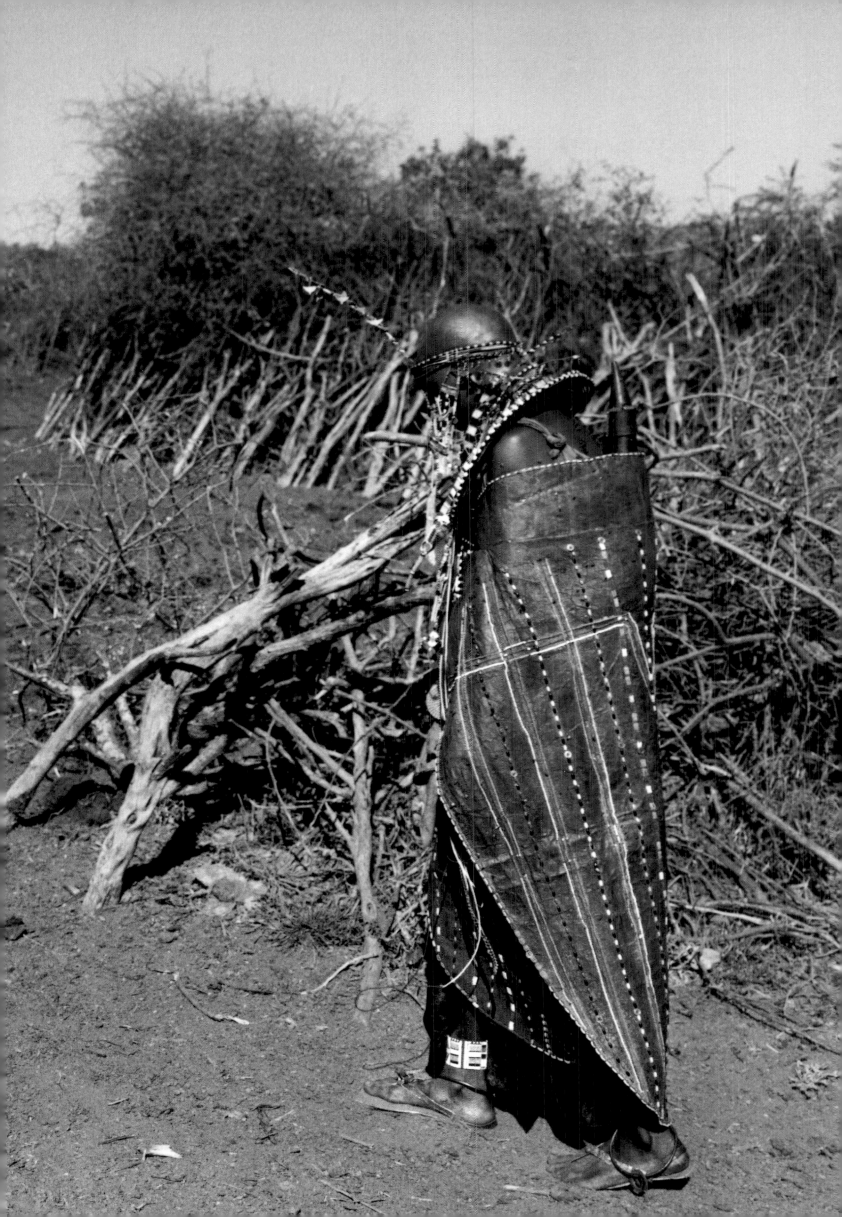

BRIDE PRICE

WEDDING PARTY IN THE FRONT SEAT OF THE LAND CRUISER

PREVIOUS PAGE
NAMASARI'S WEDDING
Namasari departs her family *boma* in a solemn procession
with the wedding party to her new home.

OVERLEAF
WOMEN'S GREETINGS
Women dance as they greet one another at the start of a
fertility ceremony, the only major ritual for women after circumcision and marriage.
Women of all ages gather at the *manyatta* to pray to God, Enkai, to bless them with children.

FOLLOWING PAGE
GRIEVING WOMEN
As the ceremony begins, women collapse with emotion. The Maasai are very fond of
children and all people hope to have large families. Women are reminded of the children they
have lost when they see everyone gathered to pray for fertility and they cry in fits of mourning.

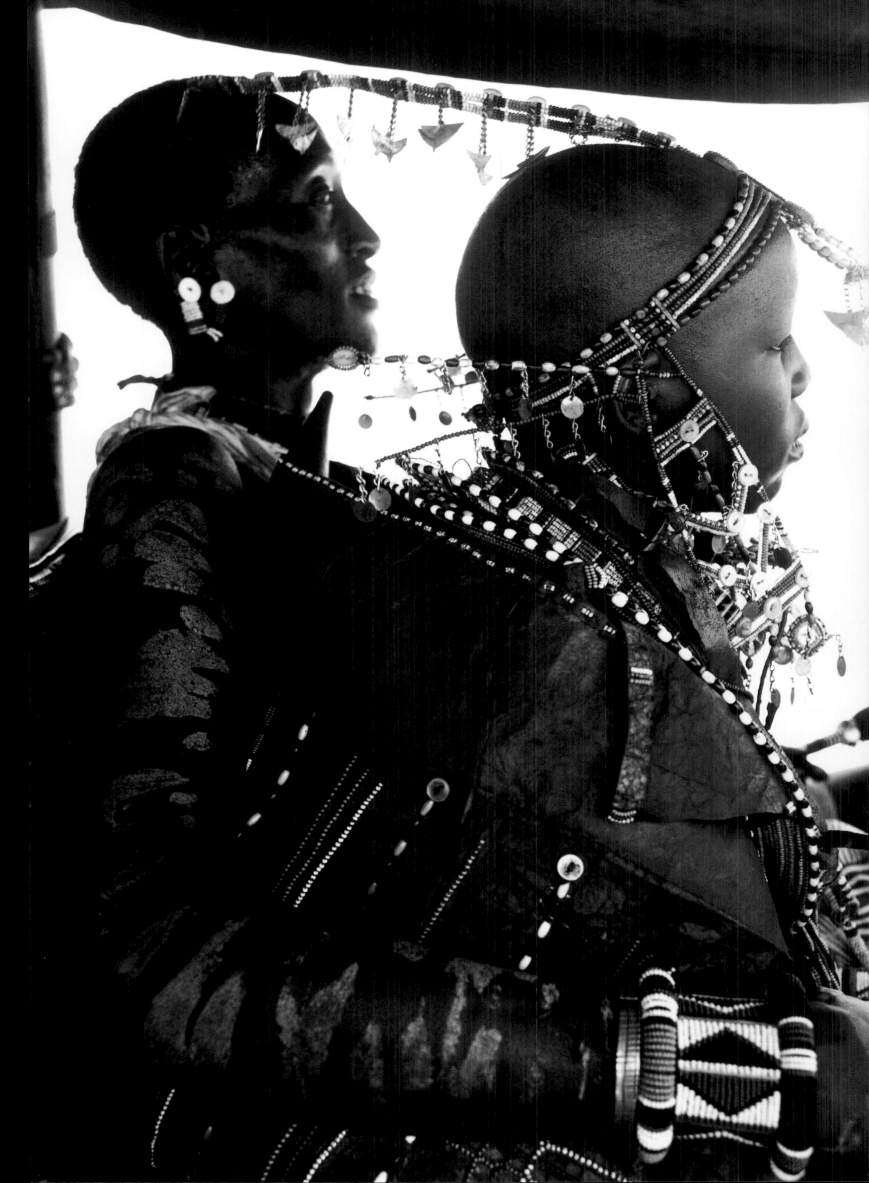

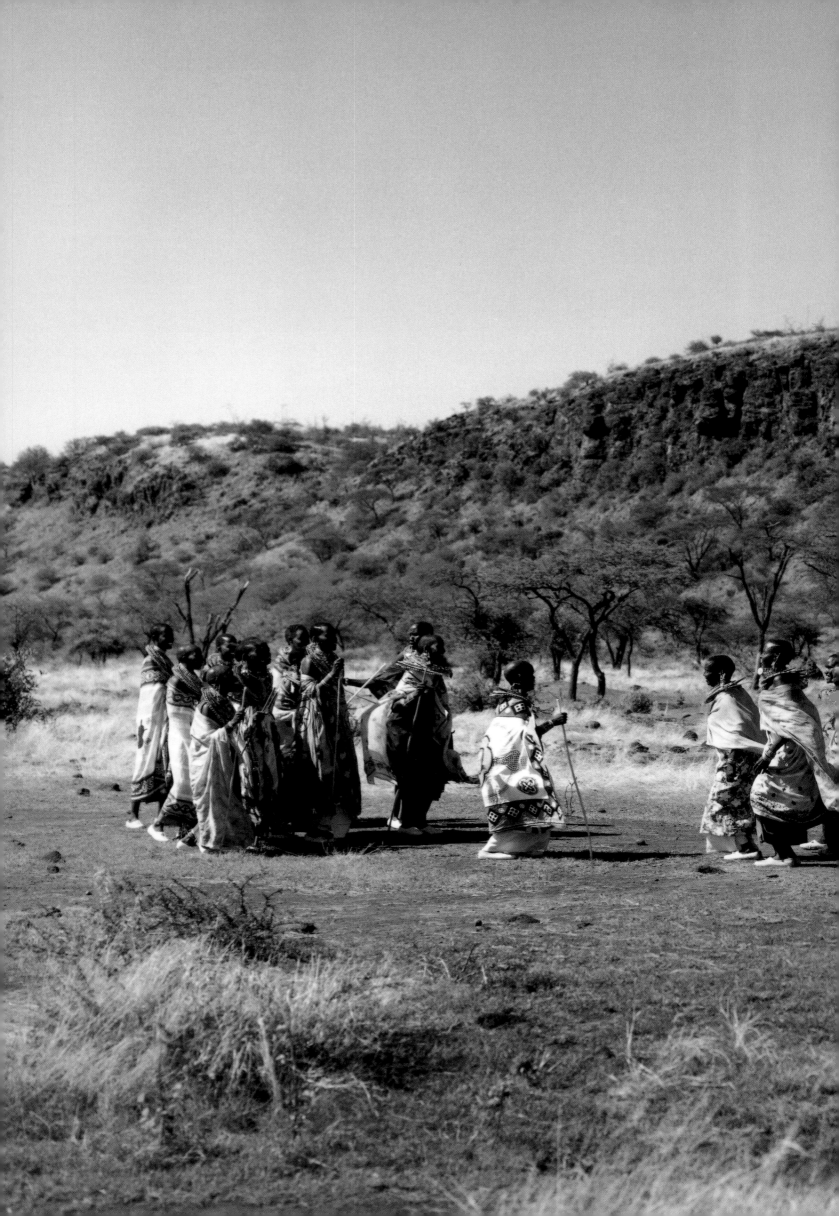

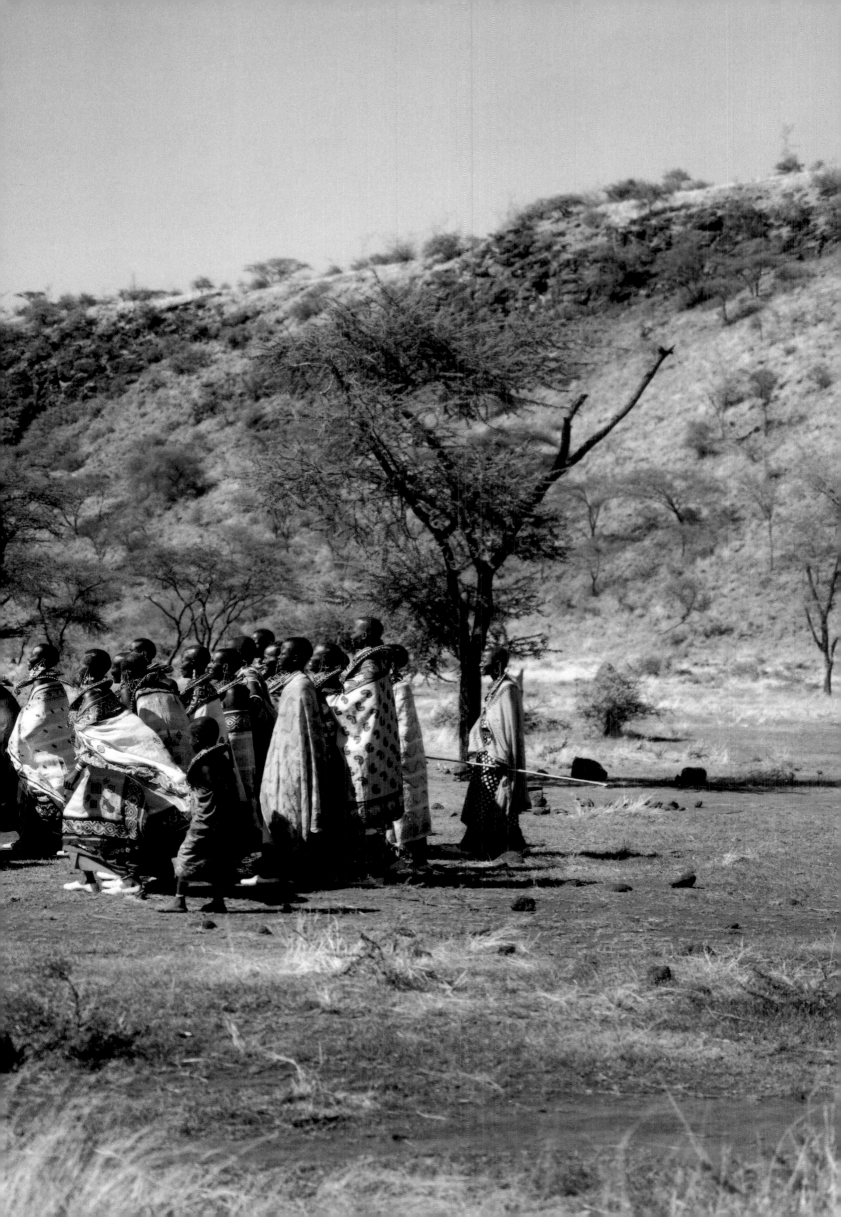

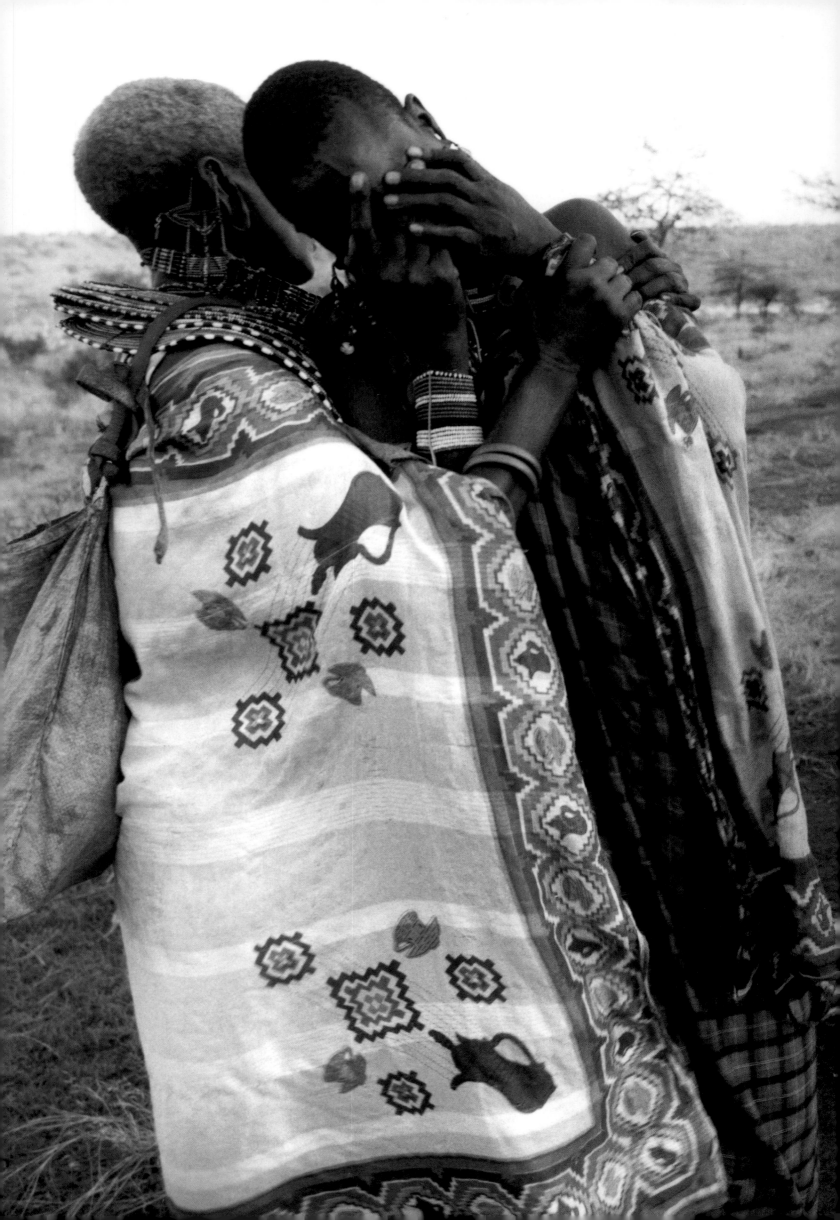

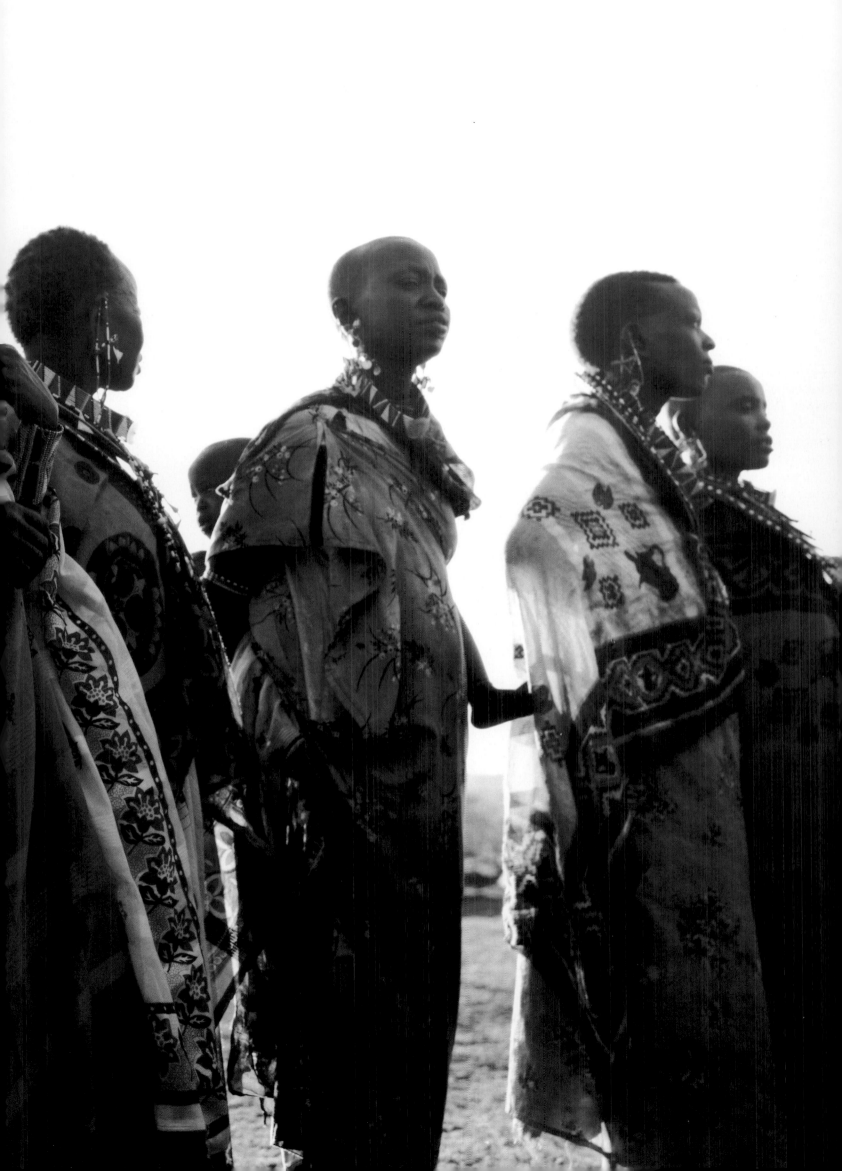

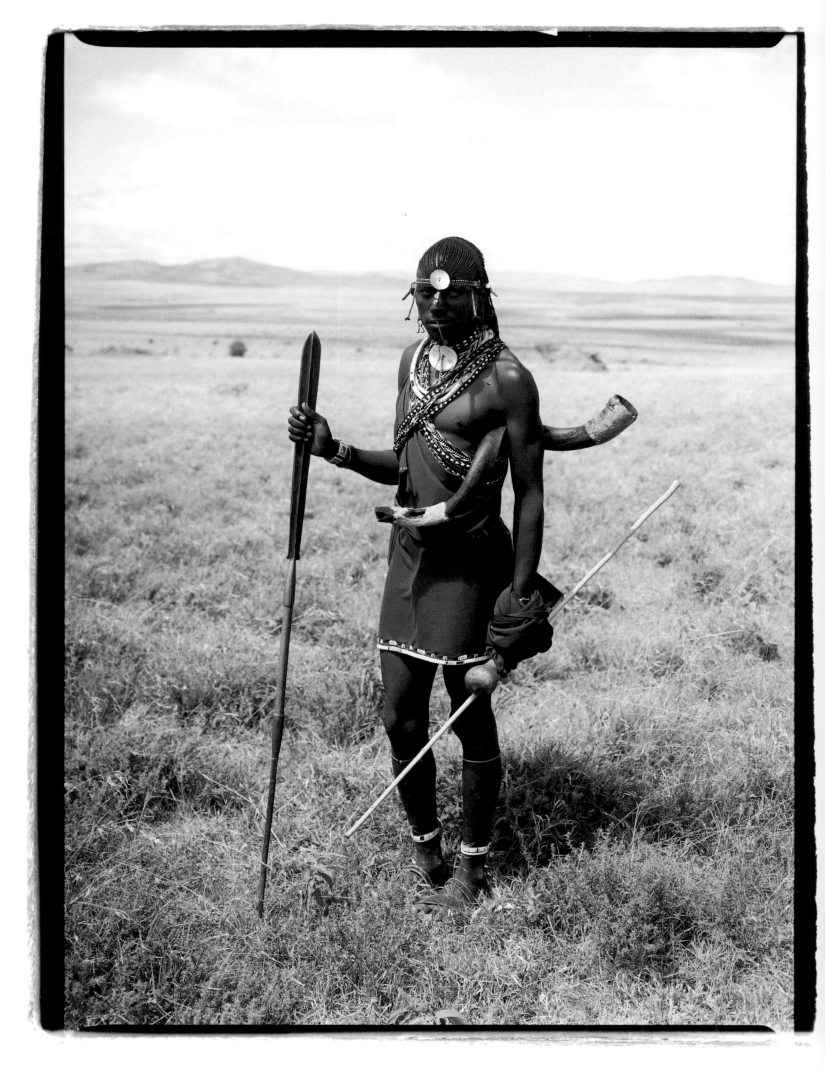

LION HUNTER OF TANZANIA

THE LION HUNT

The safaris were coming to an end. The portraits were finished, and I had documented most of the major ceremonies save one. I no longer believed I would ever see a lion hunt but decided to make a final round of inquiries before giving up. Tiampati and I drove around Narok and the Ewaso Nyiro, and chatted in the markets. We were well known in the area by then and always ran into acquaintances. The Maasai were very friendly and held our hands while they talked to us. They knew all about our photo project but hadn't heard of any lion hunting. "You might find it over in Loita or Tanzania," they'd say. "But it would be hard to see it around here."

After four years away from the Loita Hills, I drove back with Tiampati to look for a hunt. Tiampati seemed to have relatives nearly everywhere and we camped in his sister's village. A friend of the family had heard of a group of warriors across the border who were hunting. It was a long drive, and although we didn't have the necessary paperwork to cross the border we knew there was no border post there. In the early morning we drove on a remote mud road into Tanzania to find a band of warriors living in the hills north of Serengeti. Several of them bore the scars of previous hunts. After years of searching, I accepted my first invitation to a hunt.

It took three days to find a lion. The warriors gave chase and trapped her in some thick bush at the top of a small hill. Everyone screamed and foamed at the mouth, but nobody could see where she'd gone. Then someone threw a *rungu* in the bush and hit her square on the head. The sound of her roar was tremendous, and much closer than I realized. I started to run. When I turned around she was behind me and the warriors were in full chase. I veered off to the right, while the lion headed straight for a stream, disappearing into thick overgrowth at the water's edge. No one dared to follow, out of fear that she could leap out of nowhere and wreak

vengeance on the warriors. A second group of warriors who were also hunting the same plains heard the pandemonium and attempted to join the hunt. Our group was full of emotion and frustration and didn't want the second group on its chase. A frightening argument ensued with everyone pointing spears at one another. I made my way to the car.

The rains came suddenly, so we had no choice but to head home and wait until the warriors would hunt again.

When I returned the following dry season, the warriors screamed in recognition, whistling, rubbing their heads, and slamming their spears in the dirt. One hit his forehead on the car door as he ran up to hug me. They were planning to hunt in five days and said that I should meet them at my old campsite.

Tiampati and I spent the days before the hunt at Lake Natron, an arid landscape near the Mountain of God. We drove hours south through dust and canyons, and finally reached the Natron flats in the afternoon. During the day we drank Fantas and set up a makeshift studio in a local bar. The Maasai clans in Tanzania wore different jewelry than the Maasai in Kenya and had unique white-beaded belts, necklaces, and caps. We photographed nearly thirty people, then set up camp in a village near the lake's edge. It was very hot country, so at night I stretched out on the roof of the car and watched the stars. We had traveled very far from Nairobi and felt remote on the lunar landscape of the lake. Tiampati sat below in the front seat and was able to get a Nairobi radio station we often listened to. The music conjured thoughts of cold drinks and dinner parties at home in Kenya. We had been on the road a long time and knew this was to be the last of the safaris.

In the morning I climbed up the side of a hill overlooking the lake and photographed the cattle herds moving through the dust on their way to graze. We arrived at lion camp that afternoon. Set on a hill above the plains, our tents commanded a panoramic view of empty bush in every direction. After dinner we zipped up our tents and heard the first lions of the night calling out to one another. Surrounded in a stereo effect of howling, we knew we would find lions in the morning.

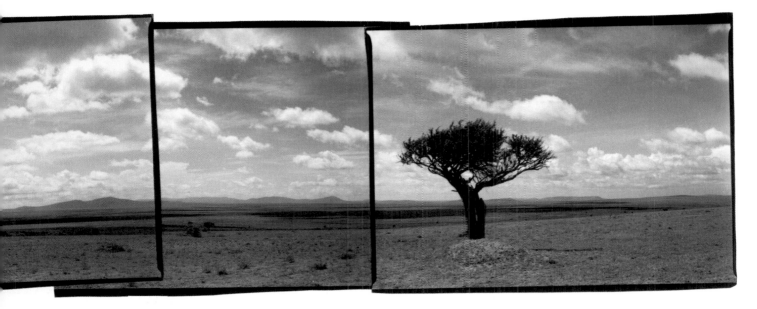

VIEW FROM LION CAMP

At sunrise the next day, fourteen warriors arrived in camp. There were predators everywhere. Vultures circled in thermals two miles out, eyeing a possible kill. A lone cheetah headed toward the Serengeti. Then we spotted three lions, a male and two females, moving across cattle country where herds had passed the day before. Very quickly the warriors picked up their spears and broke into small packs, three or four of them to a group.

The first group ran fast along the edge of the hill to cut off the lions, with the other three groups fanning out across the plains. The lions either saw this or caught the scent in the wind and they suddenly separated. With the warriors far apart from one another and the lions spreading out, I wondered how everyone was keeping track of it all. Soon I was alone, and I couldn't keep up. My cameras were slowing me down. It was a bad feeling being alone in that bush armed only with a camera. The lions could be anywhere. I could try to get back to camp and wait in my tent, but when I looked behind I was surprised to see how far away it was. It would be a lot of territory to cover alone. I could keep moving forward, hoping to catch up. But what if the warriors had flushed the lions out and I ran into them along the way as they fled? I couldn't see more than thirty or forty feet into the bush. Twigs snapped mysteriously to the right, then again behind. All these things tormented the mind.

About a mile ahead, three warriors had attacked one of the females. The bravest had already driven a spear into her side. This was not deep enough to kill her, so before the warriors could regroup the lioness dragged the first warrior down to the ground, biting into his back. The other warriors sent their spears into her, causing her to retreat into the thornbushes, but this was bad business for the first warriors who were left completely unarmed.

I could see a tawny shape, low in the whistling thorn. As the other warriors arrived on the scene they began screaming in high-pitched yelps and we made a wide circle around the lion. I joined the group and had shot three frames when I heard the roar. It was deafening, and we scattered in every direction. One warrior who had lost his spear pushed past me. I didn't have to see the lioness to know she was right

VULTURE

RUNGU

KNIFE AND
SHEATH USED IN
LION HUNTING

behind us. I looked back in time to see her tackle a warrior, ripping most of his left ear off. As I raced back to photograph, she was on her second warrior, mauling his arm and pulling him down. Another spear, the fifth, caught her in the ribs and she was down at last. The actual kill had taken less than two minutes.

The warriors wanted to cut some fat from the dead lioness to treat their wounds. I offered to drive them to the nearest clinic but they refused. They said the people at the clinic would shave their heads and put them in jail. I didn't have medicine but when we returned to camp they sat on the cooler and waited to be treated. I didn't know where to begin. One warrior's ear dangled from the lobe with all his jewelry still set in it. Another warrior had a broken hand. Still another had tufts of muscle jutting from the holes in his arm where he'd been bitten. I taped the ear together with surgical tape, and wrapped the bleeding wounds with sanitary napkins.

The mood among the warriors was mixed. Some felt triumphant, others upset. It was the third lion hunt where there had been serious injuries. In an earlier incident, one of the lions had ripped out a warrior's throat. Even the mission hospital couldn't handle the case and a priest paid to have the warrior sent to a hospital in Nairobi. Nobody knew if he'd made it or not, but everyone agreed that they should definitely not stop hunting lions.

The warriors insisted that I take them to a medicine man on the road to Loliondo. He would know what to do with the lion fat and had been treating lion accidents his whole life. They asked if I would give them some money to pay the *laibon*. I was in Maasailand and that was how things were done. So all fourteen warriors piled into the car and we left for the medicine man's village. As we drove, I talked with the warrior who'd had his ear clawed. It was still bleeding and I asked him how he was feeling.

"Being bitten is a sign of bravery," he said casually. "If you were bitten, well, it means you were there."

LION HUNTER IN OSTRICH FEATHER HEADDRESS

OVERLEAF

WARRIORS ON A LION HUNT
Having spotted a female lion on the plains north
of Serengeti, the fourteen members of the hunting party run in pursuit.

FOLLOWING PAGES

CHASING A LIONESS
Warriors chase a lioness into a dangerous area of thick shrubs where
the animal can not be seen. Once hidden in this vegetation, the lioness is able to attack without notice.

WARRIORS SPEARING A FEMALE LION
Of the fourteen warriors on the hunt, only five managed to spear the lioness.
Before she died, the lioness was able to attack several of the warriors, mauling three and
ripping the ear of another. Warriors hunt lions to protect the community and prove their bravery.
The animals are notorious for attacking Maasai cattle and are instantly pursued when such incidents occur.
When male lions are killed, warriors take the mane and have it sewn into a trophy headdress.

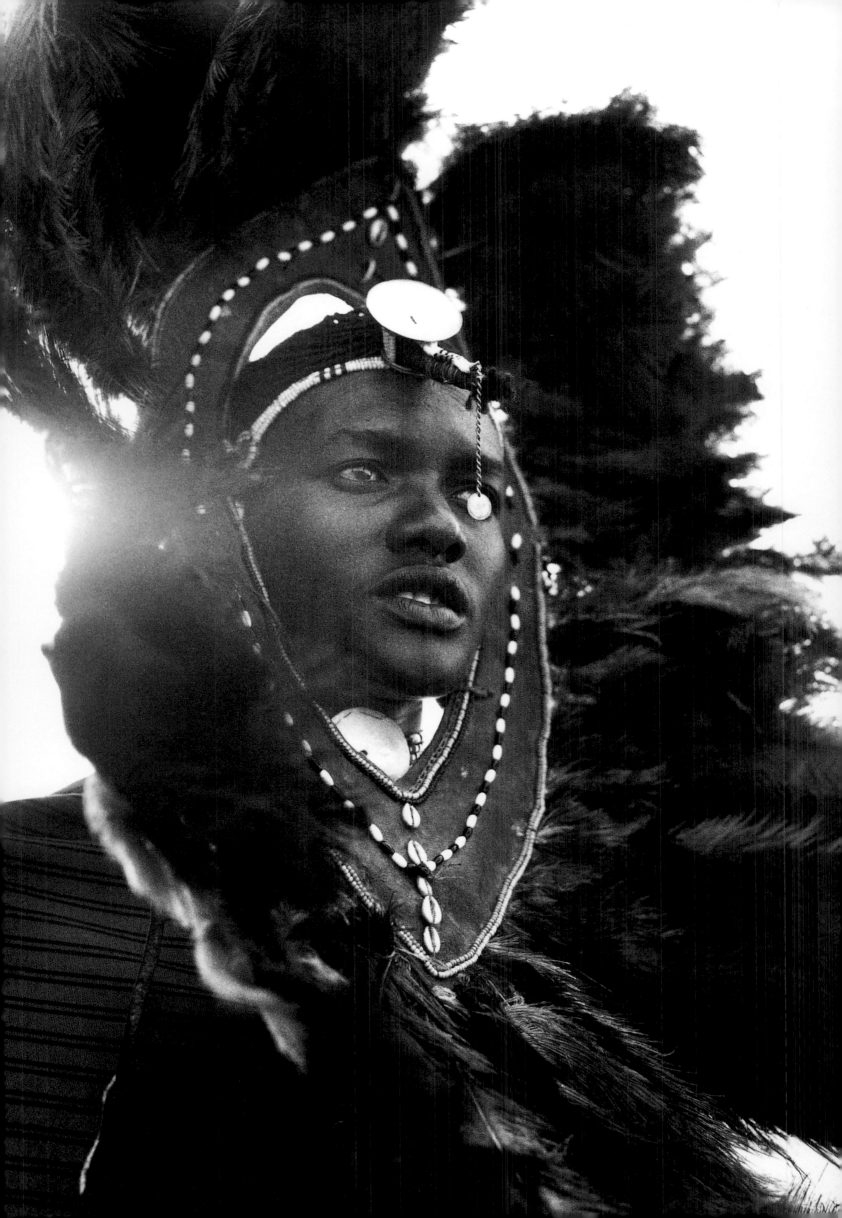

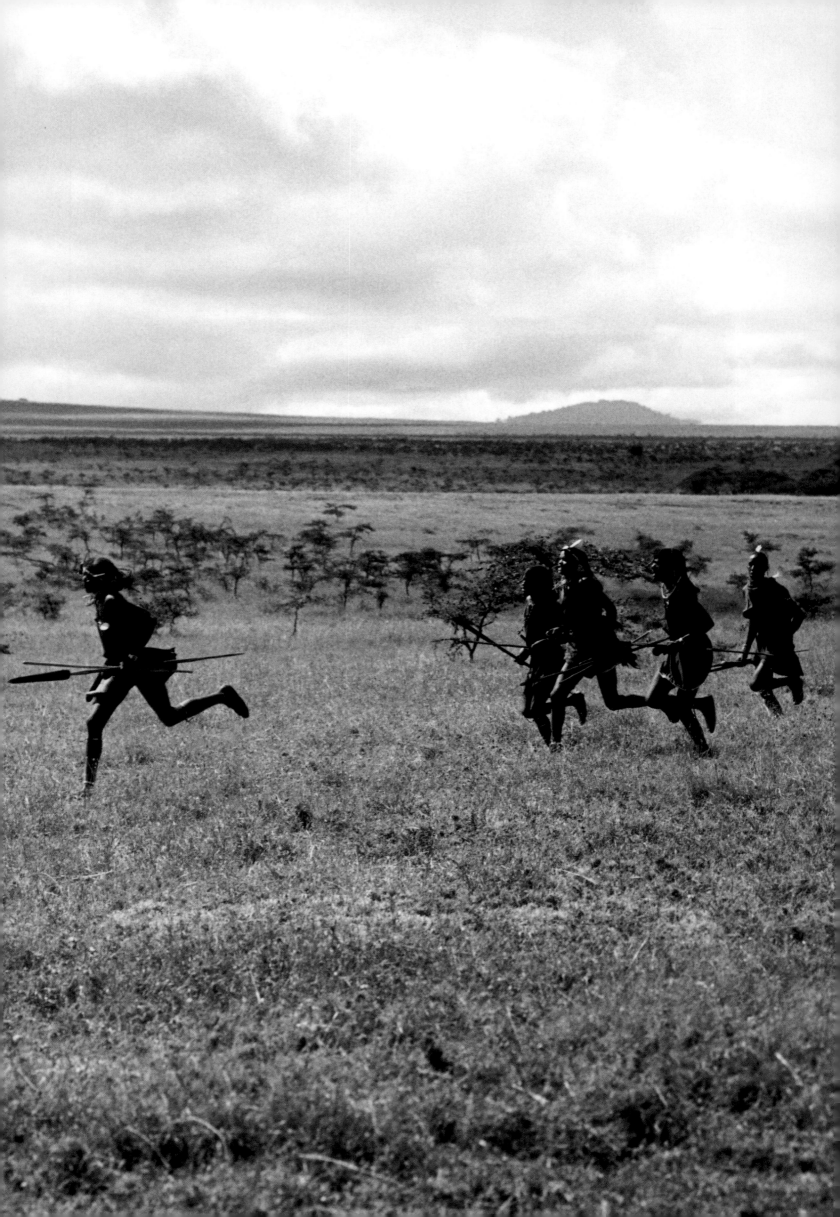

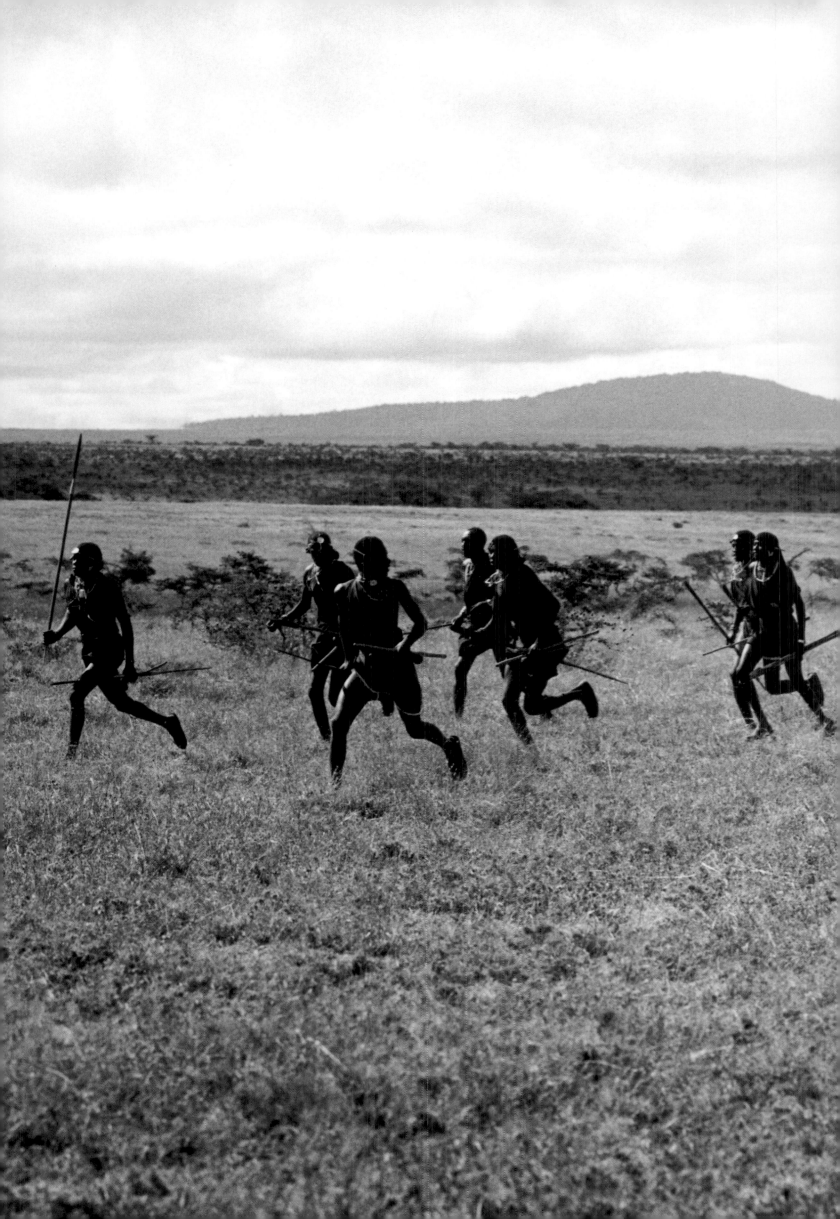

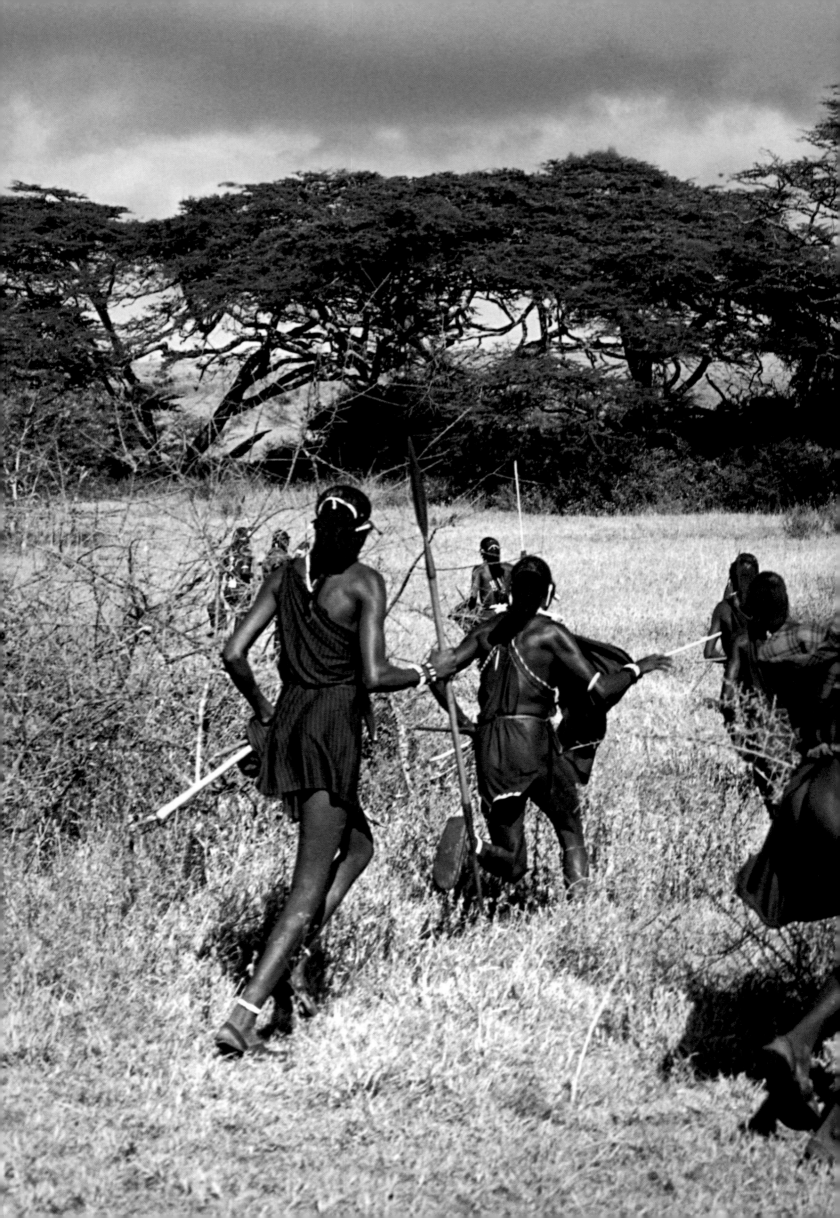

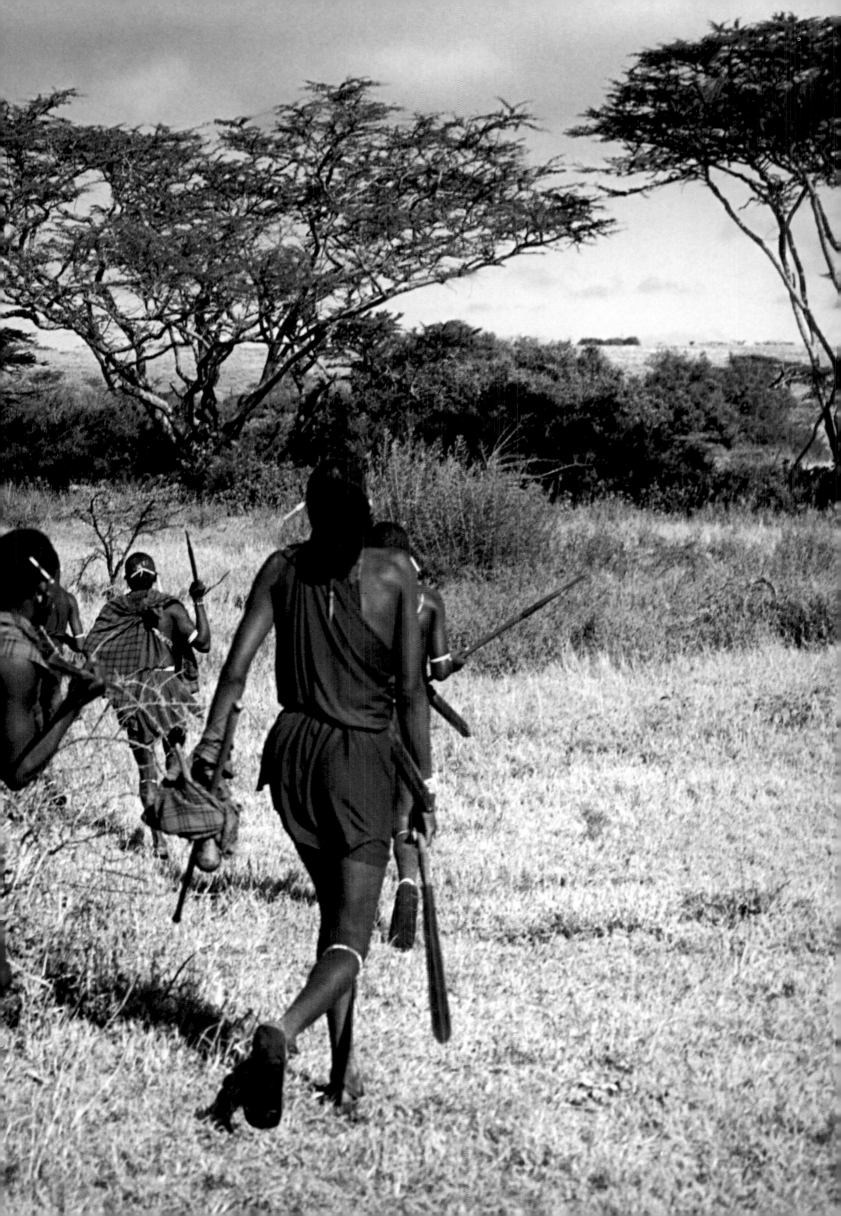

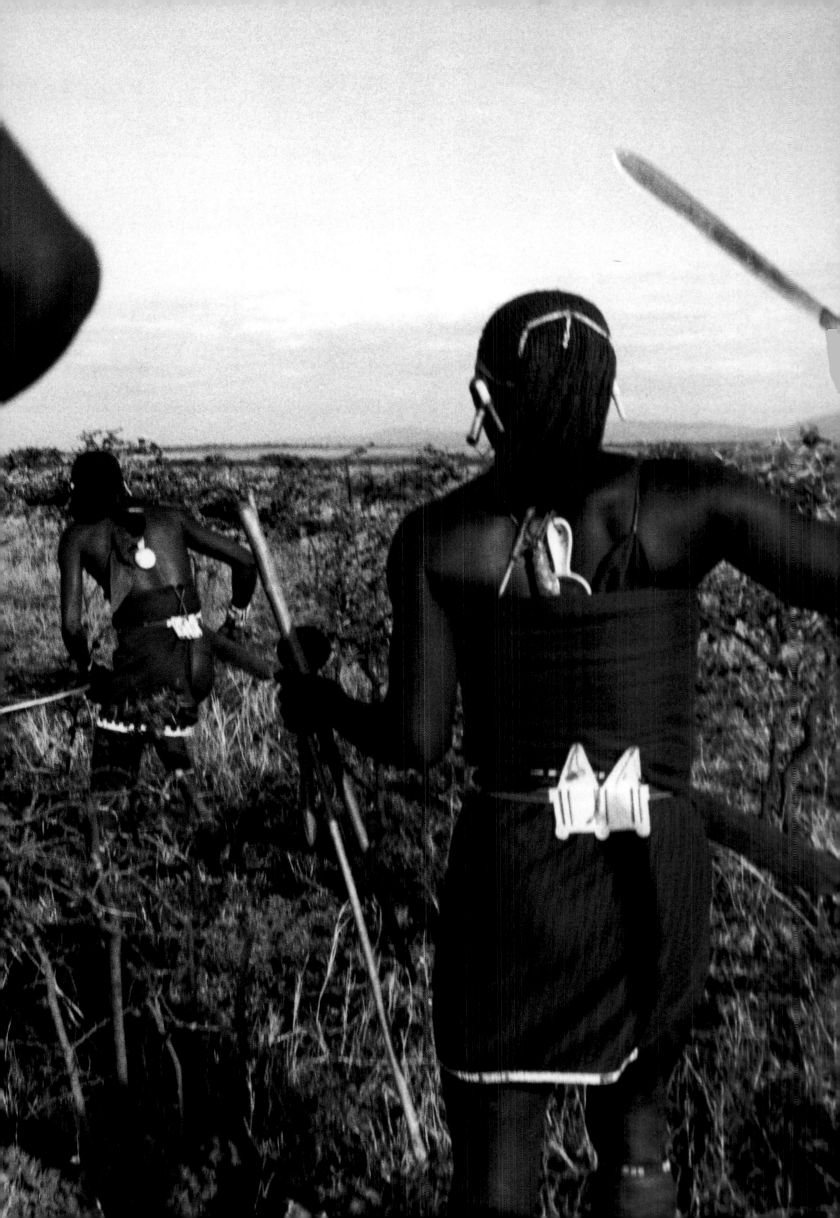

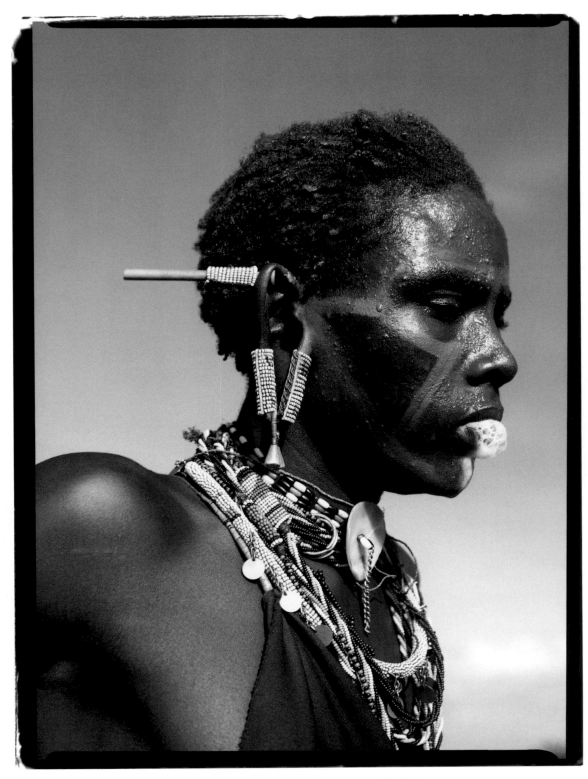

LION HUNTER IN AN EMOTIONAL SEIZURE
A warrior foams at the mouth in a fit of emotional seizure induced by the intensity of the lion hunt.

CONCLUSION OF THE LION HUNT
A warrior stands over the dead lioness moments after the hunt.

176

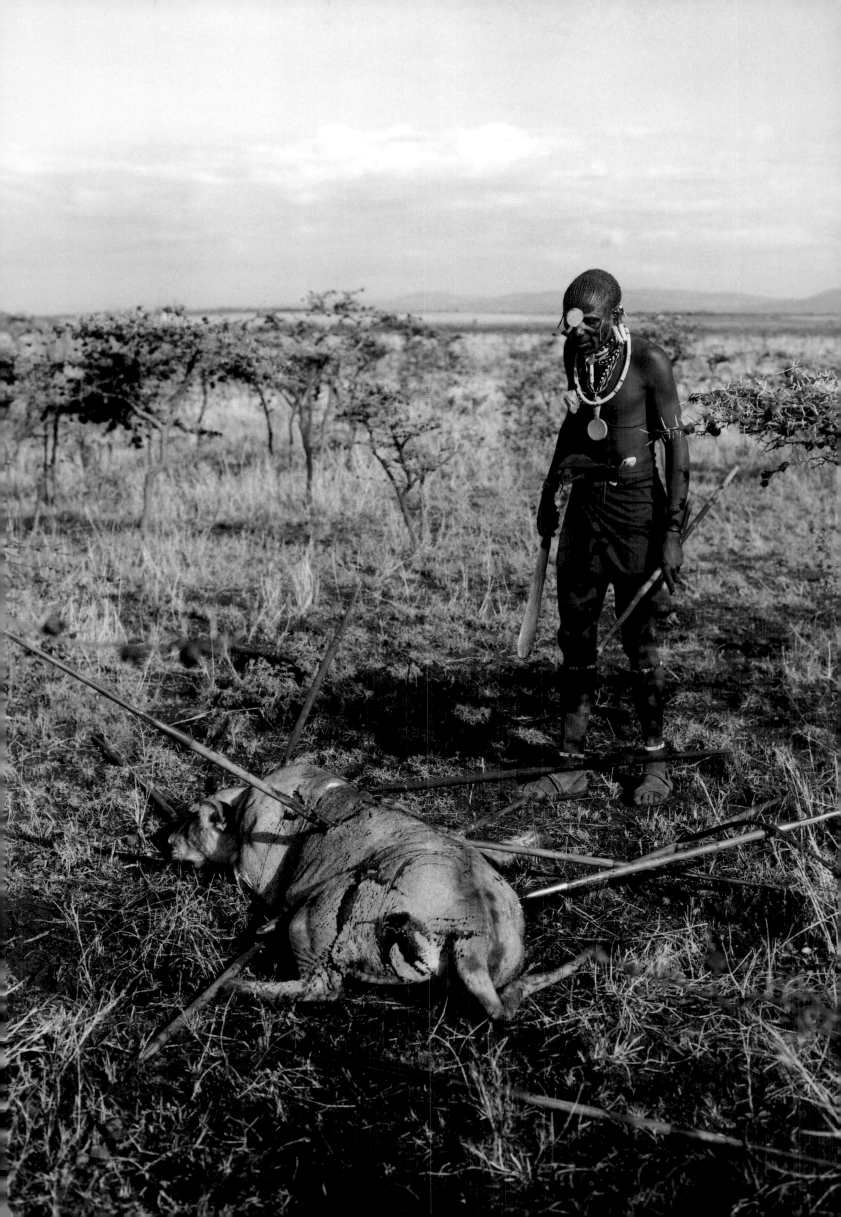

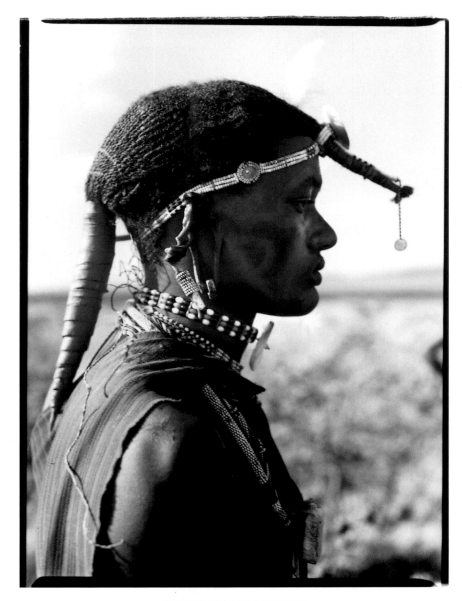

WARRIOR'S EAR INJURY

OVERLEAF
CUTTING FAT FROM THE LIONESS
Warriors cut fat from the lioness to treat their injuries. The fat will be boiled
and applied to the wounds by a Maasai medicine man who has experience treating injuries.

FOLLOWING PAGE
RAIN CLOUDS OVER THE SOUTHERN MAASAI RESERVE

INJURIES FROM A LION BITE

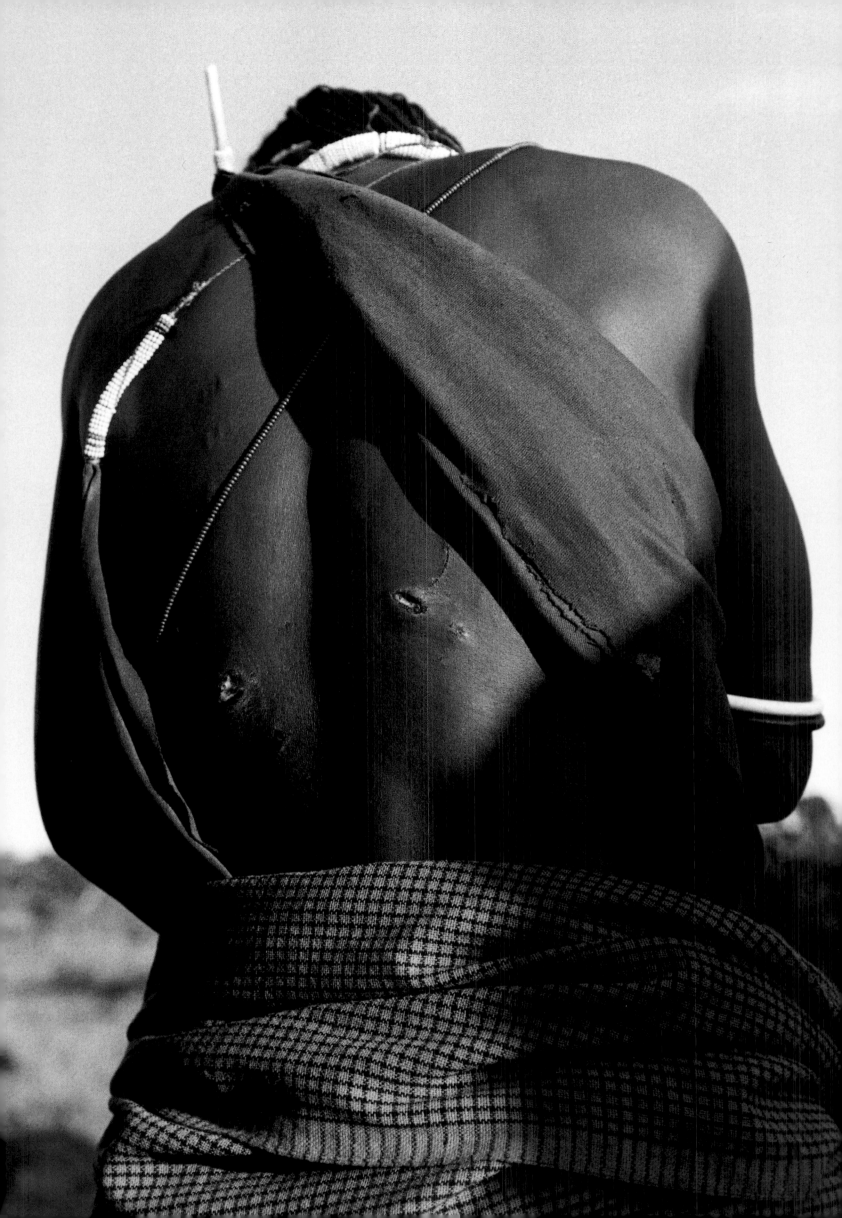

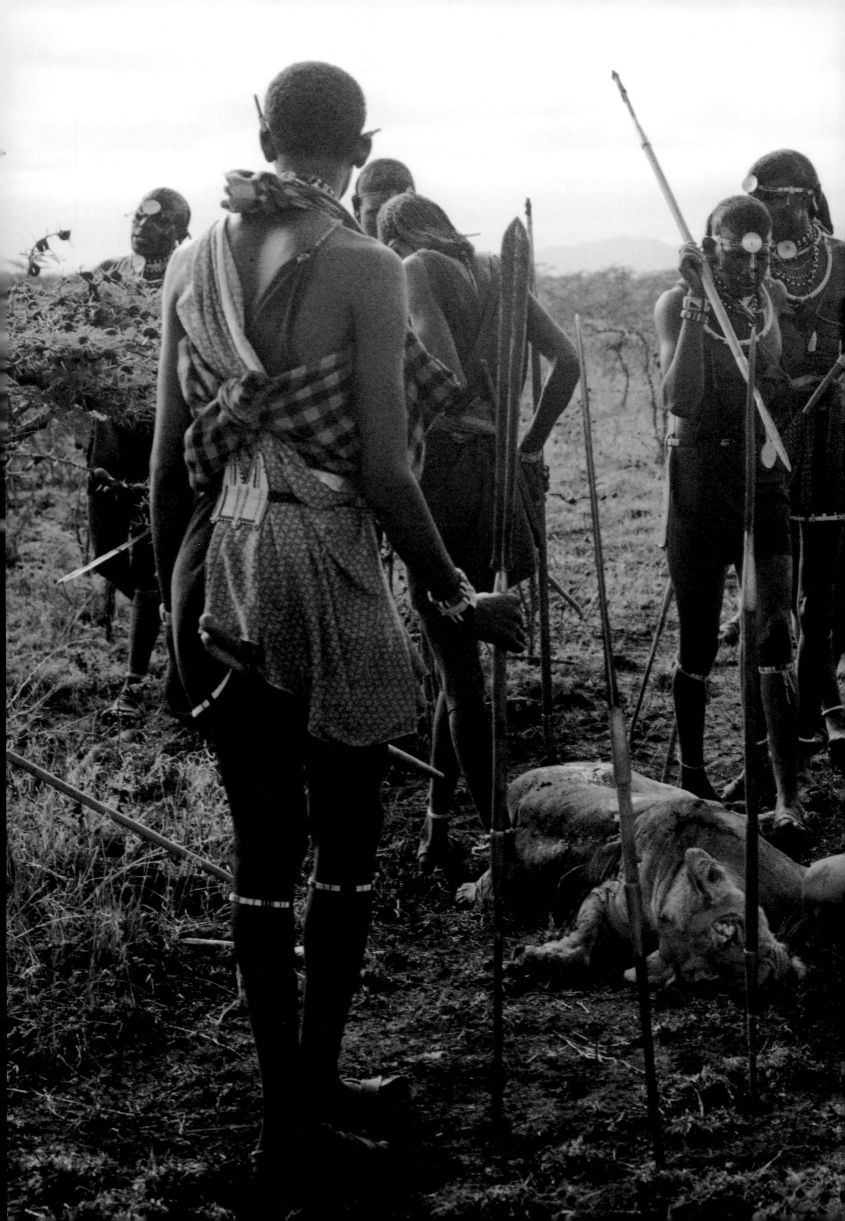

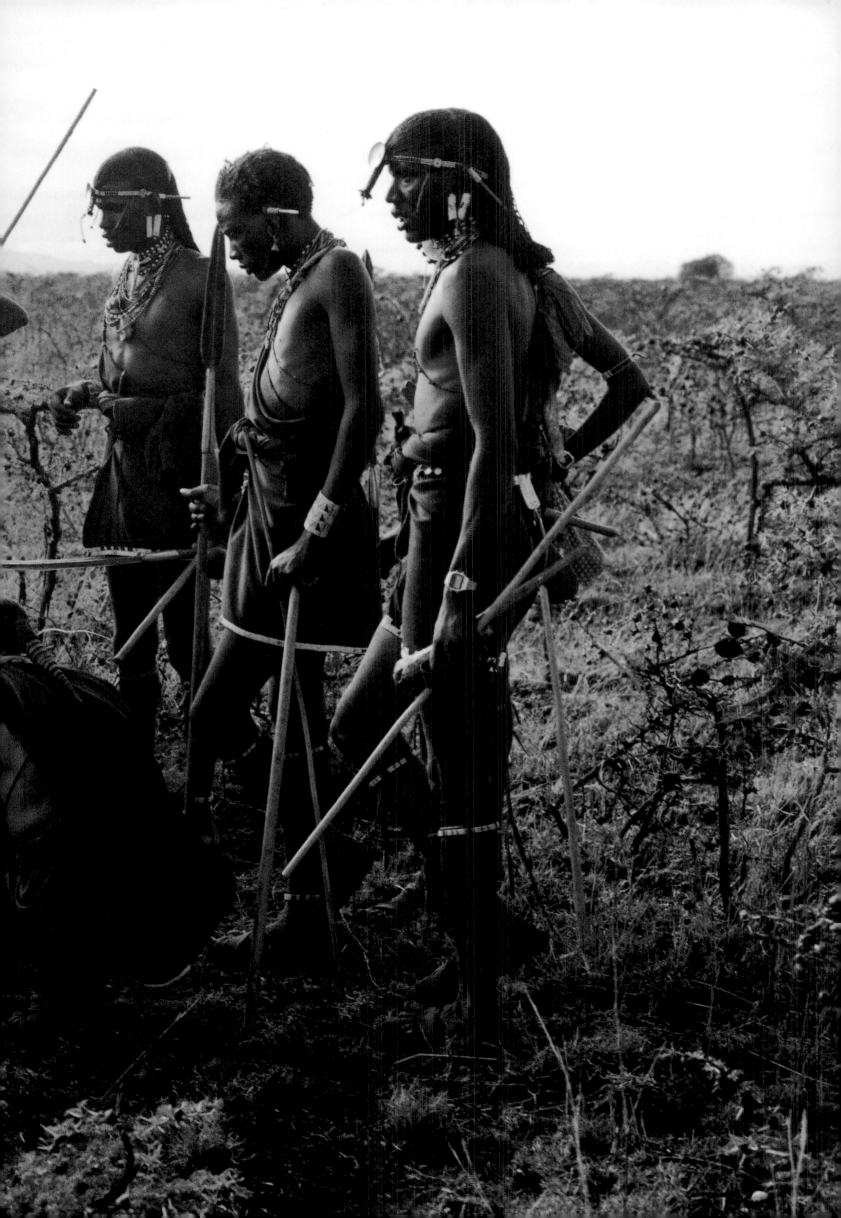

HOME

The rains had come to Kenya while we were away. Crossing the border on our way home we found the track slick and covered with skid marks, broken branches, and the telltale signs of accidents. The map on the dashboard reflected a spidery network of roads across the windscreen. Half of them would be useless to us once they were wet. Large cumulus formations struck a cauldron of clouds over the Loitas.

People pointed to the sky and told us to hurry. Gunmetal-gray clouds gathered in the distance. The road grew slippery and the car lost its traction. It pirouetted downhill and I took my foot off the gas, hoping to end up anywhere but in the ditch. The car lurched to a halt as the bumper wedged into a wall of gooey black cotton soil. Tiampati and I were digging through it with our hands when a *matatu* filled with Maasai managed to pass. We begged for help but they only sped away, while all heads turned to watch the spectacle. Water pooled around the tires and I considered spending the night in the car.

The *matatu* had only stopped at a safe spot up the hill and moments later we saw the group approaching on foot. They surrounded the vehicle, and everyone heaved. The wheels spun and smoked and a spray of mud showered the crowd.

"May I try?" offered the driver of the *matatu*. That was very African, that blend of politeness and patience. I lept out and let the driver try, throwing my weight against the rear of the car. A moment later, the car was free. We all embraced, caked in mud and lost in the exuberance of our success. I looked at Tiampati, who was spotless as usual. It was puzzling how he always worked harder than I did at getting the car unstuck and yet somehow never got dirty.

During the last hour of daylight, I watched Africa blur past my window. We drove beyond the Loita Hills and the *bomas* and the crumbled, empty *manyattas*

where we'd attended ceremonies. Fragments of the journeys passed through my mind and I froze the images in my thoughts, hoping one day to remember the feeling of freedom I knew in Africa, with the car full of all the debris of safari and the empty, open spaces before us. The world was changing. You could feel it moving out there in the bush, revolving past the stars. Where will the Maasai be in twenty years' time? With the dust beneath their feet and the sun on their backs, they experienced a connection with the natural world that people in the cities had lost.

On the way out of the hills we stopped to return a car jack to a friend and had tea with the manager of a large cattle project. An educated Maasai, he was very handsome in his pressed khaki pants and plaid shirt. He wondered what we were doing so far away from the city and Tiampati told him about the book. "I hope you won't write about the stereotype of the Maasai with the spear out in the bush. Everybody already knows about that stuff and those people are long gone. That life is over for the Maasai now."

That night we arrived in a village near the Maasai Mara. Rain poured out of the sky and formed a lake in the middle of the cattle kraal. We decided to sleep in one of the huts rather than camp. The man who offered to put us up for the night ran to the car with me to get some food supplies. We were drenched by the downpour and sat in the front seats until the worst of it passed. The night outside was very black. He didn't speak any English and my Maasai was limited, so I put on a cassette tape of music. We listened to it for an hour or so. It was peaceful to share the rain and the music together and not feel embarrassed by the lack of conversation between us.

With space in the house limited, Tiampati and I shared one of the sleeping pallets, lying on the stiff cowhide. During the night a goat gave birth inside the hut, filling the air with bleating cries. A mother and father in an adjacent pen nursed a sick baby, the grandmother whispering to them throughout the early hours of the morning as they monitored the infant's cough. Tiampati and I lay awake, listening to the rustle of cockroaches in the thatched roof. I watched the porthole window and waited for morning to come. A pride of lions called out in the bush beyond the *boma* walls. The night was a jamboree of howling dogs, driving rain, and bleating goats.

At first light we set off for the final leg of the trip home. The car slid and fishtailed along the wet roads and we spun out of control several times, drifting helplessly across the mud. We drove up the hills outside of Narok and shot out across the plains. When we reached the escarpment we passed a truck heading to town, the flatbed crowded with people on their way to Nairobi. I looked out over the Rift Valley and thought of the Maasai, who had lasted so long in their wilderness, unchanged by the world around them. They lived in a fragile moment of transition in which both past and present were briefly suspended together. Looking out over that vast bushland, however, so beautiful and terrible, empty and wide, it truly felt like the world was big enough for us all.

"Where the sky meets the grass, that is the end."

—MAASAI PROVERB

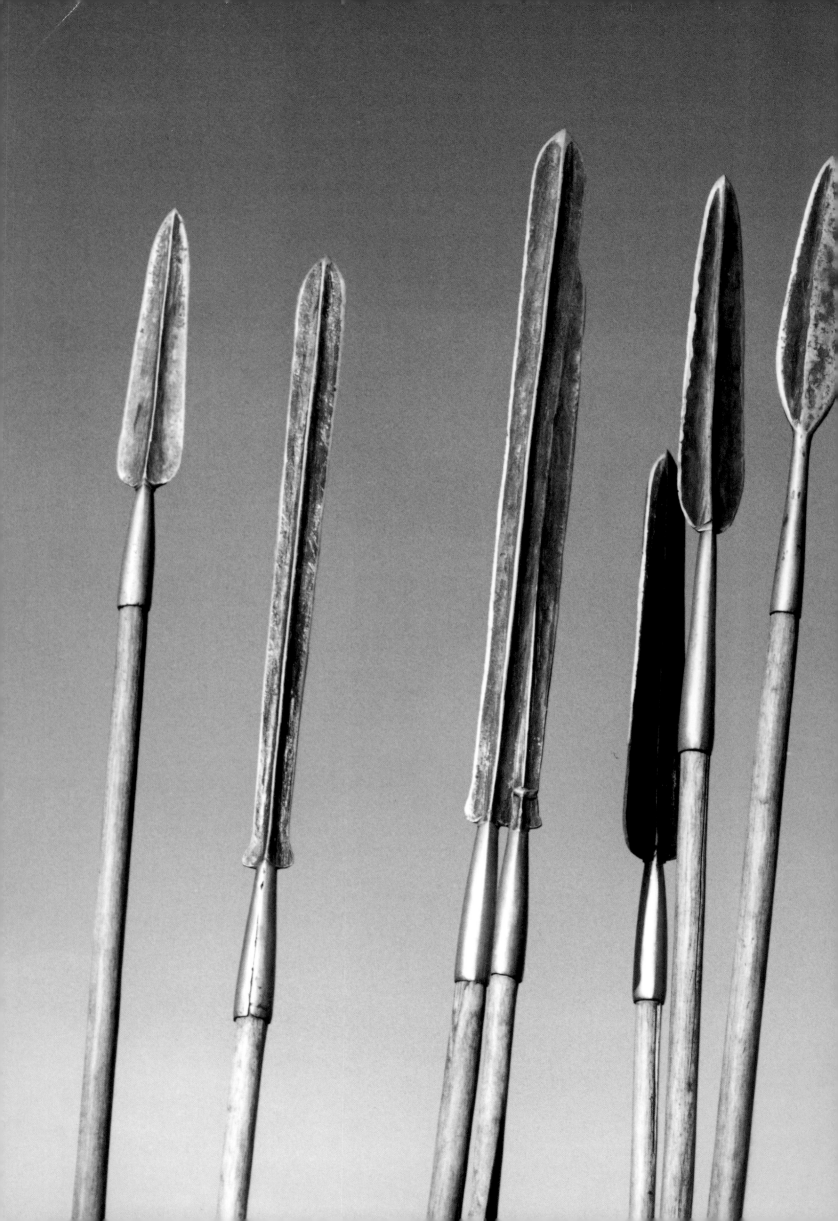

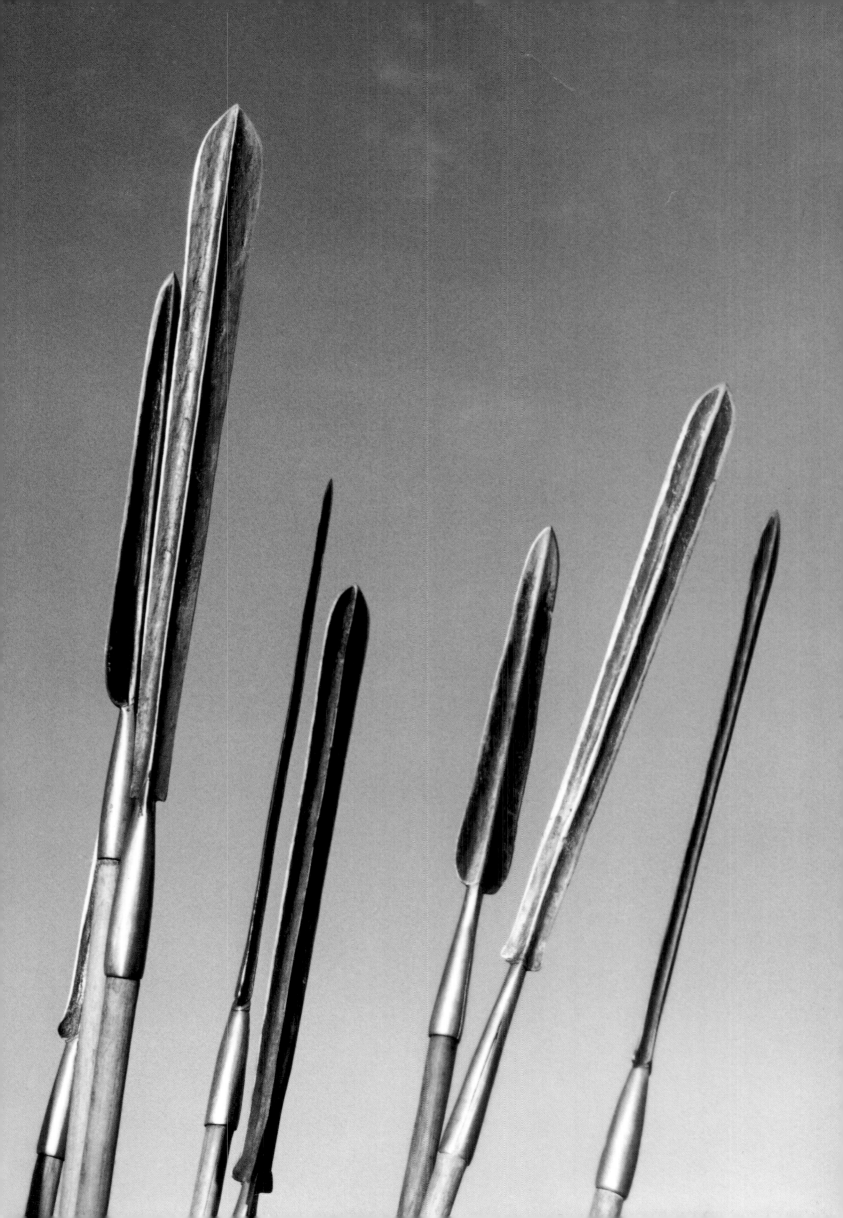

ELIZABETH L. GILBERT'S TRAVELS ACROSS MAASAILAND
WERE GENEROUSLY SPONSORED BY
CORBIS AND THE EASTMAN KODAK COMPANY

190

ACKNOWLEDGMENTS

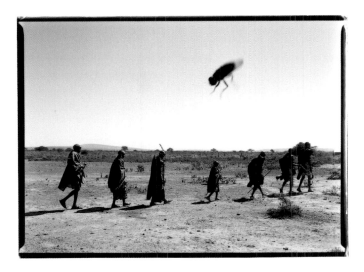

Many people have contributed to the making of this book and I wish to express to each of them my deepest gratitude. First, this book would not exist without Eliane Laffont and Terry McDonell, both of whom encouraged me and championed my work. I owe a debt of appreciation to Robert Stevens, who brought his knowledge to bear on the final picture edit, to Jim Megargee of MV Labs for artfully printing the photographs, and to Julie Duquet, who handsomely designed these pages. At Grove I would like to thank Charles Rue Woods and Brando Skyhorse for their guidance, patience, and talent, and of course I especially want to thank Morgan Entrekin, whom I feel privileged to call my publisher.

To Najma and Peter Beard I will always be grateful for bringing me to Africa in the first place. To say that it changed my life is an understatement. I would also like to deeply thank Aidan Hartley, who made the journey interesting. Many friends have given me their love and support along the way, most among them Mariella Furrer, Suzanne Georges, Rachel Cobb, William deYampert, and my brother, Walter.

The Maasai treated me with grace and kindness during my travels. Words of thanks can never fully convey the gratitude I will feel toward them for the rest of my life. I am especially indebted to those people who welcomed me into their homes, gave me their trust, and allowed me to photograph the great moments of their lives. Among them I would like to thank Dickson Letura, James Mpusia, James Ole Nampaso and his family, Namasari and Patita Ole Saigilu, the warriors of the Emaoi Plains, James Ole Sindiyo, Nelson Ole Sindiyo, Milton Ole Siloma, Chief Sammy Ole Tarakwai and the Madam Tarakwai. Most of all I would like to thank my friend and ambassador, Micheal Tiampati, and all the members of his extended family who gave us shelter on the road.

A number of people in Nairobi also opened their homes to me during my travels, and I would like to thank Alex and Samira Furrer for many fine meals, Tyler Hicks for the extended use of his guesthouse, Francesca Marciano for a place at the coast, Julian Ozanne for a camp in London, Nick Wood for the resources at Sekenani, and Firle Davies and Phil Davies for turning their homes into safari central and storing my equipment in their garages.

Finally, I would especially like to thank Dominic Cunningham Reid for the generous use of his cherished 1972 Land Cruiser. I would also like to thank the dozens of Africans who stopped to help me fix it along the way. I do not know their names—they were strangers on the path who gave me their spare oil, dug me out of the mud, coaxed dirt out of the carburetor, towed me back to Nairobi, and helped me fix a multitude of flat tires—but to all of them I owe a debt of gratitude.

Selected Reading

Much has been written about the Maasai, and I found a number of books especially helpful during my research. For those wishing to read more on the history, ethnology, and traditions of the of the Maasai, as well as the history of East Africa in general, I recommend the following books:

BEARD, PETER. *The End of the Game.* San Francisco: Chronicle Books, 1988.

BECKWITH, CAROL, AND TELEPIT OLE SAITOTI. *Maasai.* New York: Henry N. Abrams, Inc., 1980.

HANLEY, GERALD. *Warriors and Strangers.* New York: Harper & Row Publishers, Inc., 1971.

MATTHIESSEN, PETER. *The Tree Where Man Was Born.* New York: E. P. Dutton, 1972.

MOL, FRANS. *Masai: Language and Culture Dictionary.* Narok: Mill Hill Missionary, 1996.

MUNGEAM, G. H. *British Rule in Kenya 1895–1912: The Establishment of Administration in the East African Protectorate.* Oxford: Clarendon Press, 1966.

SANDFORD, G. R. *An Administrative and Political History of the Masai Reserve.* London: Waterlow & Sons, Ltd., 1919.

SANKAN, S. S. *The Masai.* Nairobi: Kenya Literature Bureau, 1971.

SORRENSON, M. P. K. *Origins of European Settlement in Kenya.* Nairobi: Oxford University Press, 1968.

SPEAR, THOMAS, AND RICHARD WALLER, eds. *Being Massai.* London: James Curry, Ltd., 1993.

THOMSON, JOSEPH, F.R.G.S. *Through Masailand.* London: Sampson Marston, Searle & Rivington, 1887.